THE ART OF COLOUR PHOTOGRAPHY

The Art of Colour Photography

G. ISERT

VNR VAN NOSTRAND REINHOLD COMPANY New York

Adapted by Leonard Gaunt from
Das Goldene Buch der Farbfotografie
© Verlag Laterna Magica
Berg am Starnberger See,
West Germany

ISBN 0 240 50725 8

Colour illustrations printed in West
Germany by St Otto-Verlag GmbH Bamberg
Text printed and bound in Great Britain by
W & J Mackay & Co Ltd, Chatham, Kent

Published in the United States of America
by Van Nostrand Reinhold Company,
A Division of Litton Educational Publishing,
Inc., 450 West 33rd Street, New York,
New York 10001
16 15 14 13 12 11 10 9 8 7 6 5 4 3 2 1

Contents

The three primary colours of pigment, mixed equally, result in black. The three primary colours of light, added in equal proportions, result in white. Unequal mixtures or additions offer the infinite variety of the artist's palette, which can reproduce any subject.

These facts are used in photography—or rather by its scientists—as a basis for colour photography.

In the early part of the 19th century, the inventors of photography—Nièpce, Daguerre, Fox-Talbot—had hoped they would succeed in unveiling and mastering the secret hidden between black and white. To them it remained an unfulfilled dream. But, in 1855 and 1861, the Englishmen Clerk-Maxwell and Sutton showed astonishing experimental work; in 1869, the Frenchmen Ducos du Hauron and Cros produced colour photographs independently; and in 1907, the Lumière brothers manufactured their Autochrome plates.

In all, however, it took 100 years—into the second half of the 1930s—for colour photography to become practicable for everybody. That it did eventually become practicable was due to the research workers, technologists and marketing men of the photo industry.

The black-and-white photograph is, in truth, an unnatural abstraction. It shows man and his world as only the afflicted see them, whereas the photograph in colour is true vision, presenting the subject in reality.

So photography became complete—but what else has become of it? It provides millions of people with billions of garish snapshots which they happily accept as natural because they are coloured. Surely colour photography can offer more than this?

Masters of the camera have shown again and again that colour can be used creatively.

They have transformed the triad of colours and created from it images of outstanding originality. By selecting and emphasizing a single colour and using others in smaller measure for harmony, or contrast, or balance, they reject the chaotic multitude of colour and bring real colour photography into being.

It is to this real colour photography that *The Art of Colour Photography* is devoted. It guides the colour photographer and inspires him by excellent examples of varying treatments of similar picture themes. Its text elucidates the basic theory and goes on to show the way to perfection. The tools are so simple : just a camera and a colour film.

L. FRITZ GRUBER DGPh, Hon FRPS, Hon EFIAP

Ten Golden Rules
for Colour Photography

Our world is full of colour and nothing reproduces colour better than colour photography. There are no secrets about such colour reproduction: any camera can take colour photographs.

The camera does not need any special parts or construction. Its ability to reproduce colour depends entirely on the construction of the film material with which it is loaded. If you study and practise the following rules until they become second nature, you will be fully acquainted with the basics of colour photography.

1 Colour photography is not *coloured* photography. There is a world of difference between the two words in this context. The difference must be learned to appreciate the true meaning of colour photography.

2 Colour films are multi-layer materials and the picture consists of three basic colours. Images in the three colours are formed at different depths in the emulsion and need to be accurately exposed. An exposure meter or camera with automatic exposure control is almost essential.

3 In colour photography, the nature of colour is important. There are, for example, colours which appear to stand out, such as red and orange. Others appear to recede, such as blue and some greens. The former look more natural in the foreground, the latter in the background.

4 It is wise to choose one film and stick to it. It is reasonable to use a reversal film for slides and a negative film when prints on paper are particularly required, but you should choose one film of each type and not chop and change between the various brands.

5 Colour film can cope with reasonable subject contrast but a good general rule is to expose slide film for the highlights and print film for the shadow areas.

6 There need be no filter problems in colour photography. Filters are rarely necessary with print film while slide film usually needs only a UV or skylight filter when there is a tendency to excess blue in the scene, as in very clear air under a blue sky, shady scenes on a sunlit day, or distant views.

7 Colour photography does not always call for colour fidelity. The nature of the incident light and even its direction can affect the appearance of a colour. Direct frontal lighting shows the full colour effect. Side or back lighting may subdue the colour by making it a faintly coloured shadow.

8 When using slide film the picture needs to be exactly framed in the viewfinder because later cropping or re-arranging is not practicable. Print film, on the other hand, allows some adjustments in format at the printing stage.

9 Colour prints can be obtained from either colour slide or colour print film. Similarly, colour slides can be obtained from either film. Generally, however, it is wise to use the type of film specifically designed to provide the end-product required.

10 The colour photographer must take his hobby seriously. It is not so easy to get away with mistakes as it is with black-and-white work and a slapdash approach rarely gives satisfactory results. Minor corrections can be made at later stages but they are sometimes quite expensive.

Quick Course
in First Principles

Colour photography can be carried out with any camera. There is no need for special lenses or any unusual features. The only necessity is sufficient light; the simplest camera may admit enough light for photography only in fairly bright daylight conditions.

Characteristics of light

Photographs can be taken by daylight, flash, photoflood or ordinary incandescent illumination. All these are electromagnetic radiations with varying mixtures of wavelengths. For every wavelength there is a colour. Our eyes can detect electromagnetic radiations in the region of 400–700 nanometres (nm, of which there are one thousand million in a millimetre). Below 400nm is the invisible ultra-violet region; beyond 700nm is the equally invisible infra-red. The violet and blue end of this region is the short-wave, and the red-orange end the long-wave. The short-wave colours, particularly blue, we regard as cool colours. The long-wave colours, especially red, we think of as warm. The in-between colours are warm or cool more or less according to their red or blue content. This is purely psychological and the warm or cool connotations have no scientific basis. Nevertheless, they have an effect on colour photography and its expression of mood and atmosphere.

The cool colours tend to recede when seen together with other colours, while the warmer colours seem to push forward. Landscape photographers often make use of this fact to increase the impression of depth in their pictures. They place warm coloured objects such as flowers, animals, leaves, crops, roofs of houses and so on in the foreground, where they seem to stand out from the often green and blue dominated background. People

13

can be used in this way if no other possibility exists. They can wear red or orange coloured clothing or accessories, or carry suitably-coloured objects.

Types of colour film

Colour films come in two forms—for colour prints (negative film) or for colour slides (reversal film). The colour print film is, just like the black-and-white negative, of no interest by itself. It is a means to an end—a material from which a colour print is eventually made. As many prints as you like can be produced from it and they can be enlarged—again, just like the black-and-white film—to any size. Black-and-white prints and colour slides can also be produced from the colour print film.

Most colour print films are "masked", i.e. they incorporate a yellow or orange coloured layer which overlays all the colours in the film and makes them rather difficult to see (see page 48). The function of this colour mask is to improve the brilliance of the colour print. Even without the mask, however, the colours in a colour print film convey little to the uninitiated. They are negative in density and complementary in colour, so that blue looks yellow, green looks red and so on.

The colour slide film, although structurally similar to colour print film (each has emulsion layers separately sensitive to red, green and blue light) is processed differently so that it becomes both the means and the end. The film used in the camera is returned to you by the processors as a full-colour transparency or slide in positive form.

Some colour slide films are made in two versions—one for use in daylight, the other for artificial light. This simply means that the sensitivity of the three emulsion layers is in different proportions, because daylight and artificial light consist of different proportions of the three primary colours—red, green and blue. There is proportionately more blue, for example, in daylight than in artificial light, so the blue-sensitive layer of the daylight film is less sensitive than that of the artificial light film.

This distinction is not necessary with colour print film because the colours can be adjusted with filters during the printing stage.

Colour slides can be duplicated with copying equipment and can also be used to produce colour or black-and-white prints, but are not so convenient for these purposes as colour print film.

Film sensitivity or speed

The varying sensitivities to light of the three layers of a colour film can be averaged to produce a single measure of sensitivity or

14

speed. This is necessary if we are to know how to expose the film correctly. There are now universally-recognized methods of calculating film speed so that it can be expressed as a single figure on a logarithmic or arithmetic scale. The best known scales are ASA, which is arithmetic, and DIN, which is logarithmic An average colour film speed is 18DIN, which is equivalent to 50ASA. The DIN figure rises in steps of three for each doubling of speed, while the ASA figure simply doubles. Thus a 100ASA film is 21DIN.

We need the film speed figure to adjust our exposure meter to the film in use, or to calculate exposure settings from published tables, or to select the correct guide number for a flashbulb or electronic flash unit.

There are colour films of various sensitivities or speeds, the faster films being necessary when the light level is low and/or the camera lens has limited light-transmitting power. Additionally, some processing laboratories will give a film special treatment after exposure which, in effect, increases its sensitivity. This is not a practice to be recommended, particularly with the slower films, but it can occasionally make pictures possible in otherwise impossible conditions.

Function of lens aperture

To take a successful colour picture you have to allow just the right amount of light to act on the film. When the light is bright, you need only a little of it. When it is not so bright, you need rather more.

You can regulate the amount of light reaching the film by covering or uncovering part of the lens. In practice, except on simple cameras, this is effected by a variable iris diaphragm situated within the lens which closes towards the centre of the lens to provide a more or less circular opening of infinitely variable proportions.

Most lenses now have a series of fixed positions for this opening, which is known as the aperture. These positions are marked by f-numbers engraved on the lens mount in the series 1, 1.4, 2, 2.8, 4, 5.6, 8, 11, 16, 22. They are roughly equivalent to the focal length of the lens divided by the diameter of the aperture, so each number indicates an aperture half as large as the previous one and therefore admitting only half as much light.

Apart from controlling light-transmission, the aperture also has an effect on the overall sharpness of the picture. In theory, any lens produces sharp images only of objects in the plane on which it is focused. Objects in front of, or behind that plane are repro-

duced less sharply. In practice, no lens can produce an image of any object with absolute sharpness but within a certain range of distances the unsharpness is not detectable by the human eye at normal viewing distance. The range of distances from the camera within which everything looks equally sharp is the depth of field, which is greater, other things being equal, when the aperture is smaller. So, for all-over sharpness, we use a small aperture (large f-number) while if we want only a limited zone of sharp focus, we use a large aperture (small f-number).

Focal length and focusing

The camera lens collects the diverging light rays from each individual point of an object and bends them so that they converge again as they emerge from the back of the lens. Thus, all points in the plane on which the lens is focused are reproduced as points a certain distance behind the lens. This distance is the focal length of the lens when the points reproduced represent objects at an infinite distance in front of the lens. This is the plane in which the film is placed, i.e. at one focal length behind the lens when the lens is set for infinity focusing. It is known as the focal plane. To focus objects nearer to the camera, the distance between lens and focal plane has to be increased. A common method of doing this is to place the lens in an inner mount which moves along a helical thread inside the outer mount, so increasing and decreasing the separation between lens and film.

Some simple cameras have no focusing facilities. They generally produce equally sharp images of objects from about 5–7 feet to infinity because they are actually focused on about 20–25 feet and the small aperture of the lens (about f11–14) takes care of the rest by means of its depth of field.

Focusing at close range

The average camera lens will focus objects as close as 2ft 6in to 3ft. To focus closer still and so produce really large images of small objects you can use supplementary lenses (see page 182) which decrease the focal length of the camera lens while leaving it at the same distance from the focal plane, which, in effect, is the same as leaving its focal length unaltered and increasing the lens-film separation. That, as we have seen, allows the lens to focus on closer objects.

If the camera lens is removable, you can fit extension tubes or bellows behind it (see page 165), again increasing the lens-film separation.

Such close-range work demands careful focusing because depth of field also depends on focused distance. Other things being equal, depth of field is greater at long range than at close range and, in real close-up work it is very shallow indeed. Thus, a tripod should be used if possible and the lens should be stopped down (i.e. a small aperture used) as far as is practicable to obtain as much depth of field as possible.

Control of exposure time

Exposure of the film to light is governed not only by the amount of light admitted by the lens (the aperture setting or f-number used) but also by the time for which the light is allowed to act. This depends on the setting of the camera shutter—a mechanism which allows the exposure time to be controlled between certain limits. The simplest camera may have only one fixed shutter speed, while those a little more advanced may have three or four speeds in the "instantaneous" range, such as, perhaps, 1/30, 1/60, 1/125 and 1/250 sec. The more expensive cameras have shutter speeds ranging from 1 second to 1/1000 second.

Naturally, your choice of shutter speed is somewhat restricted by the nature of the subject: a moving subject cannot be photographed with an exposure time of one second, unless the intention is to create a blurred image.

Types of shutter

There are two main types of shutter: the blade, leaf or between-lens shutter, similar in construction to the aperture diaphragm and usually situated close to it within the lens; and the focal plane shutter, which consists of two blinds, one following the other across the film with a separation varying with the exposure time set. Each has its own advantages but the focal plane shutter gives greater scope for the use of interchangeable lenses (see page 24), while the blade shutter makes flash synchronization (see page 95) easier.

Many modern cameras have so-called electronic shutters. They are, in fact, spring-driven shutters with an electronic timing circuit, usually giving a wider range of accurately timed slow speeds.

Built-in exposure meters

Assistance in determining the correct exposure time is now often provided by a built-in exposure meter (see page 86) coupled to the aperture and/or shutter speed settings. There are various

17

systems, including those of fully automatic cameras with which you have no more to do than press the shutter release. The meter system then regulates both shutter speed and aperture. This has obvious drawbacks and more versatile systems allow you to set either aperture or shutter speed to suit the subject, while the meter takes care of the other setting.

Colour quality of flash lighting

Artificial light generally demands the use of artificial light film but there are some sources which give light approximating to the colour quality of daylight. Prominent among these are electronic flash tubes (see page 94) and blue-tinted flashbulbs (see page 94). In fact, most ordinary flashbulbs are now made only in blue-tinted versions. The one-time recommendation that clear flashbulbs should be used with colour print film is no longer made.

Cause and treatment of colour casts

You may often find that colour photographs taken outdoors look too blue; they are said to have a blue cast. There can be various causes for this but the most common cause is diffused lighting from a blue sky. On a sunny day, for example, you may decide to shoot in the shade to avoid harsh contrasts. If there is very little cloud in the sky, your lighting comes entirely from the blue sky and has too much blue content for the film.

With colour print film, this type of cast can usually be corrected at the printing stage but with colour slide film there is no cure—only prevention. You have to use a pale pink filter over the lens.

A reddish cast may result when the sun is very low in the sky, i.e. during early morning and late afternoon or evening. Then, the sun's rays have to travel farther through the earth's atmosphere and they become diffused and scattered. The scatter is uneven, however, because the short-wave rays (blue) are more susceptible to it than the long-wave rays (red). Consequently, compared with mid-day light, morning and evening light tend to contain more red and yellow. Unless you want to present the sunrise or sunset effect, you have to use a pale blue filter to cut out the excess reddish light.

Similar, but much stronger casts occur if you use daylight film in artificial light or vice versa. The remedy is the same but in this case the filters are rather stronger. In the case of daylight film used under indoor light, in fact, the filter required is a quite deep blue because of the marked lack of blue in artificial light. This means that a great deal of the red content has to be cut out to restore the

balance and very little is left to reach the film. Consequently, much longer exposures are necessary, which may not always be practicable.

Exposure latitude of colour films

Colour films have to be exposed rather more accurately than black-and-white films. They have less tolerance of exposure errors (exposure latitude) because their emulsion layers are extremely thin and their relative sensitivities are very finely balanced. If you disturb that balance only slightly by over- or under-exposure, the layers are likely to be unequally exposed and colour distortion results. Moreover, colour slide film is reversal processed, which means that the positive image is formed by the parts of the emulsion that are *not* affected by the exposure in the camera. If the exposure is inaccurate, too much or too little emulsion remains unaffected and the resulting slide is either too dense, giving over-saturated colours or too thin, giving pale, washed-out colours.

Determining correct exposure

The inexpensive camera often gives you little or no control over exposure. Its aperture and shutter speed are either fixed or limited to only small adjustments. With such cameras you have to learn to recognize the lighting conditions that make colour photography possible. Usually, you will get quite satisfactory results in reasonably bright summer daylight between 9 or 10 a.m. and 4 to 5 p.m.

If your camera does give you a reasonable amount of control over the exposure, you should use an exposure meter to determine the correct shutter speed and aperture settings. A rule of thumb is to take your reading from the brighter parts of the picture if you use colour slide film and from the darker parts if you use colour print film, excluding the extreme highlights or deepest shadows, which should, in any event, form only very small parts of your picture.

This is most easily done with the separate exposure meter. If your camera has a built-in meter, you have to approach the subject closely to take the reading and then retire to your shooting position to take the picture.

Using depth of field

With most photographs, the foreground must be correctly focused. Landscapes, and other subjects covering a deep zone, also usually need to be sharp in the background, which may be

very distant. If you select a small lens aperture you can increase the zone of sharp focus (the depth of field). You have to calculate just how small an aperture you need. This you can do by consulting either the depth-of-field scale on your camera or reliable depth of field tables given in the camera handbook or other publications. If your camera has a focusing screen, you can also obtain some idea of the aperture required by studying the viewfinder image while slowly adjusting the diaphragm opening. Out-of-focus colours, particularly bright background colours, are not usually very attractive so you should take care to check the depth of field before shooting.

Arrangement of colours

The quality of a colour picture does not depend on the number of colours in it. In fact, the more colours there are in a scene, the more difficult it is to make a satisfactory colour picture. Try to avoid masses of colour; they often create nothing but chaos.

In every photograph, there should be one dominant colour. It usually appears as a fairly large area and all other colours are subsidiary to it. Only thus can a harmonious colour composition be achieved.

Whenever possible—and provided it is appropriate to the subject—there should be at least a little red or other warm colour in the foreground. It adds to the liveliness of the picture and also helps create an impression of depth. It is comparatively easy to follow this advice when photographing people but in other cases it may call for a little ingenuity. There will be occasions, of course, when it is totally out of sympathy with the subject.

Dangers of camera shake

Colour photographs, like any other, must be sharp and one of the most common causes of unsharpness is movement of the camera (camera shake) during the exposure. When using the smaller formats, such as 35mm film, the slightest camera shake shows up alarmingly on projected slides or enlarged prints, even though it is barely noticeable on the film. The easiest way to minimize camera shake is to use fast shutter speeds, but that is not always possible. So, whenever a shutter speed slower than 1/125 sec has to be used particular care must be taken to hold the camera still and to *squeeze* the shutter release rather than jab at it. At speeds slower than 1/30 sec a tripod or other rigid support for the camera should be used. A cable release can also be used as further protection against camera shake.

Colour temperature

A colour film is designed to be used in one particular type of light: generally daylight, photoflood lamps or studio lamps. You cannot mix these light sources for the same picture without producing some distortion in the colours. Daylight, for example, contains proportionately more blue than light from the photoflood lamp. Thus, if you use a photoflood to throw light into the shadows of a portrait taken by window light on daylight film, the colours in the shadow areas will contain too much yellow.

This applies to both colour slide and colour print film because, although overall distortions of colour can be corrected to some extent at the printing stage, it is impossible to make a selective correction of the areas wrongly exposed.

You can, however, use the light from electronic flash tubes or blue flashbulbs together with daylight, because these sources are deliberately designed to give the same quality of light as daylight. The quality of light with which we are concerned in this context is its spectral composition, i.e. the colours it contains and their proportions. It is generally designated by a figure, known as the colour temperature, which is the temperature, on the absolute scale, to which a theoretical perfect radiator of light would have to be heated to give light of the spectral composition concerned. Colour temperature is expressed in kelvins and those sources mentioned above have colour temperatures as follows: daylight 5–6,000K, photoflood lamps 3,400K, studio lamps 3,200K. In fact, daylight colour temperature can vary within wide limits but the 5–6,000K figure is taken as the average for noonday sunlight and that is the light for which daylight colour films are generally balanced.

Flash and guide numbers

Flash is an admirable form of lighting for colour photography, not only because it has a colour temperature very close to daylight but also because the light output of any particular electronic unit or type of bulb is predictable.

The exposure time when using flash, particularly electronic flash, is more often regulated by the duration of the flash itself than by the shutter speed. The average electronic flash has a duration of only about 1/800 sec, while the usable light from the popular types of flashbulb lasts for about 1/50 sec.

The amount of light reaching the film is therefore governed by the aperture setting and the distance between the subject and the light source: a smaller aperture admits less light and a greater

distance between light source and subject causes less light to be thrown on the subject. Fortunately, when apertures are translated into f-numbers these two factors work in the same way, i.e. when either the distance or the f-number is doubled, the amount of light falling on the subject is quartered (see page 95). Thus, whenever f-number and distance multiplied together give the same figure, the light reaching the film is the same. This allows each type of flashbulb or electronic flash unit to be given a "guide number" for a given film sensitivity and correct exposure can be calculated by dividing the distance of the flash into the guide number to give the correct aperture setting, or vice versa.

Filling the frame

The basic rule for any colour photograph is to approach the subject as closely as is necessary to cut out all unnecessary detail and thus include on the film only those parts of the scene that are necessary to the theme of the picture or to the objective in taking it. This is generally called "filling the frame". It is particularly vital with colour slides because it is impractical to mask slides down to various sizes for projection. A series of pictures of varying shapes and sizes projected on to a screen is rather irritating. Even with colour prints, however, it is still best to fill the frame whenever possible because selective enlarging of a part of a negative means a greater degree of enlargement, which may entail a loss of quality.

22

Optics
and Basic Equipment

The basic working principle of any camera is the same. The lens collects the light rays reflected by the object and directs them on to the film, where they form an image of the object. The image is sharp (or as sharp as the particular lens can make it) if lens and film are correctly placed in relation to each other, i.e. the image is correctly focused. The purpose of the shutter is to exclude light from the film except during the required exposure. The viewfinder shows how much of the scene in front of the camera is recorded on the film, and may also show when the lens is set for sharp focus.

If you want to take colour slides, you have to choose both camera and projector to handle the same picture format. The widest choice is in the 2 × 2in (5 × 5cm) field. Those are the overall dimensions, including the mount, of the standard 35mm slide, which is available in various forms to take transparencies of all film sizes up to 4 × 4cm. The $2\frac{1}{4}$ × $2\frac{1}{4}$in (6 × 6cm) transparency uses a $2\frac{3}{4}$ × $2\frac{3}{4}$in (7 × 7cm) mount. Subminiature (or ultraminiature) sizes have their own slide mounts and special equipment designed to handle the extremely small image.

Simple cameras

Not every photographer wishes to be bothered with technical details, so the manufacturers have produced many cameras that are easy to use. The simplest of these is the fixed-focus, fixed-aperture, fixed-speed camera. Its lens is set to take reasonably sharp pictures at any distance from about 7ft (or 2m) to the far distance (which we call infinity). Its shutter has only one speed which is normally about 1/60 sec, and the usable area of the lens

23

gives an unalterable aperture of approximately *f*11. It can be adjusted to varying light conditions only by using films of different sensitivity or "film speed".

A fairly recent simplification is the cartridge method of "instant" film loading introduced by Kodak as the Kodapak for its Instamatic range of cameras. The cartridge is simply dropped into the camera and cannot be put in the wrong way round. Its film does not have to be threaded before use or rewound afterwards. For cameras with automatic exposure control systems, the cartridge itself sets the camera to the correct film speed.

More advanced types

In choosing a camera, the first point to settle is the use to which it is to be put. No one camera is ideal for all types of photography and, if you do not know the limitations of particular models, you should seek the dealer's advice.

There are, in fact, many types of camera other than the simple type on which everything is "fixed". There are those with a limited range of apertures and shutter speeds and a focusing lens, but no means of visual focusing. With these, you have to develop some skill in judging distances before you set them.

Rather more advanced cameras may have a rangefinder incorporated in the viewfinder and coupled to the lens focusing mechanism. You turn the lens mount until two images in the viewfinder coincide and the lens is correctly focused. Such cameras may also have a fuller range of apertures and shutter speeds.

Interchangeable lenses

Then there are the cameras from which the lens can be removed and replaced by another—the interchangeable lens types. These allow you to use lenses of different focal lengths, and other specialized items of equipment. The most versatile of these are the single lens reflex cameras with focal plane shutters. Their viewfinder image is supplied by the camera lens, no matter what lens or other equipment you put on the camera. With non-reflex cameras of this type, you need a separate viewfinder for each lens or "zoom" finder of adjustable focal length. The viewfinder image of the SLR is normally visible on a focusing screen so that you can check the focus in all parts of the picture. The focal plane shutter, which is in the camera, not in the lens, allows a wide variety of accessories to be used for many specialized applications. There are even zoom lenses for some of these cameras—lenses of variable

focal length which allow you to fill the frame precisely without changing the camera position.

Advantages of SLR systems

A particular advantage of the SLR camera is that at close range its viewfinder shows the exact image that will appear on the film. The separate viewfinder of the non-reflex camera must inevitably show a slightly different image, because its viewpoint is not the same as that of the lens. The closer the camera is to the subject, the more noticeable this "parallax error" becomes.

Many SLRs not only focus the viewfinder image through the camera lens but also measure the light in the same way. These are the cameras with through-the-lens (TTL) exposure meters which measure only the light reflected from the area to be reproduced on the film or, in some cases, only a small part of that area. Moreover, they measure that light effectively at the film plane so that, even if filters, extension tubes or bellows for close-ups or other special equipment is used on the camera, they give the exposure required without the calculations necessary when other types of meter are used.

The components of the SLR viewing system are a mirror behind the lens, a focusing screen to receive the image reflected by the mirror and a specially shaped pentaprism to reflect the screen image right way up and right way round to the viewfinder eyepiece. When the shutter is released, the mirror flips away from behind the camera lens but returns to its original position as soon as the shutter closes.

Additionally, most SLR lenses have automatic diaphragms connected with the shutter release. The aperture control is set to the f-number required but the diaphragm remains fully open for viewing and focusing purposes, closing down only as the shutter is released and opening up again when the shutter closes.

The most popular type of SLR camera is that taking 35mm film but a growing number use rollfilm, giving $2\frac{1}{4} \times 2\frac{1}{4}$in (6 × 6cm) or slightly larger pictures. Some of these are extremely expensive and have a very wide range of accessories.

Twin-lens reflex

A less versatile type of reflex camera is the twin-lens reflex. This uses a lens, mirror and focusing screen just as the SLR does but the viewing lens is a separate one, situated above the taking lens on a common panel which moves bodily back and forth to focus both lenses simultaneously. Because it is not behind the

taking lens, the mirror is in a fixed position and does not need to move. The focusing screen is in the top of the camera and you usually look down on to it without the aid of a pentaprism. The image is upright but reversed left to right. Naturally, the viewfinder has the same parallax troubles that beset any other type not taking its image from the camera lens. Only one twin-lens reflex takes interchangeable lenses.

Subminiature and half-frame

The subminiature, or ultraminiature, camera owes such appeal as it has to its extremely small size. It can be carried, together with a large stock of film, without even making a significant bulge in a jacket pocket. Its film is, however, so small that only with extreme care in all operations can it provide even passably sharp results at much more than a postcard size enlargement.

There is, however, an in-between size, generally known as the half-frame—a relatively simple, but often high-performance camera using 35mm film to give 40 or 72 pictures of 18 × 24mm from standard cassettes. These are generally fixed-lens cameras with separate viewfinding systems but there is one SLR type with inter-changeable lenses, including a zoom lens.

Instant-picture cameras

A certain, unique, type of camera takes special film in packs which include the processing chemicals. This, the Polaroid-Land camera, can produce colour pictures within 60 seconds of the film material being exposed (see page 37). Polacolor can be used in the cameras designed for it or in Polaroid backs made for various other cameras.

Lenses and focal length

Photographic lenses are of two types: converging (positive) and diverging (negative). Light rays from each point of the subject radiate in all directions. Therefore, those travelling towards the camera lens are diverging. It is the job of the camera lens to bend them back so that they converge on to the focal plane and so form a point again. Thus, the camera lens must be a converging type. The diverging lens cannot bring the rays to a point and therefore cannot make an image.

In fact, although we speak of the camera lens, it is nearly always a collection of lenses, at least four for good quality results in normal focal length or wide angle lenses. A single lens (known

as a meniscus) *can* be used, but only its central portion is capable of producing a reasonably sharp image and such a lens therefore usually works at a small aperture (about *f*8–11 at most). The average camera lens consists of both positive and negative components but the positive components must be the stronger. By careful choice of different types of glass and by grinding different curvatures, the various faults or aberrations that are present in any one lens can be set off against those of another and largely cancelled out. This is the skill of the lens designer.

Naturally, the lenses can be put together to form designs with varying characteristics, particularly in their light bending power. This power is indicated by the distance from the lens to the image that it forms—the image distance—which varies in fact with the range of the subject on which the lens is focused. When the subject is so far away that the light rays reaching the lens are virtually parallel, the image distance is at its shortest and is then equal to the focal length of the lens. Thus, the focal length of a lens is the distance between the lens and the film when the lens is set to infinity. To focus closer, the lens has to be moved forward, increasing the image distance.

In passing, it should be noted that when we talk of distance from the lens in respect to compound lenses (those with more than one component) we are referring to the distance from the optical centre of the lens, which can sometimes actually be outside the lens altogether.

Zoom lens

A type of lens that has been a standard fitting for many years on better quality cine cameras is now becoming increasingly popular as an optional accessory with users of 35mm SLR cameras. This is the zoom lens, which is, in effect, several lenses in one, because its focal length and therefore angle of view can be varied within certain limits. You might, for example, have an 85–200mm zoom lens. This would mean that, without moving the camera, you could simply turn a ring on the lens and produce images of various sizes within a ratio of more than 2 : 1. If, with the 85mm focal length, you found that you were including too much detail, you could alter the focal length until just the right area was shown in the viewfinder. The focal length is *infinitely* variable within its limits.

Lens aperture

Nearly all camera lenses contain an iris diaphragm which can be opened or closed to regulate the amount of light that is allowed to

pass through the lens. Theoretically, there is no limit to the smallest diaphragm opening (aperture) but the maximum aperture is, naturally, limited by the size of the lens. To obtain a large aperture, which will admit a lot of light and is therefore useful in low-light conditions, you need a lens of large diameter. It is not easy to make such lenses of good quality and they tend to be expensive.

The diaphragm opening is, by its nature, infinitely variable, but it is now usual to provide it with definite positions, the setting of which is facilitated by a ball bearing slipping into a notch. These are known as click stops and, to distinguish between the various settings they are given numbers which indicate their light-passing ability.

Aperture numbers, or f-numbers, run in an internationally agreed series: 1, 1.4, 2, 2.8, 4, 5.6, 8, 11, 16, 22. Most lenses bear the larger numbers but how many of the smaller numbers they bear depends on the widest opening of their diaphragms, because the numbers are derived from the focal length of the lens divided by the effective diaphragm opening. For illustration purposes, we can regard this as the physical diameter of the opening. Thus, a 100mm lens with a 25mm maximum opening will start its series of numbers at f4. A 50mm lens with the same maximum opening (25mm) has an f2 maximum aperture.

The f-numbers (or their relative apertures) are so arranged that each succeeding figure in the series indicates a halving of the light transmitted to the film. The f4 lens mentioned above can thus at best transmit only one-quarter of the amount of light transmitted by the f2 lens. But when both lenses are set to f4, they transmit equal amounts of light although the aperture of the 100mm lens is twice as large. The reason for the apparent discrepancy is that we are concerned only with light reaching the film. After it leaves the rear of the lens, the light passing through the 100mm lens has twice as far to travel to the film as that from the 50mm lens. By the inverse square law (see page 95) its strength by the time it reaches the film is only one-quarter of what it would have been if it had travelled only 50mm. Therefore it has to pass four times as much light to start with—and this it does because its *area* is four times greater than the f4 aperture of the 50mm lens.

Hence the seemingly disproportionately large diameters of long-focus lenses of quite modest maximum aperture.

Long-focus and wide-angle lenses

Lenses of different focal lengths have different angles of view: they produce an image of more or less of the scene in front of

28

them. The normal or standard focal length lens has an angle of view of 40–50°, as measured at the apex of a triangle with a base equal to the diagonal of the image format and a height equal to the focal length of the lens. Angle of view is sometimes expressed on the picture width or height but as this gives two different angles for formats that are not square it is better to standardize on the diagonal.

The standard lens is generally considered to present the picture in about the same perspective as the human eye sees the original scene. The wide-angle lens, with an angle of view greater than about 40°, emphasizes the foreground and, by reducing their size, pushes mid-distance objects into the far background. Distances between near and far objects seem much greater.

The long-focus lens has the opposite effect. It reduces the size discrepancy between near (or apparently near) and far objects and therefore makes the distance between them appear less.

These effects are not actually characteristics of the lenses. They are caused by the viewpoint. If a wide-angle and a long-focus shot were taken from the same viewpoint and then a part of the wide-angle shot were enlarged to present the same portion of the scene as the long-focus shot, the two pictures would be identical. The long shot of a distant scene omits the foreground and makes the picture look as if it were shot from close range, but the perspective remains that of the distant viewpoint.

Wide-angle lenses are used to photograph subjects that are of such a size and the available shooting distance so close, that the normal lens cannot include the whole subject in its angle of view. The shooting distance may, in fact, be quite considerable, as when the subject is a high building, or it may be a matter of inches, as, for example, when photographing a notice or a detail of a statue by pushing the camera through railings. Wide-angle lenses are useful in crowds, small rooms, narrow streets, etc.

Really long-focus lenses have limited uses but the moderate long-focus, from two to four times the standard focal length can make life easier for the photographer of architectural details, some sports, birds and other relatively unapproachable subjects. Long-focus lenses up to about $2\frac{1}{2}$ times the standard focal length are also handy for portraits, especially of children. The camera can be kept back from the nervous sitter and the more distant viewpoint lessens the risk of distortion.

Depth of field

When you focus your lens at a particular distance, all points in a plane at that distance from the camera should be reproduced

sharply. In theory, *only* that plane is reproduced sharply but, in fact, no lens can project an actual point on to the film. The point is always reproduced as a disc (commonly known as the circle of confusion). Fortunately, however, the human eye cannot tell the difference between a point and a disc if the disc is small enough.

It is evident that all out-of-focus points are also discs because they are formed by the cone of light passing from the lens and converging on to the film. The cones forming out-of-focus points reach the limit of that convergence either in front of, or behind the focal plane and therefore form discs *at* the film plane, or on the film.

It is the size of this disc that we are prepared to accept as sharp that governs what we call the depth of field, i.e. the extent to which sharpness extends in front of and behind the focused plane.

It is evident that whatever standard we set, depth of field is greater with a smaller aperture, because the cone is then slimmer. Here we are talking, incidentally, of the effective aperture, not the *f*-number, which is relative aperture. The aperture at *f*8 on a 50mm lens is the same as the aperture at *f*16 on a 100mm lens and the depth of field is the same, too.

Depth of field also varies with focused distance, being greater at long range than in close-ups, because at long range the relative sizes of objects quite far apart are not easily distinguishable. At very close range, the depth of field is so limited that focusing is critical and a small aperture is advisable.

At more normal shooting distances, you can either set a small aperture to obtain sharpness throughout the picture or a large aperture to set your sharply focused subject against a more or less blurred background.

The extent of the depth of field can be gauged from the screen image in the reflex camera, read off the depth-of-field scale on the lens, or ascertained from tables published in the camera handbook or various reference books.

Lens coating

Most of the light rays striking the surface of a lens pass through it and reach the film, but all glass reflects light as well as transmits it and lenses are no exception. In fact, as most lenses contain more than one glass-air surface the loss of light by reflection could be considerable. In modern lenses however this light loss is minimized by an anti-reflection coating on the glass-air surfaces. This is a microscopically thin layer, usually of magnesium fluoride, deposited on the lens by a vacuum process. It often makes the lens look coloured—perhaps slightly purple or yellow—but the colour

is formed by reflection only. It cannot be seen when you look straight through the lens and has no effect on the light passing through it.

Accessories and their uses

Apart from interchangeable lenses, there are various accessories available for most cameras. Any camera, for example, can use filters, lens hood, supplementary lenses for close-ups, a tripod for time exposures and a cable release to avoid camera shake. Remote releases (usually air operated) are also available for some types of nature photography where you have to leave the camera unattended.

Interchangeable lens cameras can take extension tubes or bellows for close-up work, microscope adaptors for magnified reproduction, slide copiers and so on.

An exposure meter is also an item that no colour photographer can do without. He may have one built into his camera. If not, he must obtain a separate instrument.

There are innumerable accessories on the market and you should always consult the publicity material issued by the makers of your camera as well as general photographic catalogues to find out what is available. There may be many items of which you are unaware but the need for which you have often felt.

Origins
of Colour Photography

The theories of Young and Helmholtz on colour vision created the basis for colour photography. They believed that the human eye had three light-sensitive elements, each sensitive to a different primary colour. For these colours, they chose red, green and blue and it is, in fact, possible to produce a very wide range of colours by adding together suitable quantities of red, green and blue light. This is additive colour synthesis.

Additive Colour Synthesis

Clerk-Maxwell's first colour picture

James Clerk-Maxwell used this theory to produce, on 17 May 1861, at the London Royal Institute, the first colour pictures. He used three coloured filters to produce three separate images and

32

projected them through the same filters so that the images were superimposed. This set the course for the early work in colour photography. The Frenchmen du Hauron and Cros, also worked independently on this process and made their findings public in 1868.

One of the difficulties these workers were up against was the fact that all negative emulsions were at that time sensitive only to blue light. Various ingenious methods were adopted to overcome this deficiency (du Hauron apparently used paper negatives) and exposures of greatly varying durations were needed for the three images.

Introduction of panchromatic materials

A major development occurred in 1873 with H. W. Vogl's discovery that emulsions could be made sensitive to other colours by the addition of minute traces of dye. Orthochromatic material, sensitive to all colours except red appeared first on the market, followed by panchromatic emulsions, sensitive to all colours. This made the production of separation negatives (the red, green and blue images) easier, but by no means simple. These images consisted, of course, of black-and-white silver deposits and could be coloured only by projection through filters, dyeing, printing, etc. There was as yet no direct colour slide or print.

Mosaic colour slides

This first came with the screen plates produced by various manufacturers, such as Agfa, Lumière and Dufay. They made panchromatic plates with a mosaic of minute filters of red, green and blue side by side. Various substances, including rice starch grains, were used to form the filters but the principle was the same. The three coloured images appeared on the same plate and, as the individual filters could not be resolved by the eye, the effect was that the colours were added together in the proportions of the original scene when the plate was viewed by transmitted light. However, the pictures showed considerable graininess and were very dense.

In attempts to find a better solution to the problem, many curious methods were tried. One such used the same tiny filters but imprinted them with crossing red, green and blue lines only .02mm thick. The production of such films was extremely expensive so a lenticular system was tried. The filters this time were in the form of lenses impressed into the film with red, green and blue striped filters incorporated. This method was used in 1908.

Developments in cine film

A method for making colour cine film was patented in Berlin in 1897. It was based on the colour separation principle, using rotating red, green and blue filters in front of camera and projector lenses. The system did not work too well, being prone to colour fringing with moving objects. A later method developed in England had only two colour separations, blue-green and orange, at a frequency of 32 pictures a second. The system was chosen in 1911 to film the ceremony when King George V became Emperor of India. The film was shown in 1912 and was an instant success.

In Paris, an equally successful film was made by a process that employed three lenses to produce three colour separations which were projected through fixed filters. In America, a two-colour process used a beam-splitting device to produce bluish-green and purple images, one on each side of the film.

In Germany, the lenticular process was still in favour but was hindered by technical difficulties. It, too, used only two colours, which necessarily limited the colour quality. Nevertheless, reasonably acceptable films were being shown in 1935.

Chromogenic development process

While all these developments were taking place, various workers experimented with subtractive colour synthesis. This development method was not planned as a basis for colour photography. It originated from the fashion in the early 1900s for colouring black-and-white photographs. At first this was carried out after the pictures had been fully processed but a patent taken out by R. Fischer in 1911 involved a method of introducing the colours at the development stage. The oxidation of dimethyl-p-phenylenediamine in the presence of alpha-naphthol to produce naphthol blue was already known. Fischer realized that exposed silver halides could also provide oxidation products. He developed photographic paper with dialkyl-p-phenylenediamine in the presence of alpha-naphthol. In further experiments he replaced the naphthol with chemicals from the methylene group and obtained colours ranging from blue-green through purple to yellow. This created the basis for colour processing. Colour materials, known as colour couplers, could be included in the photographic emulsion along with the silver halides. They would be released during the oxidation of the developer and would provide a coloured image alongside the silver image. Removal of the silver image would then leave only a colour image on the film. Photographic papers of this type were produced but it was a long time before Fischer's ideas could be put into practice to produce the subtractive colour film.

Additive and subtractive methods compared

The difference between the additive and subtractive method is not always easy to understand. In the additive system so far described, three projectors are used with red, green and blue filters in front of them. The three images projected represent in black-and-white the red, green and blue parts of the original scene, with clear film for the colour represented and an impenetrable density for those not represented (in practice, no colours are pure and there will be varying densities). Thus, in the red projector, the red areas are clear film and the blue and green areas are black so that only the red area is illuminated (in red because of the filter).

Thus, the three projectors give red, green and blue images in proportion to the colour of the original scene. Where an intermediate colour, such as yellow, is to appear, both the red and green projectors throw some light and the mixture gives yellow.

Suppose, however, that instead of projecting black images through red, blue and green and filters, we had taken away the filters and coloured the black images in the complementary colours, i.e. cyan in the red projector, magenta in the green and yellow in the blue.

The yellow cuts out the blue light from the blue projector, just as the black did, but as there is no filter it leaves red and green, i.e. yellow, to pass. Similarly the cyan filter passes only blue and green and the magenta filter passes only red and blue.

Subtractive Colour Synthesis

The result is that the red projector puts cyan in the blue and green areas, the blue projector puts yellow in the green and red areas and the green projector puts magenta in the red and blue areas. This adds up to yellow and magenta in the red area, yellow and cyan in the green areas and magenta and cyan in the blue areas. These mixtures would give approximations of the original colours, but also, as the colour in each projector is represented by clear film, we have white light overlaying all of them.

The next step is obvious. As all the images are now transparent, we do not need three projectors. We can bind the three transparencies together and put them in one projector. Then, where the yellow and magenta overlap (in the red areas of the original) the yellow absorbs blue light, the magenta absorbs green and only the red component of the projector light can get through. White light is projected only where the original scene was white and therefore no dye is formed. Where the original was black, dye is present in all the images and no light passes. Mixed colours contain varying proportions of cyan, magenta and yellow in the three images.

All this Fischer foresaw but he was, like so many before him, ahead of his time. He realized that the three emulsions would have to be put on one base, but that called for microscopically thin emulsions not then possible. Ideal dyes could not be made—and still cannot. Once in the emulsion the dyes had to be prevented from diffusing into the wrong layers.

First subtractive colour films

Intensive research work on Fischer's ideas was undertaken by Kodak in the United States and Agfa in Germany. In the United States, Mannes and Godowsky worked on the problem for Kodak, who took out their first patent in 1923, but it was not until 1935 that Kodachrome appeared on the market as the first subtractive colour slide film. The problem of migrating colour was not so much solved as sidestepped. Kodak did not include the colour couplers in the emulsion. Instead, they put them in the colour developers, and so arranged the rather complicated processing that each layer was colour developed individually.

Later, however, Kodak produced Ektachrome film with the colour couplers in the emulsion but anchored in a substance that was insoluble in water. Processing was much easier and could be undertaken by the user.

Agfa had also been working on Fischer's ideas but they could not market their film until the Fischer patents ran out in 1936. The Agfa film was, from the beginning, a user-processing type, with the colour couplers included in the emulsion and a single colour-developing stage.

After World War II, many other manufacturers produced colour films, some of them helped by the confiscation of Agfa patents during the war. Colour slide film was produced in both daylight and artificial light versions together with colour print film and the papers on which to print it. The quality and sensitivity of the films gradually improved.

36

Dye-destruction material

Colour prints were, and still are in most cases, made from colour negatives but there are various materials for producing prints direct from colour slides. One of these, Cibachrome, from the Swiss Ciba company, was first put to practical use in 1964. It is a dye-destruction process. Instead of building up the colour required from the colour materials in the emulsions, it destroys the colours that are *not* required. Its great advantage is that the dyes used are extremely stable and are nearer to true colour fidelity than those of the normal negative-positive process.

Instant pictures with Polacolor

The normal colour picture takes some little time to process but in 1963 an instant-picture colour material became available. This is the Polacolor process made by the American Polaroid-Land company. The film is in a special pack containing its own processing chemicals. The camera in which it is used has a pair of steel rollers through which the film is pulled after exposure to crush the pods containing the chemicals and spread them evenly over the emulsion. The film is pulled right out of the camera and develops in about 60 seconds, during which time other shots can be taken if required.

Alternative uses for colour materials

The colour materials available can be used in various ways. Colour slide film, for example, is designed to produce positive-image slides for projection or direct viewing. The slide is the original film that passed through the camera. It is comparatively easy, however, to copy the slide when more than one copy is required. Prints, either coloured or black-and-white, can also be obtained from colour slides but the quality is not generally as high as it is with the appropriate negative material.

Colour print film, similarly, can be used to produce colour slides or black-and-white prints as well as the colour prints for which it is intended. Again, however, the quality is not likely to be as high as with the proper material for the process.

Polacolor film is a daylight material producing colour prints, from which duplicate prints can be supplied by the Polaroid-Land company. This is considerably more expensive than the normal colour materials but it has many specialized applications that make the expense justifiable.

Light and Colour

We are so accustomed to seeing colour all around us that we take very little notice of it. We accept it as a matter of course that the camera will reproduce what we see. But *are* the things around us coloured? What is colour? Every colour photographer should have some knowledge of this subject. He should not dismiss it as dull theory that is no concern of his.

Colour is light

Without light there is no colour. Nevertheless, we do not see colours in all forms of light. We see colours in their full intensity in good sunlight whereas we barely see them at all in sodium street lighting. The reason is that we see an object as coloured because it has the ability to absorb light of some colours and to reflect others, the exceptions being true black and white. Black absorbs all colours, white reflects all colours.

Sunlight is our conception of white light. Therefore, a surface that reflects all colours looks white to us. But there are other forms of light, such as incandescent lamps, studio lights, street lights, neon display lights, fluorescent tubes and so on. The light from the incandescent household lamp is not white. Compared with daylight, it is rather deficient in blue and over rich in yellow. Thus the substance that reflects all light shows the predominance of yellow and is no longer white.

This is true in fact but usually untrue in practice as far as the human eye is concerned. We know that the paintwork in our room is white and we still see it as white even when the curtains are drawn and the room lights are on. Only if the light is really strongly coloured do our eyes accept that colours look different.

38

Sodium street lighting, for instance, is so strongly yellow that it turns blues black, reds a muddy brown and makes most other colours totally unrecognizable.

The colour film, however, is much more sensitive to coloured light than the eye. The daylight film reproduces the yellow tint cast by the household lamp quite strongly because its three emulsions have been carefully balanced to respond to white light, i.e. light in which the red, green and blue portions of the spectrum are equally represented. If one colour is deficient, the emulsion layer sensitive to that colour does not get enough exposure and all colours containing that colour are distorted.

Nature of light

Visible light is part of the vast field of electro-magnetic radiation that includes X-rays, sound waves, radio waves and so on.

The wave motion can be represented schematically in the usual hill and dale formation. The distance from hill to hill or dale to dale is the wavelength. The height of the hill is the amplitude or intensity.

We know that there are innumerable wavelengths in radio and television and that each transmitter sends out signals on a particular wavelength to which the receiver must be tuned to pick up those signals. In the same way, the eye is tuned to the waveband representing light and there are many wavelengths within that band. As far as we are concerned, these wavelengths are grouped together into smaller bands within the spectrum of white light, each band representing a colour. This is easily seen when light is passed through a prism. It splits up into its constituent wavelengths, each of which appears as a separate colour.

Refraction of light

When light passes from one medium to another it changes its direction of travel. The light ray is, in fact, bent or refracted. If, for instance, the ray passes from air to glass and then out into the air again it is refracted twice. When the two surfaces of the glass are parallel, the two refractions cancel out and the ray is simply shifted to a parallel course.

The Electromagnetic
Spectrum

The extent to which the light is refracted depends on its wavelength. Shortwave light is refracted more strongly than longwave light. That is why the prism splits light into its different wavelengths or colours, which are violet, blue-violet, blue, blue-green, blue, yellow-green, yellow, orange, red, and purple. The blue end is shortwave and the red end longwave.

Spectral composition

The wavelength of light is currently expressed in nanometres (nm) which used to be known as millimicrons (mμ) or one-thousand millionth part of a millimetre. The visible waveband stretches from about 400nm (violet) to 750nm (red). Just outside these limits are ultra-violet and infra-red, parts of which can affect photographic emulsion.

Parallel Displacement of a Light Beam

All the visible spectrum of light is present in daylight but other light sources have a different composition. In some cases, their spectrum is not even continuous. Instead of one colour merging into the next, there may be just a few peaks at certain wavelengths and nothing else.

Forms of artificial light

Generally speaking two types of light are suitable for colour photography: daylight and artificial light. Some colour slide films are therefore made in two versions, one for each type of light. In this context, however, electronic flash and blue-tinted flashbulbs are not regarded as artificial light because they are deliberately made to give a light similar to midday sunlight.

Artificial light—photofloods, studio lamps, tungsten halogen lamps, domestic tungsten lamps etc.—are notable for their leaning towards longwave light, i.e. red, orange and yellow.

Reflection of light

As we have said, colour is light. When light falls on an object it is reflected or absorbed. It is a feature of all materials that they reflect light in varying proportions. Some reflect nearly all of it and look white. Some absorb nearly all and look black. Most reflect some wavelengths and absorb others. They look coloured according to the colour of the light they reflect.

When the object is illuminated by coloured light, there are some colours that it cannot reflect, because they are not present in the light. In pure red light, for example, no object can look blue or green.

41

The reflective ability of objects illuminated by white light is as follows:

Smooth white paper	80–90 per cent
Grey paper	15–30 per cent
Polished metal	92·2–99·9 per cent
Black satin	5–10 per cent
Matt black satin	0·3–0·8 per cent

Creation of Object Colour

Variations of artificial light

Artificial light generally appears to be constant in quantity and quality. In fact, however, all incandescent lamps (including photographic lamps) will, in time, show a change in colour quality owing to deposits of tungsten on the glass envelope. This alters the colour temperature (see page 54) and can have a significant effect on photographs in which the truest possible colour rendering is required. In practice, the amateur can generally ignore this factor because the photofloods he uses will burn out before the loss of quality becomes noticeable.

Flash, both electronic and bulb, *is* constant. Manufacturers are

Diffusion and Reflection

42

very careful to ensure that all flashbulbs of the same type give light that is substantially the same in both quality and quantity. Electronic flash tubes do not deteriorate seriously with age (except by failing altogether) but it is essential to allow the capacitors to charge fully between flashes.

Position of Sun and Light Path

Variations in daylight

Daylight is another story. There is a world of difference between early morning light and midday sun, between light from a clear sky and an overcast sky, and so on. We shall go into these matters more fully at a later stage. For the moment let us consider one interesting variable in daylight—the position of the sun.

When the sun is high in the sky, its rays fall more or less vertically on the earth. They therefore have a shorter journey through the earth's atmosphere than they have when the sun is low in the early morning or late evening. The atmosphere is not clear. There is a fair amount of solid matter floating around in it and this matter reflects and scatters light just as larger objects do. Owing to their minute size, however, the particles in the atmosphere have a much greater scattering effect on shortwave (blue) light than they do on longwave (red) light. That is why morning and evening light are rather red and sometimes spectacularly so.

Wavelength and Penetration of Atmosphere

Moreover, the sky is often excessively blue in the middle hours of the day and, as objects in the shade receive their light almost

43

exclusively from the sky instead of from the direct sun, they are illuminated by coloured light.

All this explains why we have to pay careful attention to the quality of the light when we take colour photographs. If we do not, we may find that the colour film records the facts but, because our eyes have a habit of ignoring these colour casts, the facts look false and the colour is unacceptable to us.

How Colour Pictures
are Made

The modern colour film is a multi-layer material. It is commonly called a tripack, however, because three of the layers are by far the most important. These are the three light-sensitive layers that are separately sensitized to red, green and blue light. Other important layers are a yellow-dyed filter layer between the top, blue-sensitive emulsion and the other two (because they would also react to blue light) and an antihalation dye under the bottom (red) layer to prevent light reflecting back off the film base into the emulsion. Both these dyes are washed out during the processing.

The light-sensitive layers contain not only silver halides but also chemicals which, when acted on by the colour developer, form dyes—yellow in the blue layer, magenta in the green and cyan in the red. These chemicals are the colour couplers and are present in nearly all colour films. Kodachrome, however, uses a different method with the colour couplers in the developer.

Image formation in colour slides

When colour slide film is exposed, latent images are formed in each light-sensitive layer according to the colours and intensities

Layer sensitive to:		Colour produced:
Blue	Top emulsion Yellow filter layer	Yellow
Green	Middle emulsion	Magenta
Red	Bottom emulsion Film base Anti halation layer	Cyan

of the light reflected from the subject. A pure red object forms an image in the bottom layer only, a yellow object in the middle and bottom layers and so on.

When the film is processed, these images are developed to metallic silver, as in an ordinary black-and-white negative. The developer has no effect on the colour couplers. The dyes are required in the positive image areas, so the next step is to make these areas developable. This is usually done simply by exposing the whole film to white light but it can also be done chemically. The film is then redeveloped in the colour developer which releases the colour couplers in the fogged areas but not in the original negative areas, because they are already developed and the colour developer can have no effect there.

The colours of the original are thus reproduced on the film as shown in the table below. Finally, the silver images are bleached out and the film is fixed.

Object	Colour material developed in the emulsion layer			Picture
	Top	Middle	Bottom	
Magenta	—	Magenta	—	Magenta
Red	Yellow	Magenta	—	Red
Yellow	Yellow	—	—	Yellow
Green	Yellow	—	Cyan	Green
Cyan	—	—	Cyan	Cyan
Blue	—	Magenta	Cyan	Blue
Black	Yellow	Magenta	Cyan	Black
White	—	—	—	White

Effect of inaccurate exposure

The fogging exposure and second development that colour slide film receives is characteristic of reversal exposure and is one of the reasons why this type of film needs to be accurately exposed. The colour is formed in proportion to the amount of silver salts *not* affected by the exposure. Thus, if exposure is too heavy, i.e. the film is overexposed, the silver salts remaining unaffected are too few to form a sufficient density of colour and the picture looks pale and washed out. If the film is underexposed, there is so much unaffected silver salt that the colours go much too dark and can barely be seen.

These are the extremes of inaccurate exposure of colour slide film and, apart from the fact that the resulting image is too dark or too light, it also shows some colour distortion. This is inevitable because the sensitivities of the three layers are so balanced that only correct exposure can give correct colour. The red layer, for example, being at the bottom of the pack, has to be much more sensitive than the other two layers, through which the light has to pass on its way to the bottom layer. If the exposure is inaccurate, it is unlikely to be equally inaccurate in all three layers, so one or more colours will be too strongly or too weakly formed and will affect any mixture of colours.

Nevertheless, the colour slide has reasonable exposure latitude (tolerance of error) and is undoubtedly the most satisfying method of colour reproduction, because of its brilliant transparency and long brightness range.

Construction of colour print film

Despite this, however, colour prints are extremely popular with the mass of occasional colour photographers, who like to be able to show them to their friends and perhaps even send them copies. Enlargements can be made at no very great expense, while slides need at least a hand-viewer and preferably a projector to be viewed satisfactorily.

The construction of colour print film is basically the same as that of colour slide film. It has the same three light-sensitive layers plus colour couplers. In this case, however, as the ultimate aim is to prepare positive colour prints, a negative is required. Therefore, the reversal steps of first development followed by fogging are omitted and the colour developer is used to produce the negative silver image and colour image in the same areas. Therefore the colours are "negative", too, or complementary to those in the subject. Yellow is formed where the subject is blue, magenta where it is green and cyan where it is red.

The paper on to which colour negatives are printed is also a tripack material with red, green and blue sensitive layers. So, when yellow, representing blue, is printed on it, it exposes the red and green layers, producing cyan and magenta dyes. Cyan, representing red, affects the blue and green layers and produces yellow and magenta dyes. Magenta (green) reaches the blue and red layers to give yellow and cyan dyes. Thus, the subject colours are reproduced on the paper.

It sounds simple but it is not quite as easy as that. Processing colour slide film is relatively straightforward and very little can go wrong if you follow the manufacturer's instructions precisely. It is a purely mechanical job. Printing from colour negatives needs some skill and a great deal of patience. The negative cannot be printed straight on to the paper. It always needs some filtration of the light source to balance the light quality, the negative colours and the paper sensitivity. The filtration is quite delicate and a large set of special printing filters is required. You have to work in total darkness and have to go through the whole development process with each test exposure before you can decide what corrections are required.

Masked colour negatives

When handling colour print film you will generally notice that it seems to be singularly lacking in colour. This is because most colour print films are now "masked", i.e. they have an overall yellow or orange appearance that makes individual colours difficult to see.

The mask is necessary because of the imperfections of the dyes used in colour photography. The magenta and cyan dyes in particular absorb some blue and blue-green respectively that they should transmit. It is easier to regard this as transmitting excess yellow in the case of the magenta dye and excess orange with the cyan dye.

To counteract this the couplers in the magenta layer are coloured yellow but the colour is discharged in proportion to the silver densities (and therefore magenta dye) produced. Thus the unwanted yellow in the magenta dye is balanced by the yellow produced in the non-dyed areas. The cyan layer is similarly treated with orange-coloured couplers.

The effect, of course, is that a uniform masking density is created in each layer which cancels the unwanted colour in the magenta and cyan dyes and is therefore easily removed by a filter during printing leaving them to transmit their true colours.

How Polacolor works

The first instant-picture colour cameras appeared on the market in 1963. They were the Polaroid-Land cameras using Polacolor film which produced a full-colour positive print within 60–70 seconds from the exposure being made.

Basically the method of building up the colour picture is the same as in the normal colour film but the mechanics are very different. The negative material has the same three light-sensitive layers in the same order but they are reversal processed in an ingenious manner. Attached to each light-sensitive layer, which is

separated from the next by a barrier layer, are pods of viscous developing and colour forming solutions. After the material has been exposed it is pulled out of the film plane and round to the back of the camera by a small tab. On the way it passes through steel rollers which burst the pods and spread the chemicals evenly over the three emulsions. These chemicals develop the negative image to black silver and anchor the appropriate colour material to it. The colour material is also formed, however, in the unexposed areas but there it is not anchored and it gradually diffuses to the positive material held in close contact with the negative. In 60–70 seconds the positive material receives the full colour picture.

Filters and Colour Casts

Colour print film is developed to a negative image and prints are later made from it. Thus, there is the possibility that errors made in exposing the film can be remedied at the printing stage. There is no such possibility with colour slide film, which is reversal processed (see page 47) to provide a positive image on the film exposed in the camera. So colour slide film has to be very carefully exposed, after due attention has been paid to all matters that might give rise to unsatisfactory results.

Effect of colour casts

Blue Overcast

We hear a lot about colour casts. Unfortunately, we see a lot of them, too, and in some cases we can sympathize with the photographer who suspects that there may be something wrong with the film.

There are two types of colour cast: the total and the partial. The total colour cast covers the whole picture area; the partial cast affects only part of the picture.

If you enter a room which has coloured lighting, say a distinct, but not too intense blue, you will notice that everything in the room has a blue cast. White surfaces look blue, reds look darker and yellows have a greenish tinge. Very soon, however, you realize that white surfaces are looking white again, the reds and yellows look more natural. Your eyes have adapted themselves to the light and reject what they know to be false impressions.

If you then go out into daylight, you will get the impression that you are wearing rose-tinted spectacles. Your eyes (or your senses) which have been supplying the missing red in the room lighting continue to do so for a period after you leave the room.

51

Before very long, however, you again see things in their normal colours.

Casts and colour appreciation

If this adaptability of our eyes applied also when we looked at colour photographs, we would have fewer problems. Unfortunately it does not and, as there are often considerable differences between actual colour conditions and what we believe them to be, we have to decide between avoiding certain types of shot or altering the conditions so that the colour film records them as we see them and not as they actually are.

Take as an example three photographs of a girl in a white dress. If she is in a room with incandescent lighting, her dress is actually a pale yellow. If she is outdoors in the light from a setting sun, the dress has a red-orange tint. If she lies on the grass in brilliant sunlight, the dress has a quite noticeable green colour. Nevertheless, although all these colours are easily seen if we look for them, we rarely do see them. We *know* that the dress is white and the colour cast completely escapes our notice. Moreover, when we see these colours reproduced in a colour photograph we usually reject them as unnatural. The film gives a perfectly true rendering of the colours as they are but, more often than not, we do not want such a faithful result.

The issue is further clouded by the subjective nature of colour appreciation. People see colours differently and where one may accept a particular colour in a photograph as natural and pleasing another will find it too bright, too weak, too blue or too red and so on.

Again, some casts are immediately disturbing while others may be accepted or even unnoticed. In flesh tones, for example, a reddish cast would probably not bother many people and might even be accepted as pleasing. A green or blue cast, however, would immediately be rejected as unnatural and unpleasant. In landscapes, general scenes, interiors, etc, a blue cast is very noticeable and is generally considered undesirable.

The blue cast occurs frequently and has various causes. One of the most common causes is reflected light from a blue sky and that gives a clue to the reason for many casts. A wide-brimmed coloured hat can colour the upper part of the body. A subject placed too near a coloured wall, or a bank of flowers or even under a leafy tree can pick up the reflected colour. Sometimes the cast is only slight and, if the cause of it is in the picture and the colour is a warm one we may be prepared to accept it.

If we are not prepared to accept it, there is only one remedy for

52

the partial cast—and most of those just described will be partial casts. They must be eliminated before the photograph is taken. The cast from the red hat might be acceptable but not that from a green one. The model should be asked to remove or replace it. If she is told the reason she will probably be only too willing to do so.

Sunlight and Skylight

Dealing with blue and green casts

One of the most awkward casts to deal with, however, is that thrown by a blue sky into the shadowy parts of a picture. It is not uncommon for a sunlit picture to contain some areas in light shade. If, on such an occasion, the sky is excessively blue, these shaded areas, because they receive no direct sunlight, may reproduce with a marked blue cast.

There is little that can be done in such a situation. If we use a pink filter, the shadowy areas may be corrected but the sunlit areas will then have a noticeably reddish tinge. The only courses of action are to accept the shot as it is or change the viewpoint so that the shaded areas are reduced to a minimum.

Sometimes a blue cast can occur by reflection of the blue skylight from shiny foliage or even grass. It can occur, too, in water, of course, and is not always acceptable. Strongly blue puddles, for example, or streams, or fountain water do not look very natural. Occasionally, this type of cast can be subdued by placing a polarizing screen (see page 176) over the lens. The screen should be rotated before the eye, if the camera has no viewfinder screen, before placing it on the camera, to decide its orientation for the best effect. It is not usually desirable to cut out all the reflections, but nor, in fact, is that likely to be possible.

53

Another difficult cast to deal with is green. This is common in wooded scenes and areas of considerable grassland. Green tree trunks are encountered much more frequently in colour photographs than they are in nature. Again, there is no easy remedy. Any attempt to correct the tendency to too much green in some areas inevitably has an unnatural effect on the genuinely green foliage, undergrowth, grass, etc. The usual course is to make a virtue out of necessity and emphasize the green or choose a viewpoint that contains the unnaturally green parts in a relatively small part of the picture area.

Colour temperature of light sources

To understand fully how to handle colour slide film and, particularly, the kinds of light source that can be used with it, we need to know something about kelvins (once known as Kelvin degrees). Our eyes are not particularly well equipped to judge the colour quality of light sources, so we need some scale or measurement system to help us. This is where the concept of colour temperature comes in.

When certain objects are heated to a certain temperature, they begin to give off light. As their temperature increases, the colour of the light they emit changes. It starts with a dull red, turns bright red, orange, yellow and finally a bluish-white. Thus, if we standardize the heated material, it is possible to relate the colour to the temperature.

Typical colour temperatures

Light source	Colour temperature (K)
Blue sky without cloud	10,000–30,000
Sun and blue sky	5,600–7,000
Noon day summer sun	5,000–6,000
Morning and late afternoon sun	5,000–5,600
Overcast sky	6,500–7,000
Fog and mist	7,500–8,500
Blue flashbulb	5,500–6,000
Electronic flash	5,600–6,400
Photofloods, tungsten-halogen lamp	3,400
Studio lamp	3,200
Domestic lamp	2,600–3,000
Candle	1,900–1,950

This has, indeed, been done and colour temperature is expressed in kelvins, the figures being the same as those on the absolute temperature scale (°C + 273). The blue end of the spectrum has the higher colour temperatures.

We can ascertain colour temperatures for various light sources from published lists, such as the one on the previous page. If it is necessary to find the exact temperature we have to use a colour temperature meter.

Colour temperature and film sensitivity

The light sources quoted in the table can be broadly divided into two groups: daylight and artificial light. Colour slide films are designed to be exposed ideally to light of one particular colour temperature. Daylight films are best used in noonday summer sun and the figure quoted by various manufacturers is generally in the region of 5,500–5,800K. Artificial light films are intended to be exposed to photoflood light (3,400K) or, in some cases, to studio lamps (3,200K).

A reasonable variation from the ideal source is permissible and, indeed, where the light level is low or the lighting conditions unusual (neon signs, street lighting, shop windows, fireworks, flood-lighting and so on) even large deviations can give acceptable results. Generally, however, where the colour temperature of the light source is significantly different from that for which the colour film is balanced a filter has to be used to even matters up. It is best to avoid this if possible, because filters can often have quite unforeseen results on colours unless very exact colour temperature measurements are taken.

Filters and mired values

The colour change (or colour shift) caused by a filter can be simply expressed in mired values. The term "mired" means micro reciprocal degrees, i.e. the reciprocal of the kelvin figure divided into 1,000,000. Mired values can thus be given to films, filters and light sources and, by subtracting one from the other, the filter required to match film and light source is easily found.

If the kelvin figure alone were used to express the effect of a filter, the same filter would appear to cause a much greater colour shift when dealing with higher colour temperatures. Similarly, in considering departures from the norm, one might not immediately appreciate the importance of a difference in kelvins which seems small when compared with the known variations of daylight colour temperatures.

A practical example shows the advantages of using mired values:
Assume that the colour temperature of the prevailing light is 6,500K. (This would have to be determined with the aid of a colour temperature meter.) Assume further that the film is balanced for 5,800K. Conversion into mired values is as follows:

Colour temperature: $\dfrac{1\,000\,000}{6500} = 153$ mired

Film balance: $\dfrac{1\,000\,000}{5800} = 172$ mired

In this example the mired value for the film is greater than that of the light source, so we have to add to the mired value of the light source. Remember that it is always the light source that you are altering. You cannot alter the film characteristics.

The significance of this is that filters can have either a plus or minus mired value and, because these figures are reciprocals divided into one million, the higher the mired value the more red the filter. The minus filters are blue.

In the example quoted you need a +19 filter, which is reddish to correct the tendency of the light to be too blue for the film.

As a further example assume that the film in the camera is an artificial light type balanced for 3,200K. You want to shoot in a daylight colour temperature of 5,400K. The calculations then are:

Colour temperature: $\dfrac{1\,000\,000}{5400} = 185$ mired

Film balance: $\dfrac{1\,000\,000}{3200} = 312$ mired

This time, you still need a red filter but the mired value is much greater (127) and the filter will accordingly have increased density. Such a filter, which makes colour slide film suitable for use in a form of lighting other than that for which it is balanced, is known as a conversion filter. These are made in just two values (plus and minus 120) for normal work because they are not intended for meticulous colour correction. In the above case, the actual value required is 127 mired but the standard filter will be perfectly satisfactory.

Compensating or light-balancing filters

Apart from conversion filters, some companies produce light-balancing, compensating or correction filters to make a variety of adjustments to the colour temperature of the light source. Unfortunately the designations of these filters follow no standard form

and it is often difficult to ascertain their exact effect. The Kodak Wratten range, however, are given mired shift values, as shown in the following table.

Wratten light balancing filters

Filter colour	Filter number	Increased exposure (stops)	Colour temperature to 3200K from	to 3400K from	Mired shift
Bluish	82C + 82C	$1\frac{1}{3}$	2490K	2610K	−90
	82C + 82B	$1\frac{1}{3}$	2570K	2700K	−77
	82C + 82A	1	2650K	2780K	−66
	82C + 82	1	2720K	2870K	−55
	82C	$\frac{2}{3}$	2800K	2950K	−45
	82B	$\frac{2}{3}$	2900K	3060K	−32
	82A	$\frac{1}{3}$	3000K	3180K	−21
	82	$\frac{1}{3}$	3100K	3290K	−10
Yellowish	81	$\frac{1}{3}$	3300K	3510K	+9
	81A	$\frac{1}{3}$	3400K	3630K	+18
	81B	$\frac{1}{3}$	3500K	3740K	+27
	81C	$\frac{1}{3}$	3600K	3850K	+35
	81D	$\frac{2}{3}$	3700K	3970K	+42
	81EF	$\frac{2}{3}$	3850K	4140K	+52

The recommended adjustments to the lens aperture are approximate. Where particular accuracy is required, trial exposures are necessary.

The mired shifts of the above filters are less than those given by the standard conversion filters. For larger shifts the Wratten 80 and 85 filters are used.

A popular filter with colour photographers is the so-called skylight filter. It is intended to combat a mild blue cast and therefore is pink in colour. It has insufficient density to require any exposure adjustment. The Kodak filter of this type is the Wratten 1A. It absorbs both ultra violet (as any filter does) and some visible blue and is suitable for use when the skylight is excessively blue or in misty conditions. It can also be effective with some electronic flash units.

The skylight filter can, in fact, be used on any occasion when a rather warmer rendering is required than the available light would provide. This could be in dull weather, for snow shots in sunlight or for shots taken at high altitudes or near large stretches of water.

Filters for large mired shifts

Filter colour	Filter number	Increased exposure (stops)	Colour temperature change	Mired shift
Blue	80A	$2\frac{2}{3}$	To 3200K From daylight	−131
	80B	2	To 3400K From daylight	−112
Orange	85C	$\frac{1}{3}$	To daylight From 3800K	+81
	85	$\frac{2}{3}$	To daylight From 3400K	+112
	85B	$\frac{2}{3}$	To daylight From 3200K	+131

Lighting	Ektachrome Kodachrome II daylight material	Kodachrome II Type A (artificial light)	Ektachrome Type B (artificial light)
Daylight Sunshine	No filter	Wratten 85	Wratten 85B
By daylight in shadow Overcast sky Distant views, high mountains Snow and blue sky	Skylight 1A	Wratten 85	Wratten 85B
Electronic flash	Possibly Skylight 1A	*	*
Blue flash bulbs	No filter	*	*
Photofloods 3400K	Wratten 80B	No filter	Wratten 81A
Photo lamps 3200K	*	Wratten 82A	No filter

* Not recommended

In both these latter cases, the clear air tends to pass rather more short-wave (blue) light than in other locations.

The other uses mentioned above for the skylight filter are also the occasions when a UV filter is often used. This should, more correctly, be called a UV-absorbing filter because its function is to absorb ultra violet radiations, whereas a red filter, for example, is designed to transmit red light. The true UV-absorbing filter is colourless and has no effect on visible blue or any other colour. If it is tinged with pink or a straw colour, it should be called a haze or skylight filter. Maker's descriptions of these filters vary.

Finally, in this list of colour correcting filters come the colour compensating series in red, green, blue, yellow, magenta and cyan. These are generally available in several densities for each colour so that quite meticulous correction of the colour rendering can be achieved.

Occasionally, decamired values are used instead of mireds to give more manageable figures. The decamired is, however, only ten times the value of the mired and, in general photography, its use conveys no particular benefit. The following table shows equivalent values for kelvins, mireds and decamireds.

K	Mired	Decamired	K	Mired	Decamired
7000	143	14.3	4000	250	25
6500	154	15.4	3500	286	28.6
6000	166	16.6	3000	333	33.3
5500	182	18.2	2500	400	40
5000	200	20	2000	500	50
4500	222	22.2			

Practical uses of filters

All this talk of filters could lead to the idea that colour photography is difficult and that particular care is necessary to obtain correct colour rendering. For most colour photography this is not so. The professional may be under an obligation to reproduce a particular object in colours as close as possible to the original. The amateur (and many professionals, too) is more likely to be interested in obtaining a pleasing colour composition. Absolute accuracy is rarely required.

A skylight filter is useful, because blue casts are frequently encountered. Alternatively, a UV filter may be sufficient, depending on the characteristics of the particular camera lens. Some lenses seem to give rather warmer colour rendering than others.

A weak blue filter, sometimes called a "morning and evening" filter may very occasionally be of value when the sunlight is a little reddish, as it tends to be when the sun is low in the sky. It must only be used, however, when the intention is to show the scene as if in normal sunlight. Such a filter must not be used to photograph sunrise or sunset scenes for what they are as it will destroy the characteristic colour and mood.

Use a filter only when you think it absolutely necessary and when you know exactly what you want it to do. If you try to correct every variation of colour temperature you are likely to do more harm than good.

Infra-red colour film

Despite all the filters available to ensure correct colour rendering in all lighting conditions, there is one colour film available that never will give true colours. This is Kodak Infra-red Aero Type 8443.

Infra-red rays come from beyond the red end of the visible light spectrum and are therefore invisible, but most photographic materials are sensitive to them and some are made especially sensitive for scientific and other purposes. Infra-red rays can penetrate mist and certain materials. They are strongly reflected by other materials, such as some grasses and foliage, which usually appear on black-and-white infra-red film as heavy densities that print almost white.

Infra-red colour material was first used in the second world war for the detection of camouflage and similar aerial survey work. It later found various applications in scientific research.

Ektachrome Infra-red film is similar in construction to other films but it is differently sensitized. It has the usual three layers, the bottom one of which is sensitive to infra-red radiation up to 900nm. The other layers are deliberately sensitized to give false colour rendering. Yellow is reproduced as white, red as yellow, blue as red and green as dark blue. The green of plants, foliage, etc is, however, reproduced in colours ranging from violet to red, according to the chlorophyll content of the plant. This is one of the most valuable features of the film in research because it allows healthy and unhealthy areas of forests, for example, to be located with ease.

All three layers of the film are, as in most films, sensitive to blue light and the film must be exposed through a yellow filter. The Kodak F2 filter or Wratten 8, 12 or 15 are suitable. The effective film speed is then about 125 ASA.

Ektachrome Infra-red film has an extra long leader and four blind exposures have to be made after loading the camera instead of the

usual two. The film should be stored in a refrigerator at less than 55°F (13°C). After removal from the refrigerator it must be left unopened at room temperature for some time. Otherwise, warmer air will condense into moisture on the film surface.

It must be processed as soon as possible. Processing is the same as for normal Ektachrome film (see page 121). Nevertheless, no other type of film should be developed together with the infra-red film because chemical by-products could cause various side effects.

The effect of the recommended yellow filter is to produce colours in which blue and purple predominate. Naturally, other filters can be used to provide other interesting effects. With an orange filter (film speed about 80 ASA), the pictures show cleaner yellow, red and green colours. With a "black" filter, as used for infra-red photography in black-and-white, the film speed is about 25 ASA and the result is a shot of infra-red reflection or emission only in deep red colours.

Slides or Prints ?

The previous chapters have been devoted to descriptions of the various colour photographic processes and to certain related technical aspects. These give basic information on methods but do they help with the choice of which method to use—reversal film for slides, negative film for prints or instant pictures by the Polaroid system?

The decision is not an easy one and is rarely made on aesthetic grounds. For the amateur who does none of his own processing, the colour slide is undoubtedly a superior product. It has brilliant colours, a wide brightness range and, when projected, considerable impact. The commercially produced print is generally small (large prints are expensive), much less brilliant and often, owing to "conveyor belt" processing methods, rather unsatisfactory in colour rendering.

If, on the other hand, the photographer does his own processing, he can (with patience to acquire the necessary skill) control his prints individually and obtain results far superior to those of the commercial printer. Despite their lack of brilliance compared with the slide, such prints can be very satisfying.

Preference for colour slides

The fact remains that most colour photographers use colour print material and the great majority of these have their negatives commercially printed in small sizes. There can be little doubt that the reason for this preference is the inconvenience of setting up the projector so necessary to the true appreciation of the colour slide or even of carrying a viewer to show the transparencies to friends and relations.

There is probably the additional reason that so few understand the interrelationship that exists with all colour materials: there is no difficulty or very great expense in obtaining duplicate slides, prints from slides, or slides from negative material.

Here again, however, the best results are normally obtained by using colour materials for their intended purpose—colour negative for prints, colour reversal for slides. Perfectly good prints may be obtained from slides but they can never compare with the slides themselves. Slides made from negatives may be very good but the colour slide film always seems to have just a little better quality.

Influences affecting choice

So the choice usually rests (as most choices do) on personal preference and prejudice regarding the end product and the convenience or otherwise of handling it. And it is, after all, so much easier to show prints to your friends than transparencies.

There are, however, a few facts about the various colour methods that are worth considering. First, there is the question of expense. In practice, colour prints are generally considerably more expensive than slides. In theory, of course, you need only have the film developed in the first instance and then decide which negatives to have printed. Unfortunately, as we have already mentioned, it is very difficult to judge the colour quality of a negative, owing to the unfamiliar colours they show and the overall tint of the colour masks. You can certainly eliminate those that show framing, focusing and similar faults but there really should not be many of those and you usually finish up having all, or nearly all, of the negatives printed.

Slide film, on the other hand, undergoes only one process and does not have to be printed at a later stage. Certainly you have the additional expense of the projector and a screen if you produce pictures mainly for your own enjoyment but they are one-time expenses that are eventually spread over a considerable number of pictures.

It is, in fact, the use to which you intend to put your colour photographs that must eventually influence your choice. If you are an occasional photographer, reserving your efforts mainly for holidays and special occasions, you may be prepared to bear the extra expense of prints and save the cost of a projector and screen. A few prints for friends do not cost a fortune and can give a great deal of pleasure. If they are non-photographic friends, the print is, indeed, the only thing you can give them. They will not find a slide, particularly a 35mm slide, very impressive.

Importance of size

Size is one of the things the print (and even more the Polacolor print) has in its favour. The 35mm slide is not really suitable for viewing in the hand and often meets a marked lack of interest in non-photographers, whereas they find the more familiar print easier to handle and more recognizable as a photograph.

Size is important, too, if you intend to sell your pictures. There are still remarkably few outlets for 35mm colour, for the same simple reason that it is not easy to judge the quality of such a small reproduction as a 35mm slide. The mass-produced print, on the other hand, is a complete non-starter. It *never* has the quality that will impress a picture editor. To sell colour prints you must have big individually processed enlargments made—and that can be very expensive.

The market for colour photographs is not really very large in relation to the number of people trying to break into it and any picture offered for sale must be of superb quality and be seen to be of such quality at a glance. The vast majority of professionals use at least the $2\frac{1}{4} \times 2\frac{1}{4}$in ($6 \times 6$cm) format; many use 5×4in sheet film and 10×8in is by no means uncommon.

Versatility of colour print process

The enthusiast who insists on doing all his own processing and who likes creating his pictures in the darkroom undoubtedly has to use the colour print. Colour slides leave very little room for creative work after the exposure is made. They even tend to pin you down to the format of the image area because any significant departure from that format may mean that you have to project a rather smaller picture than you would have liked in order to keep it within the confines of the screen. If you are producing pictures for sale, this argument has less significance but it does mean that you have to start off with a rather large format.

The colour print, on the other hand, can be any shape or size. You can crop the negative in printing as much or as little as you like and still make the print large enough to be appreciated. Moreover, you can introduce various darkroom techniques into the printing, such as solarization, bas relief, deliberate colour distortion, tone separation and so on. Experimental colour printing is still practised by only a handful of skilled workers and the field is wide open to newcomers.

So the argument swings back and forth. Which is best—colour slide or colour print? And, of course, there is no single answer. And what, in any case, of the instant colour print? This is, indeed, a special case, because Polacolor material is extremely expensive—

but it has that quite unique advantage of letting you see the results and correct your faults almost immediately

Only you can decide which method to use. Few recommendations can be made. It can be said that the occasional photographer will probably find prints more satisfying, whereas he who aims to sell his pictures will do better with large format transparencies. Beyond that, it is up to the individual.

Putting Colour in the Picture

The obvious advantage of colour photography over black-and-white is that the scene around us is, in fact, coloured. Therefore, the colour photograph imparts a greater sense of reality and more easily establishes contact with the viewer. The beginner is more likely to obtain pictures that interest other people when he uses colour film. Black-and-white film has to make up for the lack of colour by providing some other point of interest—unusual lighting, perhaps, or exceptionally good composition or a particularly striking likeness in a portrait.

Nevertheless, this should not be taken to mean that it is easier to produce *good* photographs in colour than it is in black-and-white. It would be more true to say that it is easy to produce bad photographs masquerading as good because of the added colour. The inveterate black-and-white photographer often claims that his is the greater skill because his pictures cannot be good unless they have qualities of composition, striking subject matter or other features that the colour picture does not need.

As always, each side has a point. Colour does often cover up weaknesses in a picture that would show up strongly in black-and-white. But the good colour photographer handles colour just as carefully as the black-and-white man handles composition or subject matter. Colour can be presented creatively to set a mood or to convey an impression or to make abstract pictures of a form and beauty that black-and-white photography can never emulate.

Colour is not easy to handle. It is a means of expression and every colour has its own message—not just the simple messages of a few well-defined colours but the complicated shades of meaning denoted by the innumerable variations each colour can show.

Colour Circle (Schematic Presentation) and Complementary Colours

Use of the colour wheel

Nature's own presentation of colours forms a good basis for creative work but it has to be recognized, analysed and applied with care. Take the sun's spectrum as an example. It shows all the

colours in a row, arranged according to their wavelengths. Imagine the spectrum bent round to form a colour wheel. Added together in this way the colours make white and the wheel also indicates the complementary colours by placing them opposite each other.

The colour wheel helps with the handling of colour in various ways. As an example, suppose that a series of colour slides is being shown to an audience. Each picture will have a particular dominant colour. Naturally, these will not be all the same and there have to be frequent changes in colour of the scenes presented. If the changes in dominant colour follow the order of the colour wheel, the transition from one slide to the next is harmonious and creates no conflict or irritation in the viewer. As soon, however, as a transition is made which leaves out several steps in the natural colour sequence, there is a break that can create a harsh and irritating effect.

A break can, of course, be deliberate (perhaps where a change in mood and subject is required) but it should not be made without such a reason. This even applies to the arrangement of pictures in an album or any other sequence of individual pictures tied together to create a story or other visual impression.

Orientation of colour

The spectrum of white light is divided into two main parts: the warm colours (longwave) and the cool colours (shortwave). Red and orange are the particularly warm colours; green and blue are

cool. The warm colours belong in the foreground. They stand out from the cool colours, whose natural place is in the background. As a general rule, colours recede more and more as the wavelength gets shorter.

We talk, for instance, of the distant blue and we get an impression of greater liveliness in foreground figures if they are dressed in red or are associated with red props, such as a ball, sunshade, telephone kiosk, etc.

These general rules regarding the orientation of colours should not be broken without justification. You will sometimes wish to create special effects and you will want to break the rules. It is easy then to recall the saying that there is an exception to every rule but your case must really *be* an exception. There is no point in breaking the rules without good reason.

Colour control

The mere fact that you have colour film in your camera does not mean that you should seek out a collection of coloured objects with a dash of red here, a blob of blue there, some yellow in another place and a bit of green for good measure. That is not likely to make a good colour photograph. Certainly you can take colourful pictures but the colours must be carefully managed, so that the end result is not just a "coloured" scene as against a colour picture. This entails choosing the camera position and, if possible, the arrangement of the subject that presents the warm and cool colours in their proper planes and eases the transition from colour to colour to avoid a series of harsh contrasts.

Furthermore, the colour in a picture should be in tune with its composition, mood, subject matter and so on. Colour is part of the structure of the picture. It must not be treated simply as a bonus— an addition to the picture that makes it look pretty or natural. The subject, its shape and form, contrast, dominant colour and so on must all be in context. The photographer's job is to create this context.

Why is it that we find Brown's colour pictures better than Smith's. Are they fortunate accidents? Or have they been specially selected from the successes—the failures having been long since discarded? Possibly, but it is more likely that Brown has discovered the secret of pictorial effect. It is not all that difficult to find. The successful colour photographer who tries to ensure that his colour shots also have interesting subject matter develops a sense for finding the right subject. It becomes second nature to him, so much so in fact that he may not even be aware of it. He "sees" subconsciously the composition of individual items, decides on his

viewpoint, selects his accessories accordingly and so succeeds in putting together a harmonious picture.

Picture structure

Colour alone cannot make the picture. Every picture must have a structure—an indefinable quality that holds the picture together and presents it as an entity. A picture without a structure has no theme or message.

Although we cannot define what makes a good picture in this sense, we can recognize it by continually studying pictures wherever they may be—in magazines, books, art galleries, posters, and so on. We will come to appreciate the good and bad and to realize the variety of forms that picture structure and composition can take.

There are, in fact, six basic forms, which apply—individually, of course—to nearly all subjects. It is a matter of recognizing them, deciding on their application and choosing the appropriate viewpoint to bring about a clear and simple effect. It is useful to study these basic forms carefully and to evaluate the observations made here about good and bad photography. Such an analysis pattern helps us to decide on the best presentation of any subject.

Straight-line arrangements

If a subject has distinct horizontal and vertical lines (as, for example, tall trees and the horizon) the camera position can usually be so chosen that a cross is produced. If these main lines happen to cross the centre of the picture, they create four equal squares, which can make a balanced, restful picture but also, quite often, a boring one.

The repetitive effect can be broken to some extent by the inclusion of dynamic elements such as people, motor cars, etc, which can introduce an effect of depth into the picture. Colours can be used, too. Typical foreground and background colours can create a form of movement which leads the eye from one part of the picture to another. In the ideal case, the movement will be towards the junction of the vertical and horizontal lines.

This type of subject often has lines that can be arranged to break the monotony of the four equal sections. They might be formed by streams, roads, mountain ranges, hedges, etc. In such cases the crossing point of the horizontals and verticals can be placed off centre. The horizon, for example, can be placed high or low, whichever suits the subject best. The verticals can be positioned on the left or right. Thus, four pictorial areas of different sizes are created and the result is less static.

To supplement the linear arrangement, the colours should also be harmoniously distributed as to foreground and background. In time this arrangement of picture areas, lines and colours becomes intuitive for the good colour photographer.

Diagonal lines always express vitality. They often appear in subjects showing some depth. The point at which the lines cross is also of importance. When it is in the centre of the picture, an element of monotony is again introduced, with equal weight in all four parts. The eye has to skip from one triangular area to another.

Generally, it is better to make one triangle of greater weight than the others but there are, of course, exceptions. An abstract pattern created by equal-sized triangles, for example, can owe its appeal to the balanced form so created.

Curves and circles

An even greater impression of vitality is given by the curved line —and particularly the S-line.

S-shaped roads, rivers, etc can dominate a pictorial composition. They generally lead the eye from foreground to background, but it is important that the curve should not lead to a blank or uninteresting area. Nor should it terminate at the edge of the picture. In the first case the eye has no resting point and tends to wander aimlessly about the picture area. In the second, it is led right out of the picture area.

The circular construction is most commonly used to frame the main subject in a picture. We see the subject as through a window. In many such cases, the composition is helped by the fact that the frame is generally darker than the parts seen beyond it. This helps to lead the eyes to the essential elements of the picture and the darker-toned frame in the foreground gives a strong impression of depth.

Triangles and angles

With the triangular construction, one side of the triangle is nearly always parallel to one or other edge of the picture while the others form diagonals. Either the vertical or the horizontal can be chosen

as the main line, remembering that the horizontal creates a restful effect and the vertical introduces an element of conflict. The diagonals can be used to add vitality and to modify the effect of the horizontal or vertical lines as required.

When the dominant vertical and horizontal lines of a subject originate from the same point, we have a right-angle. This is a commonly used form of asymmetrical construction (see page 272). Diagonals may also meet and form angles larger or smaller than the rightangles. The arrangement of the lines must depend on the nature of the subject but the angle can be used to enclose the

73

subject, as in a partial frame, to point to and emphasize it or merely to hold it in an acceptable composition.

Making the most of linear construction

This systematic use of lines in a picture can be put to various uses. Lines alone can create depth, for example, as when moving objects (people, cars, boats, etc) are made to move diagonally from foreground to background. The line guides the eye. It leads to the important parts of the scene and holds the whole picture together.

The line structure is important both for its creation of form and shape and for its effect on the colours of the subject. The photographer must choose his viewpoint so that the line structure conveys the mood or impression he is aiming at.

What about the shots that have to be taken in a hurry? There are many occasions when there is no time to consider even the simplest rules of composition. If we do not shoot immediately, the picture has gone. The rule in such cases is, of course, to get the picture at all costs and hope that there may be an opportunity for another, improved shot immediately afterwards.

Even when you are in a hurry, however, it may be possible to take advantage of the lines that so many items present—such as trees, streets, cars, boats, widespread groups of people, etc. At least there may be time to arrange such a line as a diagonal if a dynamic effect is required or to place a vertical at one edge of the picture for balance, or to include a foreground object for depth, and so on. The good photographer develops an instinct for such matters and is often able to choose his camera position very quickly. He will be able to do this, however, only if he has schooled himself well in the basics of picture structure both by analysis and the constant study of other people's photographs.

Colour and picture construction are interdependent. They must not come into conflict. Imagine, for example, that a red car is photographed on an S-curving road. If it is in the foreground or not too far back from it, it reinforces the line structure. If, however, the photograph is taken a moment later, after the car has turned off into an insignificant side road, it offers competition for the dominant line and weakens its effect.

The dominant colour

Now let us leave the subject of linear construction and pass to less obvious considerations. When we shoot in the open countryside, the cooler colours generally predominate. We do not have to

search for them. Instead we have to consider the necessity for warmer colours to offset or complement their effect. Subjects with no red, orange or yellow always look rather subdued and lacking in any sense of life or vitality. Naturally, there are subjects that such colouring suits. There is no point in adding a warm colour artifically to a scene that is normally sombre and that you wish to present as such. The dominant colour in any photograph must accord with the subject content and atmosphere.

This leads us to an important concept in colour photography: that every picture should have one colour that outweighs the rest—the dominant colour. This can be provided by any part of the picture, not necessarily by the main subject, but its colour must be in sympathy with the mood or nature of that subject.

In many cases we can provide the dominant colour: we can, for example, dress our "models" in a bright colour when we want a cheerful effect or in dark blue, green, brown, and so on when the mood is intended to be more sombre. In other circumstances, where we have to accept the colours as they are, our task is to influence, by viewpoint and framing, the colours in the surroundings.

Indeed, the surroundings may sometimes provide the dominant colour—the green of foliage, the blue of the sky, the red of a yacht sail and so on. In such cases, there must not be too many emphatic colours in other parts of the picture, which would lead to a "coloured" picture, instead of a true colour picture. There would be a struggle for dominance between the colours, creating a sense of confusion.

It is easy to fall into the trap of including too many colours in a colour picture. The riot of colour may even seem attractive at first to those who have been used to only black-and-white, but this attraction soon fades with the realization that the subject is overwhelmed by colours competing for attention.

The owner of a zoom lens, and there are now many such lenses for 35mm SLR cameras, is at an advantage when selecting the framing that will present the best colour arrangement. He can try various framings from the same viewpoint and, within the limits of his zoom, adjust his image to exactly the right size. The owner of a single-focal-length lens has to try many different viewpoints for his best picture. Even if he has more than one lens, he has only one image size for each lens.

Emphasis by repetition and rhythm

One of the methods we commonly use to emphasize a point is repetition. This can be applied to colour photography, too. Sometimes, although a colour dominates by area, it still seems not to

have the effect required. It lacks emphasis. If, however, the colour can be repeated in other parts of the subject, the repetition strengthens its effect and gives it more force.

This is a form of rhythm, which is an important concept in any type of photography. In cine photography, for example, a traditional method of shooting some scenes is to show first a general mid-distance or long shot of the scene, followed by a medium close-up and finally a close-up or big close-up. The first shot sets the scene, the others pinpoint the particular feature or action that the film maker considers important. The rhythm is in the repetition of forms and colours.

The figures on this page are a simple schematic example of the relationship between rhythm and the concept of the dominant colour. On a dark background, various lighter patches are arranged. These represent coloured patches that vary slightly in proportion but are all of similar brightness. When we look at such a "picture", we find it difficult to decide which patch is of most importance. The eye wanders about in search of a resting place but finds none.

Suppose, however, that we increase the brightness of one patch and tone down all the others. The brighter patch then dominates, but finds a supporting repetition in the less brilliant versions of the same colour that surround it. The rhythm is established.

In this particular example, the dominant colour is well within the picture frame. In the third figure, however, it is placed at the edge. The less brilliant colours lead the eye to it in the same way but the dominant colour itself tends to lead the eye out of the picture. It is, therefore, important whereabouts in the frame you position your dominant colour.

Even when it is placed near the picture edge the colour patch may be dynamic. It may take the eye in one direction or another, according to the composition of the picture and its linear arrangement. In exceptional circumstances the direction of movement may be into the picture frame. When this happens the edge positioning is acceptable. In a cine film, the movement can be made obvious but the still photographer must simulate the movement by careful arrangement of the lines in his picture.

There are many other aspects to rhythm in photography. A row of trees is an example of rhythm. It is important, however, that one of the trees must be chosen as the dominant one, and that tree must be placed in an appropriate position in the frame by careful choice of viewpoint. The dominant tree may not be chosen merely because of its size or shape. It may have distinctively coloured flowers, fruit or foliage.

Similarly a view across the housetops of a town will provide a considerable amount of repetition. If one roof is, say, bright red, it

Honeysuckle

76

can act as the dominant feature and must then be positioned within the frame according to its importance.

Aperture and depth of field

Some cameras have automatic exposure control systems that do not let us know what aperture we are shooting at—and some even keep us in the dark about the shutter speed, too. An unfortunate aspect of this, as far as the aperture is concerned, is that we cannot control the depth of field. Other things being equal, a small aperture (larger f-number) enables us to obtain a picture that is sharp from foreground to background, while a large aperture enables us to focus selectively on a particular part of a subject and let the background be rendered much less sharply. If we can control the aperture, we can control the depth of this zone of sharp focus to provide the particular effect we need.

Nevertheless, we have to be careful how we use depth of field in colour shots. When we decide to throw the background out of focus by using a large aperture we have to make sure that the background is suitable for such treatment. If it is relatively unfussy, with largely subdued colours, it can usually be blurred quite effectively. If, however, it is multicoloured and some or all of the colours are brilliant, throwing them out of focus can create quite an effect, but it will not make the background inconspicuous so that the subject can dominate. It will, in fact, make the background a feature in its own right, which is fine for some pictures but not for all.

Similar considerations apply to the foreground. It is sometimes effective to use a blurred foreground to create an impression of

depth. Again, if that is the only reason for throwing the foreground out of focus, it should not contain bright colours. Out-of-focus bright colours spread into adjoining areas of the picture and attract attention.

Working at close range

We mentioned earlier the traditional cine technique of following general or locating shots by close-ups of particular features. This, too, can be followed in colour slide work. The close-up is a useful method of creating interest in a subject because the much enlarged picture on the projection screen often looks larger than life and therefore has at least a curiosity value. Flowers or parts of flowers, jewellery, watch movements, stamps and even parts of the face or hands can make first-class close-ups and so, of course, can innumerable other objects. Such close-ups often gain considerable impact from simplification. By concentrating on a small item or a small part of a subject, you automatically exclude all extraneous matter. Even if there are some unwanted details in the background, it is quite easy to subdue their effect by throwing them out-of-focus, because depth of field is much reduced when you shoot at close range. Indeed if the subject has any depth, you may have difficulty in focusing all of it sharply and may have to shoot at a very small aperture. This need rarely creates problems because the subject is generally static and slow shutter speeds can be used with the camera on a tripod.

The close-up and ultra close-up offer innumerable photographic opportunities and many accessories are available to allow cameras to be used for this class of work. Even the simplest camera can take close-ups with the help of inexpensive supplementary lenses (see page 182) but for real versatility in close-range work, the 35mm SLR is unbeatable. It can use extension tubes or bellows to bring the scale of reproduction up to life size or more *on the film*. The projected image can then be really startling. Many of these cameras also have special microscope adaptors so that the microscope objective can be used as the camera lens to provide truly gigantic enlargements of tiny subjects like starch grains, various crystals and living cells.

Exposure and contrast

The exposure problems that many people find troublesome with colour photography can be eased to some extent by using a camera with automatic exposure control. But one drawback with this type of camera is that it cannot cope automatically with

occasions when the lighting conditions are unusual (such as back lighting or strong side lighting), when the scene or lighting contrast is high or when a straightforward representation of the actual conditions is not required. Such circumstances call for a separate exposure meter and a knowledge of how to use it to obtain the effect required.

Although colour slide film is able to handle an extensive range of tones and can therefore accurately reproduce a considerable range of subject brightnesses, it cannot render colours accurately at both ends of the brightness scale simultaneously.

Contrasty conditions can arise in various ways. The subject itself can have a wide brightness range, as with a dark-clothed figure against a snow-covered background. Or the lighting may make the subject contrasty, as with the highly directional effect of a spotlight or even of direct sunlight when there are no clouds in the sky or reflecting surfaces near the subject. The contrast can sometimes be lessened in such cases by making the light frontal but that is often an uninteresting form of lighting that does not suit the subject. Alternatively, we can use fill-in flash or a reflector to lighten the shadows (see page 98).

The exposure given in these unusual conditions depends on the effect being sought. The emphasis must be placed at one end or the other of the scale because any attempt to obtain an average reading would probably cause both extremes to be incorrectly exposed and therefore colour distorted. Thus, a separate meter, with which readings can be taken directly from the appropriate parts of the subject, is a useful accessory, even for those who have through-the-lens meters. It is easier to take individual readings with a separate meter than to change the lens on the camera for the exposure readings and then change it back again to shoot. The through-the-lens meter that takes a so-called "spot" reading can sometimes be lined up on individual areas of the subject but even that is rather more cumbersome to use than the separate meter.

When considering contrast, we have to remember that even when the lighting is full and soft there may be considerable tonal differences between the various colours in a scene. The warmer colours—red, orange, yellow, etc—are generally brighter than the cooler blues and greens. Paler hues—those mixed with white—are similarly brighter than darker hues—those mixed with black.

Again, it may not be possible to produce a true rendering of, say, a dark blue and a pale pink with the same exposure. We have to decide which colours are more important to the theme and must be reproduced as accurately as possible. We may decide that the pink can be allowed to lose almost all its colour while we give sufficient exposure to allow the blue to show through. Or we may curtail the exposure so that the pink retains its colour but the less important blue appears even darker than it really is.

Colour affinity

Another important aspect of colour is the degree of affinity between various colours. We know that some colours clash while others go well together—or harmonize. Colours that harmonize naturally create a pleasant impression and are generally to be preferred in colour pictures but the colour clash can be just as effective in the right circumstances. Not every picture is intended to portray an atmosphere of peace and quiet. There are plenty of struggles, disputes and unharmonious situations in life and the colour clash can legitimately be used when such matters are being portrayed.

Clashing colours are generally related colours, i.e. those close together in the colour circle, such as red and purple, yellow and orange, blue and mauve, etc. The degree of clash or disharmony by related colours depends on the degree of affinity between them. The more closely they are related the stronger the clash. The colours actually adjacent in the colour wheel have a particularly strong affinity. This is shown in tabular form below. The table can be read from left to right or vice versa. We start with 10 distinct colours in two groups, one in the extreme right hand column, the other in the extreme left-hand column. These columns are so arranged that the complementary colours appear at opposite ends of the horizontal lines. Thus, as we move from one end of the line to the other the degree of affinity (and, therefore, of disharmony) becomes weaker until we reach the other end, where the harmonizing complementary colour appears.

Related colours and their degree of affinity

Yellow/green	Green	—Blue—green	—Cyan	—Indigo	Violet
	Yellow	—Orange	—Red	—Purple	
Yellow	Yellow/green	—Blue—green	—Cyan	—Indigo	Indigo
	Orange	—Red	—Purple	—Violet	
Orange	Yellow	—Yellow/green	—Green	—Blue/green	Cyan
	Red	—Purple	—Violet	—Indigo	

Red	Orange Purple	—Yellow —Violet	—Yellow/green —Indigo	—Green —Cyan	Blue/green
Purple	Red Violet	—Orange —Indigo	—Yellow —Cyan	—Yellow/green Green —Blue/green	

Complementary colours contrast but do not clash. These are the colours which create white when mixed together, such as yellow and blue, red and blue-green, violet and yellow-green, etc. When these colours are used together, one should always predominate. Contrasting colours such as these fight for attention and the fight must not be too evenly balanced. The job of one of them is to add interest by creating contrast, but not so much contrast that interest is divided and drawn away from the main subject.

We rarely, if ever, see pure colours. Most colours in nature contain an admixture of black, and the majority of the rest contain white. The black content of a colour subdues its brilliance and, in the case of related colours, can restrain their competitiveness almost to the point of making them harmonious. It is a useful compositional aid, too, because a careful choice of background or surrounding objects in suitably subdued colours can emphasize the brilliance of the colour of the main subject. This is largely a studio technique because few opportunities exist outdoors for such precise colour management.

How to approach colour photography

It is discouraging sometimes for the experienced photographer turning to colour for the first time to find that a complete newcomer to photography can turn out better colour pictures than he does. The reason, however, is fairly obvious. The beginner has no prejudices. He sees in colour, is used to colour, and therefore photographs only what pleases him in colour.

The experienced photographer has been used to disregarding colour while shooting in black-and-white and has developed a sort of monochromatic vision. He has learnt not to think of colour when he takes photographs but simply of shades of grey. Consequently, when he first starts looking at colour from a photographic point of view, he is lost and finds it very difficult to reach a true colour appreciation, and may begin to wonder whether colour photography is best approached in ignorance and in a slapdash manner.

He will soon realize, however, that the beginner is reacting purely instinctively to the colours around him and that, if he continues in that way, he will never be able to bring any initiative to

bear to create or strenghten colour impressions. Only by schooling himself to understand the proper use of colour and the moods and impressions it can create will the photographer be able to achieve any individual creative work.

Practical applications of colour repetition

Let us return to one of the lessons that must be learned: that of the dominant colour and its repetitions. We have learned that the dominant colour can create an atmosphere and make a definite impression. We have also learned that the dominant colour must be given a reasonable amount of space but that it should not dominate by area alone. It is better to increase its dominance by repeating it in other parts of the picture. The repetition does not have to be as brilliant as the main subject. In fact, it should not generally be so because it would then compete for attention. It should be subdued or even reduced to a mere hint.

The repetition often has to be carefully arranged. As an example, take a portrait placed against a blue sky as a restful background. As the background (the blue sky) covers a fairly large area of the picture with a single colour, it becomes the dominant colour. In order that it shall not be out of keeping with the rest of the picture, it must be repeated in the subject. The repeated blue, however, must not have the brilliance of the dominant blue and so form a division of interest. It must be a more subdued colour and can be arranged quite easily by providing the model with a small item of blue clothing, such as a scarf or tie.

Basic rules for colour orientation

The blue of the sky is in the background, which is not surprising because it is a background colour. In fact the following basic rules apply to the main colours.

Blue is decidedly a background colour and serves to emphasize depth in a scene. It is freely available to us for this purpose in outdoor shots, not only in the form of sky but also in the bluish haze in the distance frequently caused by light scatter.

The mid-distance is dominated by green, which is best reproduced in relatively small areas. Green is therefore a colour particularly suited to details.

The longer wavelength colours dominate the foreground. Yellow is a foreground colour which harmonizes extremely well with blue in the background. Yellow reproduces well in large areas. Orange is also very effective in the foreground.

Red is the most important of the foreground colours. It seems to

reach forward to the viewer and gives a distinctive plastic effect. It forms a lively contrast for the blue and green colours that usually dominate a landscape but should be used sparingly.

These are, of course, basic rules. They are not meant to imply that the colours mentioned can only be used in the positions indicated. They are always exceptions and a shot which bends the rules can often have considerable impact.

How to Ensure Correct Exposure

Correct exposure is more important in colour photography than in black-and-white. The emulsion layers of the colour film are considerably thinner on the colour film than the single layer of the black-and-white film and thin layers are much more susceptible to errors in exposure than thicker layers. Moreover, each layer is separately sensitized, the bottom layer having to be much more sensitive than the top layer to allow for the fact that the light has to travel through two layers to reach it. Thus, too much or too little light is likely to have a different effect on each layer, causing colour distortion as well as too much or too little density.

Types of exposure meter

To obtain correct exposure we usually rely on the exposure meter, which may be built into the camera, and sometimes linked to aperture and shutter controls, or it may be a separate instrument. There are two main types of exposure meter—selenium and cadmium sulphide (CdS). The main difference between the two is that the selenium cell generates a small electric current when light falls on it, while the CdS light-sensitive element is a photoresistor which offers less resistance to electrical current as the light falling on it increases. The CdS meter is therefore powered by a small battery so that the effect is the same as with the selenium meter—a current varying with the intensity of the light. This current is generally used to drive a needle attached to a small galvanometer. The needle moves over a scale calibrated in various ways according to different manufacturer's ideas of what is wanted or is simply made to move to a certain point in a small window in the camera body. With many cameras, the meter needle is visible in the viewfinder so that meter readings can be taken at the same time as the image is framed.

Size for size, the CdS element is more sensitive than the selenium and is therefore more suitable for building into the camera. Indeed, when the meter measures through the camera lens, only the CdS type is practicable. Nevertheless, the selenium type is perfectly efficient and has the advantage of not needing a battery.

How the exposure meter works

Exposure meters are extremely useful instruments but they *are* only instruments and they have to be used intelligently if they are to enable us to give the correct exposure every time. There are many occasions when the readings they give have to be interpreted. All exposure meters are calibrated to recommend the correct exposure for an average scene—and an average scene is assumed to be one in which there is a balanced distribution of brightnesses throughout the scene that would average out to a mid-tone. This mid-tone is, in fact, the tone of the standard grey card, which reflects 18 per cent of the light falling on it and can be obtained from photo dealers.

When the exposure meter is pointed at a scene that does not correspond to this ideal, it is misled. When, for instance, it "sees" the subject we referred to in the previous chapter—a dark-clothed person against a snow background—ir recommends an exposure that would reproduce the tones in the scene so that they would average out to a mid-tone. If the snow area is large, this is not in fact the case and the recommended exposure would be too little, causing the snow to be reproduced with less than its natural brilliance and probably with some colour distortion.

Even in fairly average circumstances, the meter can give a wrong reading if it is so held that it is unduly influenced by a bright sky or a dark foreground. The aim should nearly always be to take the exposure measurement from a mid-tone when shooting in colour. This ensures that all tones receive the correct exposure, provided they are within the range that the film can cope with. Only in very exceptional circumstances should the exposure be shortened or lengthened to obtain necessary detail in really brilliant highlights or very deep shadows. However, colours at the other end of the scale, if there are any, and perhaps even some of the mid-tones, will not be ideally exposed and may show both loss of detail and colour distortion.

Through-the-lens meter

Theoretically, the ideal method of exposure measurement is that of the through-the-lens (TTL) meter which measures only the

87

light actually passing through the camera lens. This does away with the need for adjustment of meter readings to take account of the use of filters, extension tubes or bellows, tele-extenders and even microscopes, telescopes, binoculars, etc. Nevertheless, the TTL meter acts in exactly the same way as any other meter and can be misled by the non-average subject just like any other meter. The tendency nowadays is to make TTL meters read only a part of the scene, and to call them spot meters. This is a serious misnomer and the effect of such so-called spot readings needs to be thoroughly understood before correct exposures can be obtained. No meter can be pointed at a particular tone and thus automatically recommend a correct exposure for that tone. Any meter can recommend only one type of exposure for *every* tone it is pointed at. Its calibration is fixed, not variable according to the brightness of the light it receives. That calibration is so arranged that the meter recommends for any tone it is pointed at, an exposure to reproduce that tone as a mid-tone. This is very important in colour photography. If you line up the "spot" of a TTL meter on a very light tone, the exposure indicated will give a much darker tone—and vice versa. The "spot" must be lined up on a mid-tone, or it can be used to measure various tones to access whether the subject brightnesses are within the range of the film.

Exposure latitude

There are differences in exposure latitude (tolerance of exposure errors) between colour print film and colour reversal film, largely

88

owing to the possibility of correcting minor errors in the colour print film at the printing stage. The following rules apply to colour print film:

1 Colour print film should preferably be over—rather than under-exposed. Naturally, this should not be taken as advice to over-expose radically. The degree of overexposure should not exceed 1–1½ stop (aperture numbers), while for subjects of relatively low contrast, overexposure to any extent should be avoided.

2 Exposure for contrasty subjects should be biased towards the darker parts, unless they are of no importance to the picture. If a normal exposure based on a mid-tone is given to such a subject, the parts in shadow will be so far underexposed that they contain no detail at all and probably only rather degraded colour. Ideally, the shadows of such subjects should be made lighter by the use of a reflector or fill-in flash (see page 98).

3 Similarly, bright and dark colours can lead to high contrast. The treatment is the same, the exposure being based on the darker colours to ensure that they retain both colour and detail. If your camera has an automatic exposure control system you can either switch it to manual control to give the extra exposure or adjust the film speed setting to a lower figure.

Colour slide film has no separate printing stage during which errors can be corrected. Both for this reason and because it is reversal processed (see page 47) it needs to be more carefully exposed. Nevertheless, even colour slide film can tolerate minor errors without drastic colour distortion. Overexposure makes

colours look lighter, even turning rich colours into pastel hues in bad cases. Underexposure makes colours deeper. It can occasionally be used deliberately to good effect in overcast lighting conditions.

In contrast to the advice given regarding the exposure of colour print film, there is a different set of rules for colour slide film. Generally, exposure should be based on the lighter tones of the subject. In other words, it is preferable to risk slight underexposure to overexposure, which reduces the brilliance of colours. This naturally must depend on the nature of the subject. If it is very contrasty and the darker parts are more important, they must receive adequate exposure and the highlights must be sacrificed. If the colours at both ends of the scale are important then the contrast must be reduced—by reflector, fill-in flash, waiting for the sun to go behind a cloud or even by coming back some other day when the lighting conditions are more suitable.

When conditions are particularly difficult and you are in doubt about the correct exposure to give, you must resort to "bracketed" exposures, i.e. take several shots at different exposures and make your choice later when you see the results.

Making use of exposure variations

It is evident from the foregoing that variations of exposure have a much more noticeable effect with colour film than with black-and-white—especially when the colour film is a colour slide film. The facts that underexposure can make colours look brighter and that overexposure can reduce their brilliance give us a considerable measure of control over the results we get.

In dull, misty conditions, for instance, the camera has to shoot through a rather dense atmosphere which scatters light. This has a greater effect on the camera lens than it does on our eyes, because we tend to make allowances for it. Thus, it is often helpful in such conditions to underexpose colour slide film by a stop or so to increase the brilliance of any small areas of colour we intend to use as points of contrast. On the other hand, when the sun is particularly brilliant and the scene perhaps looks a little too garish, we can try a moderate overexposure to tone the colours down a little and perhaps make them a little more harmonious.

Naturally, we can go to extremes, too. When we want a really light and airy result we can overexpose by, say, two stops, perhaps burning a light background right out to clear film and making colours pale and ethereal. With such experimental work, it is wise to bracket exposures, as mentioned above, because the exact result cannot be foreseen.

90

Reflected and incident light readings

Most of your colour pictures will be taken in normal lighting conditions, i.e. what the manufacturers call average noonday sunlight. And most of your subjects will be average, i.e. with a reasonably balanced distribution of tones, showing no preponderance of either deep shadow or brilliant highlight. In such conditions, a straightforward meter reading of the light reflected from the subject will give you the correct exposure. This is what we call a reflected-light reading and is probably the most popular method of using an exposure meter.

There is, however, another way, and there is reason to believe that it is preferable when using colour film. This is the incident-light method which involves a measurement not of the light *reflected from* the subject but the light *falling on* the subject. For this method, the meter needs a special attachment in the form of a translucent, preferably hemispherical, cover over the cell window. The object of this cover is to accept light from as wide an angle as possible and to diffuse it before passing it on to the meter cell. Thus, the meter effectively measures all of the light (from sun, sky, sandy beach etc, or from lamps, walls, ceiling, etc) when it is held close to the subject and pointed *at the camera*.

The diffuser of this type of meter is so constructed that when the meter is used in this way it gives a reading that is exactly the same as the reflected light reading from an average subject. That, in turn, should be exactly the same as a reflected light reading from a standard grey card—and we have already stated that this gives the ideal exposure for almost all colour shots.

The incident-light method is now not much used by amateurs, largely owing to the prevalence of CdS meters and built-in meters. These meters are not too well suited to the method owing to their relatively small "windows" and the inconvenience of fitting them with the necessary diffuser.

Reciprocity failure

In theory, a low light level acting on an emulsion for a long time has the same effect as a higher light level acting for a proportionately shorter time. In practice, this is not so. Very long and very short exposure times have a disproportionate effect on the emulsion and when an exposure meter indicates exposures in these regions, the readings have to be adjusted.

The effect of very short exposure times is of little importance because all popular colour films react quite satisfactorily to the shortest exposure time the normal camera can give. When the

91

exposure runs to more than one or two seconds, however, the effect, known as the Schwarzschild effect or reciprocity failure, can be significant. Very roughly, an indicated exposure of 3 seconds should be extended by one second and 8 seconds by 4 or 5 seconds. Indicated exposures of 10–15 seconds might need to be doubled. The effect varies according to the make of film and, if authoritative figures are not available, the best procedure is to make several, widely varying exposures when shooting in such conditions.

Smile if you must !

Colour Shooting with Flash

Flash has an important role in colour photography. It makes us independent of any other form of lighting and can be used anywhere, even in the open air. Moreover, flash is fast. With electronic flash, the exposure time is no longer controlled by the shutter speed but by the flash duration.

Normally flash is synchronized with the operation of the shutter so that it fires when the shutter is fully open. That sounds reasonable and straightforward but there are a few points to note about synchronization. For instance, a flashbulb does not give its maximum light output as soon as it is ignited but it builds up output gradually, as shown in the diagram on this page.

When the shutter release is pressed, the flash circuit is completed and the bulb ignites. From the time the circuit is completed

Burning Curve of Flash

to the time the bulb reaches half of its peak output there is a period known as the delay, which is measured in milliseconds (msec). From half peak, the light output increases to the peak or maximum output, which is measured in lumens. Then it declines again to the half peak and is eventually extinguished.

The usable amount of light, known as the flash duration, stretches from the first to the second half peak and is usually about 1/50 sec. Its strength is measured in lumen seconds and is constant with all flashbulbs of the same type.

Flashbulbs and flashguns

There are two main types of flash equipment—the flashbulb which we have just been discussing and electronic flash. The flashbulb is used in a flashgun that is now usually a very small case housing a battery, a capacitor and a resistor. Originally, bulbs were fired direct from a battery but, as they need a fairly heavy current, although only for a short period, firing tended to become unreliable as the battery voltage dropped. With a capacitor in the circuit, reliability is considerably increased because even when the battery is nearly exhausted it can still recharge the capacitor to its full potential at a relatively slow rate (a second or two at most). The capacitor is then ready to discharge immediately at full power as soon as the circuit is closed.

The bulbs used in such flashguns are now usually blue-coated to simulate daylight. Clear bulbs are available in some larger sizes but they are not suitable for use with colour film. The bulb gives only one flash and then has to be discarded but the battery (generally 15–22 volts) will last for many months in normal use. This applies also to the flash cube, a pack of four bulbs that fits on top of the camera and is fired by a battery inside the camera housing.

Electronic flash

The other type of flash is of more complicated construction. It uses a gas-filled tube which acts as a discharge lamp and will give many thousands of flashes before it burns out. This is the electronic flash, much more expensive than the capacitor gun and working at a very much higher voltage (rarely less than 300). The electronic flash unit is a great deal more expensive than the capacitor flashgun but each shot costs virtually nothing. On the other hand it needs careful maintenance. Most units are powered by rechargeable batteries that must be kept in a state of charge. If

94

they are allowed to become completely discharged they may be ruined and are rather expensive to replace.

Shutter synchronization

Electronic flash has almost no delay. As soon as the camera flash contacts are closed the flash fires at full power and its duration is rarely longer than 1/500 sec. This means that shutter synchronization needs to be different for electronic and bulb flash. Blade shutters usually have X and M synchronization. The X setting fires the flash just as the shutter reaches its fully open position and is really designed for the instantaneous electronic flash. Bulbs can be used at this setting however when the shutter speed is 1/30 sec or slower because the shutter then remains open long enough for the flash to fire. At faster speeds the shutter would start to close before the flash had time to fire.

The M setting is for use with flashbulbs only. It fires the flash before the shutter reaches its fully open position so that the flash has time to build up to peak power when the shutter is fully open. This allows bulbs to be used at all shutter speeds although at the faster speeds only part of the usable output is in fact used.

Focal plane shutters are always X-synchronized but cannot be used at the fastest shutter speeds with either electronic flash or bulbs. This is because the film must be totally uncovered when the flash is fired. The fastest speed at which the film is totally uncovered is often only 1/30 sec but with some shutters of different design it can be as fast as 1/125 sec. Thus, electronic flash can often be synchronized at relatively fast shutter speeds but bulbs usually have to be used at speeds of 1/30 second or slower.

There is sometimes an FP setting on cameras with focal plane shutters for special focal plane bulbs which have an extended flash duration. This allows any shutter speed to be selected but the bulbs are rather expensive and are not stocked by many camera dealers.

Control of exposure by aperture and distance

As the flash duration is usually shorter than the shutter speed, the only factors controlling the amount of light falling on the film are variations of flash distance and lens aperture. The distance between the flash and the subject controls the amount of light falling on the subject and therefore reflected by it to the camera lens. The relationship between the distance and the light power follows roughly the inverse square law, which says that the amount of light falling on a subject is inversely proportional to the square of the distance

between light source and subject. Thus, at 3ft the light reaching the subject is only one-ninth the power at 1ft. Similarly, at 12ft it is one-ninth the power at 4ft calculated from $\left(\dfrac{12}{4}\right)^2$.

There is a similar relationship between f-numbers (aperture numbers). At $f8$ the amount of light transmitted by the lens is one quarter the amount at $f4$, from $\left(\dfrac{8}{4}\right)^2$. It follows, therefore, that whenever f-number and distance multiplied together give the same answer, the light reaching the film is the same, i.e. 10ft and $f4$, 5ft and $f8$, $2\frac{1}{2}$ft and $f16$, and so on.

Guide number system

This is the basis of the guide number system. Every flashbulb and every electronic unit is given a guide number which varies only with the film speed and, in the case of bulbs, with the shutter speed when it is faster than 1/30 sec. So, if you shoot from a certain distance the aperture you must use is found by dividing the distance into the guide number. If you shoot at a certain aperture the flash-to-subject distance is found by dividing the f-number into the guide number. Note that it is the flash-to-subject distance that counts, not the camera to subject distance, unless the flash is on the camera.

Some experience is needed in the use of guide numbers because they assume the normal shooting conditions of an average-sized room, with reasonably light-toned walls and ceiling, medium-toned subject matter and (usually) a 4-inch or larger reflector behind the bulb. Deviations from these conditions, such as shooting outdoors at night with no near-by reflecting surfaces, could reduce the guide number by up to 50 per cent.

Light distribution and shadows

The working of the inverse square law is convenient for the guide number system but is a nuisance in other aspects of flash work. It means, for example, that when you shoot a group of people, some of whom are four feet away and some six feet, those farthest away will be less well lit than the nearest. In fact, they receive less than half as much light and will therefore not only appear darker in tone but probably show some colour distortion, too. This is the reason for the colour distorted backgrounds so often seen in colour photographs taken by flash.

Generally, therefore, it is better to avoid too much depth in flash pictures unless you can use more than one flash or can place the

96

flash off the camera in a position to distribute the light evenly throughout the subject.

The usual advice with black-and-white photography is to take the flash off the camera and use it to one side of the subject on an extension lead. This improves the modelling, i.e. it introduces shadows that indicate shape, form and texture. This is often helpful in colour photography, too, but frontal flash from the camera position is acceptable with a wide range of subjects. The main exception is a subject placed rather close to the background. The effect of frontal flash is then often to put a hard, dark outline shadow around the subject which looks very unnatural and disturbing.

Effect of lamp position on guide number

Taking the flash off the camera does not affect the guide number unless it is taken to a very acute angle or round to the back of the subject. In such cases, the guide number may well need altering but the amount of the alteration depends on the effect required.

No alteration of the guide number is necessary if a second flash is used to lighten the shadows cast by the first. The amount of light the fill-in flash adds to the general illumination is minimal, unless it is placed practically alongside the main light. It simply makes the rather heavy shadows lighter and any reduction in aperture would largely cancel out the effect.

The guide number should, in fact, very rarely be increased. It might be necessary to do so if the subject is surrounded by very close, highly reflecting surfaces or is itself exceptionally light in tone. There are likely to be more occasions when the guide number should be reduced, as in the case of dark-toned subjects, lack of, or sombre reflecting surfaces, angling the flash so that the subject does not catch the main beam, indirect lighting, and so on.

Indirect or "bounced" lighting

Indirect flash lighting is a very useful technique in colour photography with flash. One of the great drawbacks of flash is the difficulty of controlling the shadows formed by what is really a remarkably brilliant light source. The best way of controlling them, in fact, is to practically eliminate them at source. This can be done by aiming the flash not at the subject but at a reflecting surface, so that all light reaches the subject indirectly as from a very large floodlight. The ceiling is particularly useful for this purpose.

An old technique for indirect lighting that has recently become popular again is to place a white umbrella in front of the subject and to direct the flash into it so that it acts as a sort of condenser to collect the light and throw it forward on to the subject. Naturally, however, almost any reflecting surface can be used for this purpose, provided we remember that it must be white or neutral coloured, such as grey or silver. Coloured reflectors throw a colour cast on to the subject that the film shows much more strongly than it appears to the eye.

The effect on exposure calculations of indirect lighting depends on the particular set-up. A rough idea can be obtained, however, by regarding the flash-to-subject distance as the flash-to-reflector distance plus the reflector-to-subject distance. Some allowance may also have to be made for the light absorbed by the reflecting surface but that can be ascertained only from experience of the equipment used.

In the home, a mixture of direct and indirect lighting can often give pleasing results. A corner of a light-walled room, for example, enables the subject to be lit from all directions simultaneously, with the strongest light coming from the front. The proximity of the reflecting surfaces may in this case call for a slight increase in the guide number but the additional exposure given should rarely amount to more than half a stop.

Fill-in flash in daylight

Outdoor shooting in bright sunshine often produces heavy shadows. When the sun is high in the sky, the shadows are small and can give a very unpleasant effect, particularly in portraits. Hard, small shadows under chin and nose, heavy shadows in eye sockets or, perhaps, most of the face in shadow but a brilliant highlight on the nose, are not attractive features. Normally, it would be better not to shoot at all in such conditions but if you have a flashgun you can subdue the effect of these shadows to any extent you think necessary. Any flashbulb is in fact, so powerful that, used close to the subject, it can completely eliminate the shadows cast by the sun and create shadows of its own.

That is not the ideal with fill-in flash. You really want only a very weak flash that will soften the shadows without eliminating them. The usual advice is to double the guide number and divide it by the aperture decided on for normal daylight shooting in the conditions prevailing. This often works out to an uncomfortably distant position for the flash and it is better to experiment with various methods of diffusing the flash with tissues, gauze, handkerchief, etc to cut its power down to about one-quarter of the

normal strength. You can then use the normal guide number and shoot from sufficiently close range to fill the frame.

Flash as a substitute sun

Flash can also be used as a substitute for sun light on a dull day. It is useful, for example, for wedding pictures on days when the weather is unkind. Held fairly high or on an extension cable it can give a passable imitation of sun light and can add the necessary sparkle to what would otherwise be rather dull pictures. In such a case, you use the full guide number as if for a normal flash exposure. This time, the daylight acts as a fill-in. It is best to avoid including any sky in the picture because it will be underexposed and make the shot look unnatural.

Fill-in flash indoors

Problems of harsh shadows can also arise when shooting indoors by window light. Unless your windows are particularly favourably arranged for photography, you will find that one side of your subject is excessively dark. The remedy is exactly the same as for sunlight outdoors and the same dangers are present. It is fatally easy to overlight the shadows so that the characteristically soft effect of window-lighting is lost.

Indoors, however, you are more likely to be able to place the flash at some distance from the camera on an extension cable. If so, it is best to calculate the exposure for the window light in the normal way and then divide the chosen aperture (*f*-number) into the *doubled* guide number to obtain the flash distance. If your flash cannot be removed from the camera, you have to use the method recommended for outdoor shooting, i.e. experiment with flash diffusers to cut down the power of the flash.

All such flash work is, in fact, a matter for experiment with your own equipment. Find a method of keeping the flash as weak as possible. If your shadows are still a little stronger than they should be, at least the shot is not ruined. If the fill-in effect is too strong, the picture looks utterly false.

Outdoors at night

When flash is used outdoors at night, conditions are generally totally different from those envisaged by the flash equipment manufacturers when they allocate guide numbers to their bulbs or electronic units. They allow for reflecting surfaces all around the subject at fairly close quarters, whereas outdoors there may be no

99

reflecting surfaces within range of the flash. The effect is considerable and the guide number should be reduced by at least one half. This means that two stops more exposure is given than if the shot were taken indoors.

Most, if not all, of the background in such shots will be completely unlit, so you should make sure that there are no small spots that might pick up some of the light and cause disturbing elements.

Flash at close range

It sometimes happens that when flash units are used very close to the subject the guide number becomes unreliable. This is partly due to the reduced influence of reflected light and partly to the design of the flash unit and its reflector, which is primarily intended to cover a fairly broad area at reasonable distances. When the flash is attached to the camera there can even be some parallax error at very close range, so that only part of the light actually reaches the subject.

Where possible it is best to detach the flash from the camera and position it at least four or five feet from the subject. In either event, however, reflecting screens should be placed close to the subject if the circumstances and lighting requirements allow.

Slides and Slide Projection

There is no colour reproduction method that quite compares for quality and effect with the projected colour slide—provided, of course, that the film was correctly exposed and the colour rendering is good. Moreover, as we have already mentioned, the series of slides projected at any one time must be in a related sequence of both content and colour mood.

Films sent by post

For processing the amateur often sends his exposed film through the post to a processing laboratory. In due course, he receives a smaller or greater number of slides. Or perhaps he never hears of his film again, or only gets it back after protracted correspondence. When this happens it is nearly always his own fault.

101

Sending films through the post is a reasonably safe procedure but it is not uncommon for photographers to cram two or three films into the mailing bag intended for one film. Very often they get damaged or the bag bursts and the films are lost. Innumerable people have received their films back after long delays because they failed to include their names and addresses with the mailing bags or because they wrote them illegibly. Others have omitted to pay postage.

The good processing laboratories have special search departments and the work they are called on to do would often baffle the CID. The sins of omission committed by photographers may leave such a department with hundreds of films a day to be sorted out. All have to be recorded in some detail so that inquiries from clients can be related to "lost" films as quickly as possible.

So, remember! Whenever you send a film to be processed, make sure that your own name and address is included in clear, readable characters, preferably block letters. Make sure, too, that the mailing bag is securely tied or fastened and that you prepay the correct postage.

Types of slide mount

Processing laboratories may give you the alternative of receiving your films either cut into individual frames and mounted or cut into strips or left in the roll and unmounted. Most 35mm films are returned in either card or plastic mounts ready to be loaded into slide magazines for the projector.

These mounts are a comparatively recent innovation. Originally, and for many years, colour slide films were returned in the roll, perhaps interleaved with a roll of paper and the user mounted them himself between thin sheets of glass bound with passe-partout. Many people still prefer to mount their slides between glass for various reasons. One very good reason is that the glass sheets offer complete protection against dirt, dust and fingermarks. If the mounting is well done, the slides are also protected against attack by mould, fungus, etc. If it is badly done, however, perhaps when film or glass is damp or the air is humid, moisture can be trapped in the mount and lead to various troubles.

If you wish to use glass for protection, the best solution may be the plastic or metal press-together mounts which use loose glass plates. The glass affords protection but does not exclude air, so silica gel or a similar drying agent can be kept in the storage box to combat the effects of any dampness that may be present. At least one film manufacturer returns the slides ready mounted in glass and plastic.

102

Pros and cons of glass mounts

There are many arguments for and against mounting between glass and they are, perhaps, best summarized in a table.

	Glass frames	Slides
Cost	Determined by the kind of frame	Slight, often included in the cost of the film
Weight	Considerable, particularly in large numbers	Slight
Framing effort	Time consuming and costly, according to type	Either already included in cost of film, or slight
Time spent on framing	Considerable, in varying degrees	Slight or non-existent
Dust	Slides treated in an anti-static bath will still need cleaning of glass	An anti-static bath treatment will repel dust for a long time
Damage	Glass is easily broken, and could also damage slide	Careful with fingerprints and scratches
Newton's rings	Can be avoided by using special glass	Do not occur
Sharpness in projection	Adjustment of sharpness during projection only required if slides vary in thickness	Buckling due to heat of projector. Not a problem in modern projectors
Dampness Precipitate	Can occur on inside, causing fungus and mould	Precipation cannot happen

The most common criticism of glassless mounts, whether card or plastic, is that the film is not held completely flat and that it can bend under the influence of heat from the projector lamp. This is not generally very troublesome in practice.

Slides bound between glasses stay flat but are prone to produce Newton's rings—a peculiar rainbow-like formation of concentric, more-or-less circular shapes caused by rather less than perfect contact between film and glass. The insertion of paper or foil masks in this type of slide usually avoids this trouble but it can arise with glass and plastic mounts, too. As the glass in these mounts is only as large as the image area, masks cannot be used. Special, lightly-grained glasses are, however, available. The graining holds the glasses microscopically apart so that perfect flatness is not necessary.

Slide viewers

Slides can be viewed directly in the hand if held in front of a light source or strongly reflecting surface but, as most slides are 35mm or smaller, they cannot be fully appreciated in this way. A slightly better impression is obtained by using a viewer. These take many forms. The simplest is a plastic housing containing a small lens at one end and a diffusing screen at the other. The slide is placed in front of the screen and viewed through the lens in front of a light source. Larger versions have a built-in light source and stronger viewing lenses to give larger images.

The disadvantage of viewers is that most models allow only one person to see the image at any time. Their "optical systems" are primitive and the colour rendering depends on the light source at which they are pointed or the state of their batteries. They are useful for supplying a preliminary rough check on quality and colour but real appreciation is only possible with a projector.

Slide projectors

There are very many projectors on the market for 35mm slides but comparatively few for 6 × 6cm. Projectors to take formats larger than 6 × 6cm are quite rare. The 35mm projector takes slide mounts in the 5 × 5cm (2 × 2in) size, which can also accommodate the 4 × 4 image or super slide.

The basic equipment for slide projection is simply a projector and a screen, but you can, of course, add sound to your slide shows. There are many items of equipment for this purpose, including synchronizing units which will change the slide as required to suit the commentary or background music.

It is not easy to make a choice from the many projectors on the market. The first requirements, however, are a sharp image and even illumination. Sharpness in this connection means all-over sharpness. Projector lenses do not need to be of as high quality as

camera lenses but it *is* necessary that they give a sharp image in the centre, at the edges and in the corners.

No projector will give absolutely perfect illumination. The corners will always be at least slightly less bright than the centre but the effect in a good projector is barely noticeable.

The next most important feature is the slide-changing mechanism. There are, regrettably, many projectors with mechanisms that are prone to jam, especially when slides of different types and thicknesses are used. The good projector can accommodate card or plastic mounts and glass-bound slides without jamming. Naturally, as you change from one type of mount to another, the position of the actual film may change and refocusing becomes necessary but even this is overcome by one or two more expensive models.

A useful feature is the ability to project single slides. Unfortunately, this is rare in modern projectors, most of which use magazines. If you want to project a single slide you have to put it into a magazine first and then manoeuvre the magazine into place.

Slide magazines are not standardized. There are different models for different projectors, the usual points of variation being the mechanism for moving the magazine forward and back, and the method of loading the magazine into the projector.

Nearly all projectors need a cooling fan because the heat generated, even by low-voltage projector lamps, is quite considerable. Apart from the efficiency of the fan—which can be checked with an item known as a thermoslide—noise-level too is important if you intend to provide a sound accompaniment to your slide shows.

A point of overriding importance, but a difficult one to check, is

electrical safety. The projector should have a three-core cable so that the case and/or any exposed metal parts can be efficiently earthed. Any switch incorporated must be in the live (brown) cable. The lamp switch should be independent of the fan so that the cooling system can continue to work after the lamp is switched off.

Projection formulae

The size of the projected image depends on the size of the slide, the focal length of the projector lens and the distance between projector and screen (the "throw"). The following formula shows the relationship between these factors

$$Pa = \frac{P_b \times F}{B_b}$$

Where Pa = distance from projector to screen, P_b = the width of the projected picture, F = the focal length of the lens and B_b = the width of the slide image. Pa and P_b are in metres while F and B_b are in millimetres.

The formula can be expressed in various ways and the most useful form is probably that which allows us to calculate the focal length of the lens required to provide a certain size of picture at a given throw. For this purpose, the formula is expressed as

$$F = \frac{B_b \times Pa}{P_b}$$

As an example, assume that the available throw is 4m, the picture size required is 1·6m, and the usable image size is 34mm. The required focal length is then

$$F = \frac{34 \times 4}{1·6} = 85mm$$

You will notice that the calculation is based on a 34mm image width, although the 35mm format is actually 24 × 36mm. In practice, however, the slide mount always encroaches slightly on the picture edge and the visible picture format is normally about 22 × 34mm.

The standard lens for 35mm projection is, in fact, of about 85mm focal length. Where the length of throw is required to be unusually short or long, however, a different focal length is advisable. If projection is frequently carried out in different-sized rooms a zoom lens is useful. This type of lens has a control allowing its focal length to be varied to meet a wide range of projection conditions.

106

For those who fight shy of mathematical calculations, the most important data are summarized in the table below:

Projection distance, focal length and picture size with slide format 23 × 25mm

Projection distance in metres	Focal length of lens			
	85mm	90mm	100mm	125mm
1.5	0.30 × 0.58			
2	0.52 × 0.79			
2.5	0.65 × 1.00			
3	0.81 × 1.23	0.76 × 1.17	0.67 × 1.02	
4	1.08 × 1.64	1.02 × 1.55	0.90 × 1.36	
5	1.35 × 2.06	1.28 × 1.94	1.13 × 1.72	0.90 × 1.38
6	1.62 × 2.47	1.53 × 2.33	1.36 × 2.07	1.10 × 1.66

Projector illumination

Most modern projectors use low-voltage tungsten halogen lamps (once known as quartz-iodine) as the light source. Their advantages are that they do not blacken with age and so do not change in colour quality, and they give a brighter light with rather less heat than a lamp running at mains voltage.

Methods of slide changing

Slide changing mechanisms take various forms. There are still inexpensive projectors which allow only two slides to be loaded at one time, the changeover being effected by moving the slide carrier across in front of the light source. The slide that has been shown is then extracted and replaced by another.

A more sophisticated method is to load about 30 or 40 slides into a grooved box known as a magazine which runs along a track in the projector. A push-pull type mechanism similar to that in the simpler projectors then extracts the slide, pulls a shutter behind the lens and moves the magazine forward on the pull stroke and inserts the next slide on the push stroke. The shutter ensures that the screen remains unilluminated between slides.

More expensive models effect the magazine movement and slide changing from a remote position. You can then sit in an armchair, perhaps nearer to the screen than the projector, and control your

slide show in comfort. Such projectors are often called fully automatic but most models have to be focused manually. Only a few models automatically refocus the lens when varying thicknesses of mount affect the film position.

Adding sound accompaniment

Adding sound to a slide show can be as simple as playing a gramophone record of background music or a tape-recorded commentary into which you incorporate certain cue words to tell you when to make the slide change. In fact, you can do little more than that if your slide changing mechanism is manually operated.

The electrically-operated mechanism of the automatic projector, however, enables more ambitious sound effects to be added. You can, for example, record a sound track with music, commentary, effects, etc on one track and a series of electrical impulses on another. Equipment is available to link the tape recorder and the projector so that these impulses can be picked up and transmitted to the projector to bring its slide-changing mechanism into play. Thus, slides can be changed automatically in synchronism with the sound track.

The effectiveness of the sound track is limited only by your ingenuity and tape-recording skill. Apart from music and commentary, you can use various natural and mechanical sounds such as those made by rain, birds, animals, farm tractors, traffic, and so on (see page 111). You should not overdo it, however. The sound track should reinforce the picture, not provide an alternative interest or entertainment. The commentary should not point out the obvious; it should *add* information to that supplied by the picture.

Projection screens

The quality of the projected picture depends to a great extent on the screen. You can project on to a sheet or a white painted wall but a specially-designed projection screen is generally more convenient and will certainly give better results than a crumpled sheet. It creates a better impression, too. The commercially-produced screen may be of a type that hangs on the wall and unrolls like a map, it may be in an elaborate wall-mounted cabinet or it may be free standing. The hanging type is the most portable but it needs something to hang on. The free-standing type is usually supported by its own tripod and is also reasonably portable.

The slide projection screen should preferably be square so that it

can accommodate both horizontal and vertical shots at the same magnification.

Screen surfaces are of various types. The plain, matt-surfaced screen (or emulsion-painted wall) reflects light in all directions. Thus, the picture can be viewed from quite acute angles, which is desirable when many people are viewing and they cannot all be seated directly in front of the screen. This widespread reflection has its disadvantages, too. It throws light on to ceiling, walls and floor and thus back again on to the screen, where it may diffuse the image and reduce its brilliance.

Screens are available with some directional control of the reflection so that most of the light is thrown forward and the reflection on to surrounding surfaces is minimized. The picture is then considerably brighter—but only for those viewing from within the ideal angle of reflection. Those viewing from acute angles see only a very dim picture. This directional control has in fact been taken to the point where a screen material is made that reflects light only straight back along the axis of the lens. A viewer standing only slightly off the axis can see no image at all. Naturally, this material is for specialist use and has no application in ordinary slide projection.

The best type of screen is that which suits the normal viewing conditions, size of audience, greatest angle of view, etc. You generally have to compromise between brilliance and practicable viewing angle. If only three or four people normally view your slides, you can use a highly directional screen such as the beaded type. It gives a brilliant picture but a rather restricted angle of view. There is a wide variety of other screens available with various ingenious surface constructions but for general use there is, in fact, nothing to beat a clean, smooth, matt white screen—and a simple way of obtaining such a screen is to paint a sheet of hardboard with the whitest matt emulsion paint you can find. Such a screen can be washed and repainted at any time. One of the patent screen materials may provide a more brilliant picture for viewers near the projector lens axis but only at the expense of the picture seen by viewers at a greater angle.

A patent screen generally has the advantage of compactness, portability, free standing facilities, etc. and the lenticular type, which is a compromise between the beaded and the matt white is probably the best buy.

Making the slide selection

The success of a slide show depends largely on a careful selection of slides to make an interesting programme. Everything

should be prepared in advance, including setting up the equipment ready for an immediate start as soon as all the guests are seated. Electrical cables should be so placed that there is no danger of anybody tripping over them. If a sound accompaniment is used, the loudspeaker should be hidden behind the screen or near to it.

You must be strongly critical of your own efforts when selecting the slides. First discard those you do not like yourself, then those with technical faults. The number of slides shown is relatively unimportant, compared with their quality and interest. A show that is too long will bore your guests and their boredom may become only too apparent. A selection of about 60 slides should be quite enough for most circumstances.

The order of showing and interrelationship of the slides must be carefully arranged so that there is a definite pattern and, preferably, a heightening of interest as the show proceeds.

The best shots should be reserved for the last third or so of the series. There should be no violent change of colour theme to confuse the viewer.

Advantage of titles

Titles can often add interest to a slide show and are easily prepared if you have equipment suitable for close-up photography. Titling letters are available in various forms from photo dealers or self-adhesive lettering systems such as Letraset can be used (see page 115). Those with an artistic bent can even draw their own titles.

Titles should be kept as brief as possible. Long explanations tend to bore the audience and may not be easily read. If the title is combined with a picture it must be so placed in the image area that it is completely legibile.

Arrangement and tempo

It will repay you to put the slide show together on an organized basic theme. A confused mixture of pictures on different subjects or even unrelated aspects of the same subject is unlikely to create much interest.

The tempo of the show is of importance, too. If you leave a slide on the screen for so long that attention wanders, you may lose your audience altogether. No slide should be shown for more than 20 seconds and many slides can be shown for much shorter periods. Naturally, the picture content infuences the screen time. A long shot with a fair amount of detail should generally be shown

110

for rather longer than a single-detail close-up. Where a particular aspect of a subject is of importance it may be preferable to show another view of it, or even two or three, taken from different angles rather than leave a more general shot on the screen for too long.

The tempo can also be related to the mood. Peaceful scenes can be changed at a relatively slow rate. Then, if action is to be implied or more dramatic shots presented, slide changes can become more rapid.

Using two projectors

When you change from one slide to another there is necessarily a brief pause followed by the abrupt appearance of the next picture. This cannot be avoided unless you use two projectors. We have no room here for full details but it is possible by this means to create dissolves and other smooth changes from picture to picture that approximate to cine usage and help to keep the show flowing rather than proceeding in a series of jerks. Various items of equipment are available from your photo dealer to add refinements to this method of projection.

Production of special effects

It is not difficult to provide commentary and background music for a slide show and they undoubtedly increase the entertainment value. The show can be further improved, however, by the addition of "special effects". Specialist dealers can supply discs and tapes containing innumerable sounds and effects put together for

this very purpose. They range from a baby crying to a bomb bursting, traffic noises to thunderstorms, and so on. It is a simple matter to re-record such effects on to the tape you play back during your slide show.

You can manufacture your own special effects with a little ingenuity. It is surprising how realistic the most artificially produced effects can sound when recorded on tape.

Footsteps

The sound of footsteps varies according to the surface producing them and the footwear. To imitate footsteps on soft ground, as in a wood, crumple a piece of waste tape and squeeze it in footstep rhythm close to the microphone. Footsteps in snow can be produced by similarly squeezing a small bag filled with starch. An impression of marching soldiers can be obtained by pressing a sheet of wrapping paper together and straightening it out again in the required rhythm. The distance from the microphone controls the apparent distance of the marching troops and can be varied to indicate approach and departure.

Telephone conversation

A telephone voice can be created by speaking into a plastic beaker near the microphone.

Rain

Shaking dried peas from side to side in a large sieve can give a convincing impression of rain. A heavy downpour is simulated by dropping the peas progressively into an empty bath tub.

112

Waves and surf

Colour shots of the sea are vastly improved if the play of the waves can be sensed. Fill a pan, preferably not metal, with water to the brim and stir the surface of the water with the hand to create the splashing of the waves as required. If you push the water against the edge of the vessel with the flat of the hand you can even imitate breaking waves. The microphone should be near the water surface.

For surf, you need two brushes and a sheet of tin. Draw the brushes over the tin with the frequency of waves and the surf is there in your projection room.

Ship's siren

The sound of a ship's siren comes out of a bottle. The bottle (a milk bottle works well) is part filled with water and you blow steadily directly into it. The pitch of the note varies with the level of the water.

Wind and storm

Wind effects are most easily made by blowing gently across the face of the microphone. Alternatively, a length of silk, such as a scarf, can be drawn across a sheet of plywood. The apparent strength of the wind varies with the rapidity in the movement.

Thunder is created by holding a sheet of fairly stiff paper or card or thin metal by one edge or a corner and shaking it in front of the microphone.

Pistol and rifle shots

Shots have various characteristic sounds. The flat side of a ruler rapped smartly on a table top sounds like a pistol shot. A rifle shot

is best produced by striking the flat of a hand with one or two fingers of the other hand. For a loud shot, clap the hands.

Fire

Fire is generally a crackling sound and a good substitute is to crumple an empty matchbox in front of the microphone. Crumpling Cellophane gives a more powerful effect.

Machinery

Domestic machines can easily imitate the noise of industrial machinery. Experiment with an electric razor, a ventilator fan, a clock, kitchen machinery, toys with spring or electric motors, electric drill, etc. Try using several of them together. The possibilities are endless.

To create various engine noises, try experiments with any electric fans you have available or can borrow. Sometimes a typical aircraft rumble sound can be picked up if the microphone is held close to the fan. A piston engine noise comes from a stiff piece of card held against the fan blades.

A whistle makes a good substitute for a jet engine. You can vary the opening in the whistle to alter the pitch of the sound.

Bells

Finally, if you tap with a pencil a series of wine glasses part filled with water you can produce bell ringing, tolling or chiming sounds. The level of the water controls the pitch of the note and you can exercise further control by recording the sound at one speed and playing it back at another. If you have three speeds a really impressive reverberating gong can be obtained by recording a pencil tapping a glass at the fastest speed and playing it back at the slowest.

Recording original sounds

Sounds are often created artificially because it is difficult to make a perfect recording of the required original sound as it occurs. Nevertheless, try to make original recordings when you can. For this, you need a portable, battery-operated recorder of reasonable quality and, for preference, one that allows you to monitor the sound as it goes on to the tape. A visible recording level indicator is useful but not essential. The automatic-level-control models

work surprisingly well and the fewer controls you have to operate while working in the field, the better.

The types of recording best made by this means are those that cannot easily be imitated, such as crowd noise at a sporting event, street traffic noises, bird song, etc.

Specialized projection equipment

There are many specialized items of equipment available that make the production of a slide show much easier.

Titling equipment

We have already briefly mentioned titling equipment. Titles can be produced in various ways. In some cases adhesive letters, available in many styles from photodealers, can be stuck to actual items in the picture and photographed as part of the scene. If that is not practicable, smaller letters can be stuck on a sheet of glass, through which a suitable scene is subsequently photographed. This generally calls for shooting at a very small aperture to obtain the necessary depth of field.

There are also titling outfits available, consisting basically of a frame and jig to facilitate copying of pictures, maps, etc, with which lettering is combined to form any type of title slide you want. This method can, of course, be used with any camera capable of taking close-up pictures. It is merely a copying method.

Projector stands

Most people probably set up their projectors on a table, sideboard or other item of furniture and control its height and tilt by adding books or other small items. If you are trying to put on a "polished" show before an audience, such arrangements are not particularly impressive and it is preferable to invest in a real projector stand.

There are table models with horizontal and vertical adjustments that are more efficient than books and matchboxes but they do require that a table be available. This is rather a waste of space and the free-standing projector stand is preferable. This type is usually of a split-level design with a lower table to hold magazines, notes, etc and an upper, adjustable platform for the projector itself.

Pointer torch

A useful item of equipment if your slide show takes the character of a lecture is a pointer torch. If you want to draw attention to a

particular item in the picture, it is not always convenient to describe it, or practicable to use an ordinary pointer. The pointer torch throws a light on to the picture in the form of an arrowhead which can be moved across the picture at will by "remote control" from the projector position or elsewhere.

Filters

Everybody knows the filters you put over the camera lens but not all slide enthusiasts realize that you can use filters in the projector as well to control colour casts or subdue the effects of overexposure. For the latter purpose, neutral density filters can dim the brilliance of the overexposed slide by 25, 50 or 75 per cent so that it harmonizes at least in brightness with the rest of the series.

Such adjustments should, of course, be made before the slide show starts. The required filter should be bound up with the slide, where it does not need to be of optical quality. Coloured filters can be used to remove colour casts but there will be some pictures for which such a remedy is not possible. You cannot, for example, place a coloured filter over a slide that contains (correctly) pure white or nearly white areas. Nor can you correct partial casts, such as those appearing in shadow areas or caused by reflection, without affecting other areas of the picture as well.

Slide mounting equipment

To be projected, slides first have to be put into some form of mount. The processor will normally return 35mm slides in self adhesive card mounts, which are not reusable, or in press-together plastic mounts which can, if required, be taken apart and used for other slides.

If you mount your own slides, you have a wide choice of mounts, including the two types already mentioned plus plastic or metal versions with loose glass covers in various ingenious designs. The glass may be plain or one of each pair may be of the etched anti-Newton's Ring type (see page 104).

It is now comparatively rare to bind 35mm slides completely in glass but some still favour this method for the larger sizes. For this purpose kits are available including glasses, folding masks with various image area sizes and pre-cut and folded binding tape to seal the edges.

Useful non-photographic items for marking slide mounts can be obtained from most stationers in the form of adhesive labels, spots, numbers, etc in a variety of shapes, sizes and colours. These can

116

be valuable for general identification, group colour coding, numbering within a group and so on.

Dust control

One of the most common enemies of slide quality is dust. Both glass and film attract dust very easily and it takes only a few almost invisible specks to ruin the appearance of a slide by appearing as enormous blemishes on the screen. Cleaning by normal friction makes matters worse and it is preferable to use a blower or very soft brush. There are, however, various anti-static solutions, brushes and cleaning cloths that can go a long way towards solving the problem.

Slide storage

Slides can be stored in the boxes in which they are delivered, in special grooved cases, in box files, drawers, cupboards and various other places. It is probably best to store them, in suitable sequences, in the projector magazines—or in transfer magazines. These are containers similar to magazines into which the whole load can be tipped without handling. They are not suitable for use in the projector and are rather cheaper than the projector magazines.

Slide sorting

Selecting the slides for a particular show is made much easier if you have a sorting tray. This useful item of equipment takes various forms but basically it is a flat holder for a large number of slides, displaying them in such a way that all of them can be seen at a glance and any individual slide can be examined closely without handling it. The unit either incorporates a light behind the tray or can be arranged so that any available light shines through it.

Dye protection

The dyes used in colour slides are not permanent. They will fade in time and they will not all fade at the same rate. Colour distortion is usually evident before the fading really shows up. With normal care and not too much exposure to light, most slides will, in fact, retain their colours for many years, but if you intend to show your slides frequently it might be as well to use one of the pro-

prietary lacquers designed to inhibit fading. These products are supplied in aerosols for spray application or in bottles for use with a brush. Apart from preserving the colours, they also afford some protection against abrasion and other mechanical damage.

Colour Film Processing

Should you or should you not do your own colour processing?
Colour slide films are often sold at a price including the processing
charges and there is little point in processing those films yourself.
Kodachrome, moreover, needs special treatment that only a few
professional laboratories can provide. Nevertheless, there are some
films you can process yourself and the manufacturers supply kits of
chemicals, complete with instructions that make the task easy.
There is some satisfaction to be obtained, as always, from doing
the whole job yourself, but it takes time to process a colour film
and not everybody thinks the time well spent.

Colour print films are never sold with the processing charge included in the price and all types can be developed by the user. You can do your own colour printing, too, but you need a few items of special equipment that are worth buying only if you use colour print film regularly. Again, the colour print takes time. It also needs a fair amount of skill but it repays the efforts of individual treatment handsomely.

This chapter and the one following are intended to help you make up your mind whether it is worth while in your individual circumstances to undertake your own colour processing. The instructions and processing details given should not be taken as working instructions for the films mentioned. They are quoted as an indication of the amount of work involved and the time it takes. When actually processing a film, you must adhere strictly to the instructions packed with the processing chemicals. These are always precise and fully detailed.

Care and cleanliness are vital

Colour processing needs to be carried out with care and strictly according to the manufacturer's instructions. Those instructions state the temperatures at which the various solutions are to be used. Slight variations are possible except with the first and colour developers, where deviations of even half a degree Centigrade can affect the colour rendering.

Developing tanks and trays must be perfectly clean if they are to be used for colour processing. Black-and-white developers leave deposits that can affect colour films and it is preferable to use separate equipment for colour processing. If the black-and-white equipment is used it should first be soaked for at least a quarter of an hour in the following solution:

Potassium bichromate	5gm
Sodium or potassium bisulphite	20gm
Water to	1000ml

The equipment must be thoroughly washed after immersion in the cleaning bath to remove all traces of the chemicals, which can also be harmful to colour films.

Timing by tape recorder

Successful colour processing depends on accurate timing of each step and a useful way of keeping a check on times is to use a tape recorder. If you record at the appropriate intervals the various changes of solution, rinses or washes and their duration

and so on, giving fair warning well in advance of each step, you need not fear that you will fail to notice the time, or forget the time you started, or omit part of the process. Thus, you can record in advance "Empty out X bath and rinse for one minute in thirty seconds' time" . . . "15 seconds to go" . . . "10 seconds" . . . "5, 4, 3, 2, 1 Empty X bath and rinse" and so on. The longer intervals can be filled with music recordings or any other material that interests you.

Procedure for Ektachrome films

One of the most popular ranges of films for user processing is Kodak's Ektachrome series, consisting of Ektachrome X, Ektachrome professional rollfilm E3 and two high-speed versions Ektachrome HS and HS Type B. There are also various sizes of sheet film for larger format cameras.

The processing of Ektachrome amateur colour slide film can now only be carried out by the E4 process, which uses a chemical fogging procedure instead of the re-exposure to white light of the previous E2 process. Kodak no longer supply the E2 chemicals but

Method of working with process E-4

Bath	Remarks	Temperature °C	Time in minutes	Total time in mins
1 Pre-hardener		$29.5 \pm \frac{1}{2}$	3	3
2 Neutraliser		28–31	1	4
3 First developer		$29.5 \pm \frac{1}{4}$	6	10
4 First stop bath		28–31	2	12
After the first stop bath, work can be done by normal lighting				
5 Wash	Running water	27–32	4	16
6 Colour developer		28–31	9	25
7 Second stop bath		28–31	3	28
8 Wash	Running water	27–32	3	31
9 Bleach	Note: this bath attacks metal	28–31	5	36
10 Fixer		28–31	6	42
11 Wash	Running water	27–32	6	48
12 Stabiliser		28–31	1	49
13 Dry		Not over 43		

various workers have devised and published substitutes for them. These cannot now be expected to give perfect results with films designed for E4 processing but no doubt enthusiasts will still experiment with them.

The various steps in the E4 process are detailed in the table on the previous page.

E3 chemicals are still supplied for processing Ektachrome E3 professional rollfilm and Ektachrome sheet film. The various steps involved are shown in the following table.

Method of working with process E-3

Bath	Remarks	Temperature °C	Time in minutes	Total time in mins
1 First developer	Watch the agitation instructions	24 ± ¼	10	10
2 Wash	Running water	23–25	1	11
3 Hardener		23–25	3	14
After the hardening bath, work can be done by normal lighting				
4 Rinse	Running water	23–25	3	17
5 Reversal exposure	With a 500 watt lamp at a distance of 30cm			
6 Colour developer		23–25	15	32
7 Wash	Running water	23–25	5	37
8 Clearing bath		23–25	5	42
9 Wash	Running water	23–25	1	43
10 Bleach	Note: this bath attacks metal	23–25	8	51
11 Wash	Running water	23–25	1	52
12 Fixer		23–25	6	58
13 Wash	Running water	23–25	8	66
14 Stabiliser		23–25	1	67
15 Dry		Not over 43		

All colour processing chemicals must be handled with caution. Some of them are toxic and you have no claim against the manufacturer if you misuse them. Read the instructions carefully and

follow them to the letter. Particularly, make sure that you store the solutions in bottles that cannot be mistaken for soft drinks, etc and keep them well away from foodstuffs and out of the reach of children.

Making up the solutions

In all colour processing, it is vital to follow the manufacturer's instructions precisely unless you are conducting experiments or have perfected alternative methods. The first task is to make up the solutions from the chemicals contained in the processing kit. Some of these are in liquid form, others as 1, 2 or 3 powders which must be carefully mixed in the order and manner stipulated. Make sure that all chemicals are thoroughly mixed or dissolved before using the solutions. Otherwise, unwanted chemical compounds may be formed by interaction between the various chemicals.

All baths can be prepared with ordinary tap water because each set of chemicals incorporates a substance to prevent the formation of chalk.

Brown glass bottles are recommended for storage and those containing the developers should be kept completely full by the inclusion of glass marbles to prevent aerial oxidization. The bottles should be kept at normal room temperatures.

Maintaining solution temperatures

The temperatures at which the various baths should be used is stated in the manufacturer's instructions. These temperatures are really only critical in the case of the developers but it is as well to adhere closely to them for all solutions to ensure that results are reproducible. The simplest way of maintaining bath temperatures is to fill a large bowl or the kitchen sink with water at the required temperature and stand the storage bottles in the water until they are required. As the processing goes on for some time the temperature of the water must be checked and more warm water added from time to time.

Increasing effective film speed

Most colour films are relatively slow compared with black-and-white films but it is possible to subject them to special processing methods to increase effective speed (and to decrease it in cases of known over-exposure). Kodak publish recommendations for such processing of High-speed Ektachrome and Ektachrome-X but do not recommend it for the normal versions. Some laboratories will under-

123

take this work but the film must be prominently marked to indicate the speed at which it was rated.

The method used to vary lens speed is to increase or decrease the time in the first developer. The possibilities with Ektachrome HS and Ektachrome-X are detailed in the following table.

Film	Speed scale	Time in first developer (minutes) Process E-4					
		10½	9	8	**6**	4¼	3*
		Meter setting					
High speed Ektachrome, Daylight Type	ASA	650	400	320	**160**	80	40
	DIN	29	27	26	**23**	20	17
High Speed Ektachrome, Type B	ASA	500	320	250	**125**	64	32
	DIN	28	26	25	**22**	19	16
Ektachrome X	ASA	250	160	125	**64**	32	16
	DIN	25	23	22	**19**	16	13

NOTE: Figures in bold are normal recommendations.

* Colour variation from normal will be significant—recommended only for exposure error compensation.

The recommendations in this table are issued by Kodak, but they do not normally offer special processing services. The films have to be sent to a laboratory specializing in such treatment and must be clearly marked to indicate the speed rating at which they were exposed. The information in the table can also be used by those who wish to conduct their own experiments, either with Ektachrome or other colour slide films.

It cannot be expected, however, with any film, that departures from the normal processing times will yield perfect results. It is likely that there will be some shift in colour balance.

Agitation methods

Agitation of solutions is an important feature of any film processing but it is particularly important with colour films. The

124

recommended procedure is to withdraw the tank spiral completely from the tank and allow the solution to drain from the film back into the tank for five seconds. Then re-insert the spiral and raise and lower it twice. This procedure removes partly exhausted developer from the film surface and allows fresh developer to reach the emulsion.

The normal amateur tank, however, now allows inversion agitation, i.e. complete inversion of the tank is possible because it has a water-tight top. One inversion every minute with two or three seconds before returning the tank to its normal position should be sufficient, but it is best to follow the instructions supplied with the processing chemicals so that the timing of the various processes is not upset.

Over-agitation in the developing solutions is equivalent to giving longer development times, such overdevelopment produces "thin" slides and possibly a colour shift. Lack of agitation can result in underdevelopment of parts of the image, together with colour shifts, and may also cause unwanted "edge effects" at borders between colours of markedly different tonal value.

Washing time and temperature

Washing times should also be strictly adhered to. Where only a brief rinse is stipulated, washing should not be prolonged because some interaction is allowed for. Where longer washing times are stipulated, the temperature is important, too. If the wash water is at a lower temperature the time must be increased to ensure that washing is completed. It is preferable, however, to arrange beforehand for a plentiful supply of washing water at the correct temperature to be available. Otherwise, some difficulty may be experienced in keeping the following baths at the correct temperature when they come into contact with the cold film and tank.

Effect of stabilizer

Films that use a stablization bath as the final processing stage do not show a true colour image until they are dry. While wet, they are opalescent and the colours look subdued and milky even when viewed against a strong light. As the film dries, however, the opalescence disappears and the colours become truly transparent.

Faults and their causes

The faults that arise in colour films and the causes of them vary according to the make of film. The following are typical of Ektachrome materials processed in E3 chemicals.

125

All colours dark and degraded: First development too short, or temperature too low, or first developer nearly exhausted. This fault can also be due to underexposure.

Film almost opaque: Omission of bleach or fixing bath. Always make sure that you have the instructions by you when processing and never rely on your memory.

All colours too light: First development too long, or temperature too high, or too much agitation. This fault can also be due to over-exposure.

Dark green weak negative picture: First developer and colour developer interchanged.

Dark brown picture: Insufficient bleach-fix owing to too short immersion or exhausted solutions.

Red cast: Fogging of film by red light or omission of hardening bath or washing after hardening bath, or transfer from colour developer to bleach without intermediate wash.

Green cast: Fogging by green light, or first developer or colour developer contaminated by other solutions.

Magenta highlights: Clearing bath omitted. If the highlights are a light magenta, the rinse after the colour developer was insufficient or omitted.

Yellow cast: Fogging by yellow light or contamination of developer by bleach bath or too short bleach.

Blue cast: Omission of rinse after first developer, or, if most noticeable in denser image parts, contamination of first developer by tin (this can occur with repaired developing tanks).

Blue spots: Usually caused by chemicals (particularly the bleach bath) reacting with iron.

Emulsion frilling or reticulation: Water too soft. Add one gram magnesium sulphate per litre of water used to make up first and colour developers. Also caused by excessive washing or too high temperature of processing baths.

Magenta streaks or cloudy magenta areas: Insufficient agitation in first or colour developer.

Greenish-yellow shift in colour balance: Insufficient first development of daylight material owing to too short immersion, too little agitation or low temperature.

Magenta to blue shift: Overdevelopment of daylight material in first developer owing to too lengthy immersion, too high temperature or excessive agitation.

Greenish blue shift: Insufficient first development of artificial light material.

Red-yellow shift: Overdevelopment in first developer of artificial light material.

Additional causes of trouble with films processed in E4 chemicals are as follows:

All colours too light: Too short immersion in prehardener or first stop bath. If at the same time there is a shift towards cyan, the first developer could be contaminated with fixer. A reddish-blue shift indicates contamination of the colour developer.

Red cast: Wrongly constituted colour developer or iron contamination of prehardening bath.

Yellow-green cast: Colour developer alkalinity too high.

Reticulated Image

Magenta highlights: Second stop bath exhausted or followed by insufficient rinsing.

Magenta-blue shift: Colour developer exhausted or diluted or insufficiently alkaline.

Yellow cast: Wrongly constituted prehardener. Intense yellow indicates exposure through film base.

Cyan colour shift: Contaminated first developer.

Emulsion frilling or reticulation: Insufficient prehardening. Rinsing after prehardening too long or temperature of rinse too high.

These causes of faults with E4 processed films are in addition to those quoted for E3-processed films. It will be noticed that in all cases the faults are always caused by faulty work by the processor. If the manufacturer's instructions are followed precisely (and they are always given in full detail), none of these faults can occur.

Agfa films for user processing

Rivals to Ektachrome's popularity as a user-processed film are the Agfa-Gevaert colour slide films. These are available in both daylight and artificial light versions in roll, 35mm and sheet film sizes. The daylight film is balanced for 5500K lighting (corresponding to 18 decamireds) and the artificial light film to 3100K (corresponding to 32 decamireds).

Layer construction of Agfacolor Slide film

Unexposed film	Developed film
1 Gelatine protective layer	Gelatine protective layer
2 Blue sensitive layer	Yellow dye stuff
3 Yellow filter layer	Filter layer
4 Green sensitive layer	Purple dye stuff
5 Gelatine protective layer	Gelatine protective layer
6 Red sensitive layer	Blue/green dye stuff
7 Anti halation* layer	Colourless anti halation layer
8 Film base	Film base
9 Anti-curl layer	Anti-curl layer

* Light screening

The total thickness of the layers 1–7 in this table amount to about 1/500mm. Rollfilm is 0·10mm thick, 35mm film 0·13mm and sheet film 0·20mm.

128

The daylight film is intended to be given exposures between 1/30 and 1/1000 second for perfect colour reproduction. Longer exposures may result in a colour shift towards yellow or yellow green, while shorter exposures may cause colours to show too much blue content. If these deviations do occur they should be corrected by using compensating filters whenever such exposures are necessary.

If the artificial light film is exposed for longer than 10 seconds (60 seconds for the sheet film) there may be a tendency to show a colour shift towards yellow, yellow-green or yellow-red. Again, filters can be used to compensate.

Procedure for Agfa films

The manufacturers supply chemicals for the processing of Agfacolor films in various packs, generally as a complete kit in the small quantities but larger quantities of each constituent are available separately.

The procedure, assuming a temperature of 68°F (20°C), is as follows:

The first developer time is 18 minutes, followed by a rinse of 15 seconds. The film then goes into a stop bath for 4 minutes, after which all processing can be carried out in normal lighting. A 10-minute wash after the stop bath precedes the re-exposure. This is best carried out by exposing each side of the film to a 500-watt bulb for one minute. A 14-minute immersion in the colour developer is followed by a 20-minute wash before bleaching the film for 5 minutes. Then the film is washed for 5 minutes and fixed for 5 minutes. The final wash is for 10 minutes and is preferably followed by a one-minute immersion in a bath containing wetting agent before drying.

The developing solutions should be discarded within two weeks from their first use.

Agfacolor films can also be specially processed to increase their effective speed by increasing the first development time. Generally, however, this causes a colour shift towards yellow green and reduces the colour saturation.

Prints from negatives or slides

Colour print film processing can also be carried out by the user and is, indeed, rather more straightforward than colour slide film processing. Colour print film was originally produced to meet the demand for copies and enlargements. Since then, however, developments in the colour photography field have made multiple

reproduction possible in various ways, so that it is no longer the prerogative of the negative-positive process. Duplicate slides can be produced quite easily, even by the amateur, and processing laboratories can make prints from slides at reasonable cost.

Thus, we have the following possibilities:

1 Starting point **Colour print film**

Colour positive (print) Colour positive (slide)

It is also possible to make black-and-white prints from colour materials but for correct tonal reproduction the emulsion on which the print is made should be fully panchromatic.

2 Starting point **Colour slide film**

Interim stage **Intermediate colour negative**

Colour print or slide Colour Colour slide
on reversal material print

Some of these processes are best left to the laboratories. Reversal print material, for example, is expensive and it is not easy to produce colour prints direct from colour slides. Similarly, the production of intermediate colour negatives from slides calls for some skill. Colour slides can be duplicated without too much difficulty and various duplicating attachments are available for single-lens reflex cameras.

Perhaps the most rewarding opportunities for the amateur, however, lie in the processing of colour print films and the production of colour prints from the resulting negatives.

Meaning of "chrome" and "color"

Some manufacturers use a code of recognition to differentiate between colour print and colour slide film. They use the suffix "chrome", as in Ektachrome, Kodachrome, etc, for colour slide film and "color", as in Kodacolor, Ektacolor, etc, to indicate colour print film. Agfa-Gevaert use the same system in most countries, so that their colour slide film is known as Agfachrome. In Britain, however, the popular version is still known as Agfacolor, while some professional versions are known as Agfachrome.

This terminology sometimes extends to papers and other print materials, too. Ektachrome paper, for instance, is a reversal materali producing a direct positive from a positive. Ektacolor is a normal emulsion producing a positive from a negative.

It was the Agfa company who started the custom of calling colour print film "universal", to draw attention to the fact that this

film can be used to produce all types of positives—colour print, colour slide and black-and-white print. As we have remarked, this is not now so important, because most laboratories will also produce all positive versions from colour slides.

Processing of Ektacolor and Kodacolor films

Ektacolor professional films and Kodacolor-X, the popular colour print film, are processed in Kodak's C22 chemicals. These comprise developer, stop bath, hardener, bleach and fixer. The processing steps are shown in the table below.

Bath	Remarks	Temperature °C	Treatment in mins	Total mins
1 Developer	Observe agitation instructions	$24 \pm \frac{1}{4}$	14	14
2 Stop bath	Agitation as described later	23–25	4	18
3 Hardener	Agitation as described later	23–25	4	22
The film can be handled under normal light after the hardening bath				
4 Wash	Running water	23–25	4	26
5 Bleach	Attention: bath attacks metal	23–25	6	32
6 Wash	Running water	23–25	4	36
7 Fixer	Agitation as described later	23–25	8	44
8 Wash	Running water	23–25	8	52
9 Wetting agent		23–25	maximum 1	53
10 Dry		Not over 45		

The aim of agitation during processing is to disperse air bubbles that may have formed when the solution was poured in and to keep the solutions circulating so that solution adjacent to the film does not become exhausted or weak. The normal method of agitation is to invert the tank and allow some solution to drain into the lid

131

before returning it to its original position. It is important, however, to follow the film manufacturer's instructions precisely. Too little or too much agitation can have a significant effect on colour density and purity. Similarly, the baths must be maintained at the stipulated temperatures.

Faults and the use of filters

We cannot list all the faults that may occur in a colour negative, because many of them are not recognizable until a colour print has been made. The print may, for instance show a considerable green cast, which draws attention to the fact that the negative has a red cast. This may not have been immediately apparent in the film owing to the masking dye now incorporated in most colour print films.

The red cast in the negative can be caused by overdevelopment, contaminated developer or exposure of the film to green light.

When such casts show up in a colour negative, there is a tendency to blame them on failure to use the appropriate filter. This is virtually never true because filters are very rarely required with colour print films. The professional might use them when he seeks a particular result or when he has to expose the film in particularly unsuitable lighting, such as, for example, low power tungsten lamps. Kodak recommend four particular light balancing filters to adjust the lighting to the sensitivity of Ektacolor film:

DARKROOM

Do Not Disturb
AWAIT
DEVELOPMENTS

Wratten filter	80A	blue	factor 2
	80C	blue	$1\frac{2}{3}$
	81A	yellowish	$1\frac{1}{3}$
	85	orange	$1\frac{2}{3}$

The factor indicates the effect the filter has on the exposure. As any coloured filter absorbs some light, additional exposure is required and the factor tells you how much extra exposure to give. As the factors are mathematically calculated, however, they sometimes need rounding off. The $1\frac{1}{3}$ factor above, for instance, can only be translated as an extra half-stop in practice.

Agfa films and chemicals

Agfacolor colour print film is another type particularly suited to processing by the user. Chemicals are available in quantities suitable for amateur use and the standard packs include the colour developer, intermediate bath, bleach and fixer. The made-up developer keeps for about six weeks in a full bottle but once used it will not keep for more than a few days. It is therefore advisable to divide the made-up solution into quantities equivalent to the tank capacity and to store them in separate smaller bottles.

The developer should not be used immediately after it is made up. Agfa-Gevaert recommend that it should stand for at least twelve hours and should therefore be made up the day before it is required. The developer can also cause a rash on sensitive skins and, if any such tendency is noticed, rubber gloves should be worn. If the hands should come into contact with the developer, they should be washed in a 2 per cent solution of acetic acid and then thoroughly rinsed in water.

The recommended temperatures for the solutions should be strictly adhered to, particularly for the developer, for which the tolerance is no more than half a degree Centigrade. It is important to monitor temperatures in the tank and to warm the tank before putting the first solution in. A cold tank can lower the temperature of the solution rapidly.

Darkroom illumination

The film must be loaded into the tank in total darkness but there are daylight loading tanks for those who find it difficult to get the film into the spirals now universally used for roll and 35mm films.

Generally, it is unwise to rely on darkroom lamp illumination when handling colour films but, if absolutely necessary, the special dark green safelights, such as the Agfa-Gevaert G6, can be used for the briefest inspection. The bulb fitted must not be more powerful than 15 watts and it must not be nearer the film than 30 inches.

Procedure for Agfacolor films

The developing time in the Agfa colour developer at 68°F (20°C) for Agfa colour print film is eight minutes. Longer development will produce a negative leading to a contrasty print with poor definition in the highlights and distorted colour. Too short development produces flat negatives leading to prints of rather dull and indeterminate colour.

At the end of the development time, the developer must be

133

emptied from the tank as rapidly as possible. Any developer adhering to the film while you pour the rest out continues to work and can lead to overdevelopment—and sometimes patchy overdevelopment, which is even worse. Therefore, when buying a developing tank, make sure that it can be emptied within a few seconds.

The developer is followed by the intermediate bath, in which the film is immersed for four minutes, and a thorough washing for 14 minutes. Next comes six minutes in the bleach bath which, like the colour developer and intermediate bath must be kept within half a degree of 20°C. A further six-minute wash ensues before the film is fixed for six minutes and then finally washed for ten minutes. To facilitate even drying, the film is then immersed in a bath containing wetting agent. During the drying stage the film should be protected from draughts (which may carry dust, etc) and from temperature variations. It is best to let the film dry at normal room temperature. Induced heat, except in a properly designed drying cabinet, can cause uneven drying that may leave ineradicable marks in the emulsion.

The following table sets out the processing steps for Agfacolor negative film.

Processing bath	Time in mins	Temperature °C	Keeping qualities of fresh bath
1 Developer	8	20 ± 0.5	6 weeks
2 Intermediate bath (with 3% developer added)	4	20 ± 0.5	6 weeks
3 Wash	14	17 ± 3	
4 Bleach	6	20 ± 0.5	3 months
5 Wash	6	17 ± 3	
6 Fixer	6	20 ± 1	3 months
7 Wash	10	17 ± 3	
8 Wetting agent	1	20 ± 1	1 week

Speed increase with Neofin Color

There is a special developer—Neofin Color, by Tetenal—which allows Agfacolor CNS, normally rated at 80 ASA, to be exposed at 160 ASA. The processing steps are then:

1 Developing 8 minutes at 20°C
2 Intermediate wash 10 minutes

3 Stop-fix	10 minutes
4 Add bleach and then Bleach-fix	20 minutes
5 Final wash	15 minutes

The 20-minute bleach-fix provides normal contrast and mask density. If only a light masking is required, the bleach-fix can be cut to 10 minutes.

Processing hints and tips

The amateur developing his own colour films nearly always uses a small tank and handles only one film at a time. The tank needs relatively small quantities of solutions. It is therefore just as well to throw the developer away after one use, so that the storage bottle always contains fresh solution.

Underexposed colour print films can be corrected by extending the development. In such special cases, and also to obtain greater contrast, the developing time for Agfacolor, for example, can be increased to 12 minutes.

The wash after development should not be curtailed. It is intended to remove virtually all the developer chemicals from the emulsion because, if any significant quantity of these chemicals remains, it will continue to work on the exposed halides in the emulsion and bring about unpredictable results.

The developing tank must be washed between baths as well as

the film. Otherwise it can carry over chemicals from one bath to another and lead to all sorts of troubles that cannot be corrected.

Colour films are frequently said to be grain-free. The emulsion does, in fact, contain silver halides that are converted to metallic silver in exactly the same way as in a black-and-white film. The colour dyes are formed in the vicinity of the silver grains and the structure of the image is, therefore, granular. Because the colours are transparent, however, the graininess is not so obvious as in the black-and-white film and, in the colour print, the colour outweighs the tonal contrast between grain and paper base so that the colour print *looks* less grainy than the black-and-white print.

As colour negatives need to be stored against possible future demands for prints it is as well to protect them against mishandling that may cause blemishes in the prints. The enlargement usually required can make even the smallest blemish on the film look enormous on the print.

There are various film lacquers available to afford this protection. Agfa produce one which can be tipped into a basin so that the film can be drawn slowly through it. The time in the lacquer should not, however, exceed 20 seconds. After lacquering, the film should be hung up to dry in a completely dust-free atmosphere and no naked flame should be taken near it. The lacquer is inflammable.

Printing
from Colour Negatives

Enlarged colour prints can be made from both colour negatives and colour slides. Black and white prints can also be made from colour negatives. The amateur *can* undertake this work without any specialized equipment but a very useful item is an enlarger with a filter drawer (see page 139) and various other accessories are advisable if reasonable results are to be obtained.

In principle the construction of negative and positive colour materials is the same. Practical experience with positive materials, however, led gradually to some modifications in their structure. In Agfacolor paper and positive film, the yellow filter layer has been eliminated and the sequence of the emulsion layers changed. The layers of Agfacolor papers are now as follows:

Layer sensitive to:	Protective layer	Colour produced:
Red		Cyan
Green		Magenta
Blue		Yellow
	Paper base	

Making black-and-white prints

Black-and-white prints can be produced directly from colour negatives in exactly the same manner as from black-and-white negatives. This is very useful for the amateur because the process is simple and the costs are low, particularly if several copies are required from the one negative.

Normal enlarging paper is virtually colour blind. It reacts only to light at the blue end of the spectrum, including some green. Thus, a black-and-white print from a colour negative may show some inaccuracy in tonal values. Also, the colour mask of the colour negative prolongs the exposure required.

For this reason, Kodak market Panalure—a special paper for black-and-white printing from colour negatives. Panalure is a panchromatic paper—sensitive to light of all colours, so that tonally correct black-and-white prints can be produced.

Panalure should preferably be processed in complete darkness but a Wratten No. 10H safelight filter in front of a 15-watt bulb can be used at no less than 4 ft from the paper.

The enlarger light source for Panalure paper should be an opal incandescent lamp. Cold cathode or similar light sources distort the tonal values and have to be used in conjunction with a colour compensating filter.

When processing Panalure paper, the safelight, if used, should not be switched on until the print has been in the developer for 30 seconds. It is best to work in total darkness, standardizing your procedure so that the developing time is always the same. The recommended time is 2 minutes at 68°F.

The most suitable developer is D163, diluted 1:3. This gives a normal warm-black tone. Lower contrast is given by Soft Gradation developer, diluted 1:3.

Colour printing materials and methods

The paper used to produce colour prints is a multi-layer material and should be handled either in total darkness or by the very dim recommended safelight. Full instructions are always packed with the paper. Technical leaflets can also be obtained from the manufacturers.

The materials required for the production of colour prints from colour negatives are different from those required for colour slides. Kodak's materials, for example, are Ektacolor paper for negative material and Ektachrome paper for slides.

Colour printing from colour negatives is becoming increasingly popular and, although the processing steps have to be rigidly controlled to ensure acceptable results, there is still some room for individual experiment.

Printing can be effected by additive or subtractive methods. The subtractive method has by far the greater following. It involves a single exposure of the paper to "white" light, i.e. a tungsten lamp in an enlarger. When the negative is placed in the enlarger it absorbs varying amounts of red, green and blue light according to

the colours in the image. To adjust this absorption to the colour sensitivity of the paper so that the colours of the original can be correctly reproduced filters are also placed in the light beam of the enlarger. The filters are accommodated in a filter drawer or tray situated above the condensers.

Many of the normal black-and-white printing adjustment methods can be used in colour printing, such as shading, burning in, dodging, etc. Special colour effects can also be introduced by the imaginative use of filters.

In the additive process, three separate exposures are made through red, green and blue filters.

Colour printing filters

The filters used for subtractive colour printing should preferably be those supplied by the manufacturer of the colour paper. You need a set of filters in various densities of yellow, magenta and cyan. Kodak supply sets known as CC and CP filters.

CP (colour printing) filters are available as acetate sheets in various sizes. The densities supplied are expressed as 05, 10, 20, 40. Additionally a UV filter 2B is available and remains permanently in the filter drawer.

The filters can be mounted in glass for protection but if you decide to do so, make sure that you employ the same type and thickness of glass for all filters.

CC (colour compensating) filters are intended for the camera and, being made from gelatine, are more expensive. They can be applied in colour printing but the amateur will find the cheaper acetate variety adequate.

The general use of the terms "subtractive" and "additive" colours is more a matter of convenience than fact. We talk of yellow, magenta and cyan as subtractive colours and red, green and blue as additive. These colours are, in fact, complementary to each other in the following way:

Yellow is the complementary colour to blue.
Magenta is the complementary colour to green.
Cyan is the complementary colour to red.

To obtain the additive colours, the subtractive colours are mixed as follows:

Yellow and magenta make red.
Yellow and cyan make green.
Magenta and cyan make blue

Typical sets of CP and CC filters

The following table shows some of the available filters.

CP Filters for subtractive system

Yellow	CP 05Y	CP 10Y	CP 20Y	CP 40Y		
Magenta	CP 05M	CP 10M	CP 20M	CP 40M		
Cyan	CP 05C	CP 10C	CP 20C	CP 40C		

CC filters for subtractive system

Yellow	CC 05Y	CC 10Y	CC 20Y	CC 30Y	CC 40Y	CC 50Y
Magenta	CC 05M	CC 10M	CC 20M	CC 30M	CC 40M	CC 50M
Cyan	CC 05C	CC 10C	CC 20C	CC 30C	CC 40C	CC 50C

CC filters for additive methods

Blue	CC 05B	CC 10B	CC 20B	CC 30B	CC 40B	CC 50B
Green	CC 05G	CC 10G	CC 20G	CC 30G	CC 40G	CC 50G
Red	CC 05R	CC 10R	CC 20R	CC 30R	CC 40R	CC 50R

The filter designations are therefore self-explanatory in that the two figures express the density and the following letter the colour. To standardize the procedure the filters required are always given in the order yellow, magenta, cyan so that when all three are quoted there is no need to use the colour identifying letter.

The filtration required differs from negative to negative and from batch to batch of colour paper. It is therefore always wise when making colour prints to compile complete records of each exposure, giving the composition of the filter pack (i.e. the filters placed in the filter drawer), the exposure time and the lens aperture.

Effect of filter on exposure

Naturally, the exposure time is affected by both the density and the colour of the filter. The effect of each filter can be expressed as a factor.

When more than one filter is used the filter factor can be found in the following table. The table is based on two filters. When more than two filters are used, you first ascertain the factor for two filters and then treat that factor as one filter to consult the table again, and so on.

Filter factors for Kodak CC and CP filters

Colour	Density					
	05	10	20	30	40	50
Yellow	1·1	1·1	1·1	1·1	1·1	1·1
Magenta	1·2	1·3	1·5	1·7	1·9	2·1
Cyan	1·1	1·2	1·3	1·4	1·5	1·6

Factors for two or more filters

Filter factor	1.1	1.2	1.3	1.4	1.5	1.6	1.7	1.8	1.9	2	2.1	2.2	2.3	2.4	2.5	2.6
1.1	1.2	1.3	1.4	1.5	1.6	1.7	1.9	2	2.1	2.2	2.3	2.4	2.5	2.6	2.7	2.8
1.2	1.3	1.4	1.5	1.7	1.8	1.9	2	2.1	2.3	2.4	2.5	2.6	2.7	2.9	3	3.1
1.3	1.4	1.5	1.7	1.8	1.9	2.1	2 2	2.3	2.4	2.6	2.7	2.8	3	3.1	3.2	3.4
1.4	1.5	1.7	1.8	2	2.1	2.2	2.4	2.5	2.6	2.8	2.9	3	3.2	3.4	3.5	3.6
1.5	1.6	1.8	2	2.1	2.2	2.4	2.5	2.7	2.8	3	3.1	3.4	3.6	3.7	3.9	4
1.6	1.7	1.9	2.1	2.2	2.4	2.6	2.7	2.9	3	3.2	3.3	3.5	3.7	3.8	4	4.2
1.7	1.8	2	2.2	2.4	2.6	2.7	2.9	3.1	3.2	3.4	3.5	3.7	3.9	4	4.2	4.4
1.9	2	2.3	2.4	2.6	2.8	3	3.2	3.4	3.6	3.8	4	4.2	4.4	4.6	4.7	4.9
2.1	2.3	2.5	2.7	2.9	3.1	3.3	3.6	3.8	4	4.2	4.4	4.6	4.8	5	5.2	5.5

Cancelling out superfluous filters

Filter combinations should consist of only two colours because where three filters are concerned, there will always be excess density. We are concerned with extracting varying amounts of light of the three components from white light. If we extract equal quantities of yellow, magenta and cyan, we are still left with white light, but of less brilliance. So, whenever our trial exposures lead to a filter pack containing all three colours we can always cancel out equal amounts of each colour to leave only two. Thus:

$$15Y + 30M + 10C$$
$$-\quad 10\quad\ \ 10\quad\ \ 10$$
$$05Y\quad 20M\quad -$$

We are left, therefore, with a yellow filter of 05 density and a magenta filter of 20 density. The 10Y, 10M and 10C we have cancelled out would simply have dimmed the brilliance of the light without affecting its quality. The factors of the two remaining filters are 1.1 for the yellow and 1.5 for the magenta so that the

combined factor as shown in the table above is 1.6. Thus, the exposure time for an exposure without filters should be multiplied by 1.6 to determine the exposure required with these two filters.

Processing conditions for Ektacolor

Processing of Ektacolor papers is carried out in the usual manner. It goes without saying that every precaution must be taken to keep the dishes clean and to maintain the stipulated solution temperatures. The paper is sensitive to light of all colours and should therefore be exposed to the darkroom safelight only for the briefest periods. The safelight is the Wratten No. 10H, which should not be used closer than 4ft from the material with a 15-watt bulb. The safe time is then said to be two minutes. If the safelight is 7 feet away the paper can be exposed to it for four minutes.

The quality of colour prints depends to a great extent on the cleanliness and freedom from dust of all optical parts, carrier glasses, etc. of the enlarger. The negative should be masked down to the area actually being printed to exclude stray light.

The voltage of household electricity supplies tends to fluctuate. Such fluctuations influence the colour temperature of the enlarger light source and can therefore make the filtration inaccurate. If you intend to make colour prints regularly and are anxious to obtain the best and most consistent results possible, you should consider buying a voltage stabilizer.

Batch-to-batch sensitivity variations

Colour papers are multilayer materials and the sensitivities of the three light-sensitive emulsion layers are very carefully balanced. Nevertheless, small variations between each manufacturing batch are unavoidable. Therefore, each batch contains an indication of its sensitivity balance so that it can be compared with other batches. This allows you to calculate the alterations required in exposure time and filtration for a negative previously printed on another batch.

So, when you change to a fresh batch of paper, read the filter correction instructions on the old packaging. The figure values may contain plus or minus signs. With Ektacolor paper, the following calculations are required to obtain the new filter values:

 Old filtration
 − Old filter correction
 + New filter correction
 = New filtration

As an example, assume that the old paper package bore the correction −15Y and −10M. To use these figures for calculating the filtration we must transcribe them as follows:

−15Y (equal to 15 blue) =	− 15	15
−10M (equal to 10 green) =	10 −	10

Another example:

+10Y (equal to 10 yellow) =	10 −	−
−20M (equal to 20 green) −	20 −	20

Correcting colour casts

This method of calculation is easily understandable if we remember the connection between colour cast and the filter correction required. We can either take away the filter or add one, as the following table shows:

Colour cast and filter correction

	To correct		
Colour cast	Remove filter	OR	Add filter
Yellow	Magenta + Cyan		Yellow
Purple	Cyan + Yellow		Magenta
Cyan	Yellow + Magenta		Cyan
Blue	Yellow		Magenta + Cyan
Green	Magenta		Cyan + Yellow
Red	Cyan		Yellow + Magenta

If a colour print looks too green, you have a green cast and the remedy is to remove a magenta filter from the filter pack or to add a cyan and a yellow filter. This is understandable if we refer back to the diagram on page 137 showing the sensitivity of the three emulsion layers.

Batch-change calculations

To change from one batch of paper to another we must, with Ektacolor paper, make the calculations shown in the following table to avoid having to start again from scratch to discover the required filtration and exposure. Assume that the correction figures for the old batch of paper were −05Y, −15M. Assume that the

negative concerned was printed with a filtration of 40, 30, —. Assume, however, that the new paper has correction figures of −05Y, +10M.

Correction figures for old emulsion −05Y =	—	05	05
−15M =	15	—	15
	15	05	20
− Excess density or grey value	05	05	05
	10	—	15

Correction figures for the new emulsion −05Y	—	05	05
+10M	—	10	—
	—	15	05
Old filtration	40	30	—
+ grey value	15	15	15
− Correction figures for old emulsion	10	—	15
	45	45	—
+ Correction figures for new emulsion	—	15	05
	45	60	05
− Grey value	05	05	05
New filtration	40	55	—

You will notice that in this calculation we have had to use a "trick" to get out of an impossible situation. When we came to subtract the figures for the old emulsion from those for the old filtration, we found that there was no density in the cyan column from which to subtract the 15C of the correction figures. Such situations often arise in these calculations but we overcome them simply by making use of the fact that we can always add or subtract the same density from each filter value without altering the effect the combination has on the colour of the light. All it does is to affect the brilliance of the light because three filters of equal value take out an equal quantity of each colour and leave the balance the same. So, in this case we added the required 15 to the cyan column and, to balance it, added 15 to the yellow and magenta columns as well.

To calculate the exposure time for the new emulsion, we use the formula:

$$\text{New exposure time} = \text{old exposure time} \times \frac{\text{new exposure factor}}{\text{old exposure factor}}$$

Storing Ektacolor paper

Warmth and dampness are the enemies when storing Ektacolor papers. They keep best in a refrigerator at 4–10°C, but must be taken out and allowed to reach room temperature before being used. This will take at least half an hour. If you neglect this precaution the warmer air of the darkroom may condense into water droplets on the paper. After the printing session, any remaining paper must be carefully resealed in its foil container and returned to the refrigerator.

Procedure with Ektaprint C process

Kits of chemicals are available for colour print processing and the various baths must be made up strictly in accordance with the instructions contained in the kit. The instructions also set out the processing steps and these, too, must be followed exactly as to temperature of solutions and duration of each bath.

For the Ektaprint C process, Kodak formulate two procedures. The times quoted in these procedures include 20 seconds for draining of solutions and the papers should therefore be removed from the bath correspondingly early or, if a print tank is used, the emptying time must be allowed for (see table overleaf).

Ektacolor printing faults

The faults that can arise in the printing of Ektacolor papers are usually due to over- or under-development. Over-development produces pictures that are too dark and emphasizes graininess, which can also be caused by insufficient time in the stop-fix bath.

Bath	Procedure I			Procedure II		
	Temp (°C)	Time (min)	Total (min)	Temp (°C)	Time (min)	Total (min)
1 Developer	30 ± ¼	7	7	30 ± ¼	7	7
2 Stop-fix	29–31	2	9	23–25	2	9
After the stop-fix, remaining work can be done in normal light						
3 Wash	29–31	2	11	23–25	2	11
4 Bleach	29–31	2	13	23–25	4	15
5 Wash	29–31	2	15	23–25	2	17
6 Formalin-fix	29–31	2	17	23–25	3	20
7 Wash	29–31	4	21	23–25	8	28
8 Stabilizer	29–31	2	23	23–25	3	31
9 Dry	under 80			under 80		

Under-development leads to light-toned pictures and can also produce a reddish tint in the highlights. Bluish shadows can be caused by a weak or nearly exhausted bleach bath.

Colour spots can occur if the solutions become contaminated by intermixing or if the intermediate washes are not properly carried out.

Printing from slides

The production of colour prints from colour slides is effected on reversal paper, such as Ektachrome paper. All the general remarks we have made about Ektacolor printing apply equally to Ektachrome. The subtractive method is used with CP filters.

The method of using the filters is basically the same as with Ektacolor but the reversal paper calls for a reversal of filtration, too, as the following table shows.

Colour casts and filter correction for reversal process

Colour cast	To correct		
	Remove filter	OR	Add filter
Yellow	Yellow		Magenta + Cyan
Magenta	Magenta		Yellow + Cyan
Cyan	Cyan		Yellow + Magenta
Blue	Magenta + Cyan		Yellow
Green	Yellow + Cyan		Magenta
Red	Yellow + Magenta		Cyan

146

Filtration is effected in the usual way, with only two colours of filter at the most. If test strips and experiments result in the presence in the filter pack of all three colours the excess density (grey value) must be removed, as in the following example:

Calculated filtering	30	25	10
— Grey value	10	10	10
Filter pack	20	15	—

Ektachrome papers are reversal processed because the original is a positive and the result required is a positive. Therefore, if the paper is held in a masking frame in the usual way during exposure, we get black borders, not white. To obtain white borders, the edges of the paper have to be exposed to light with the image area completely covered.

Procedure with Ektaprint R process

Ektachrome papers are developed by the Ektaprint R process, which is practicable for the amateur only if he does a fair volume of work. Nevertheless, the process is interesting and is as shown in the following table.

Reversal developing with the Ektaprint R Process

Bath	Temp (°C)	Time (min)	Total time (min)
1 Pre-wash (1 min submerged, allow to drip for 2 min)	28–31	3	3
2 First developer	30±¼	3	6
3 First stop bath	28–31	2	8
Normal lighting can be used after this bath			
4 Wash	28–31	7	15
5 Reversal exposure			
6 Colour developer	38–31	4	19
7 Harden-stop	28–31	3	22
8 Wash	28–31	2	24
9 Bleach	29–31	4	28
10 Wash	28–31	4	32
11 Formalin-fix	28–31	4	36
12 Wash	28–31	10	46
13 Stabilizer	28–31	2	48
14 Rinse in running water	28–31	15 secs	48¼
15 Dry	70 maximum		

It is not always appreciated that colour slides can be made from colour negatives. There is an Ektacolor print film available for this purpose in 35mm form, but only in rather large quantities.

Agfacolor printing papers

The Agfa company also have products for making prints from colour negatives and slides. Agfacolor paper has a strong paper base and is supplied with a glossy surface in two sensitivity grades. The difference is in the relative sensitivities of the three layers.

Agfacolor CN111 paper is of similar sensitivity to normal black-and-white enlarging paper. The three layers have equal sensitivity. CN111 is designed for unmasked colour negatives and cannot be used with masked negatives.

Agfacolor MCN111 is about twice as sensitive as CN111. Sensitivity in the blue and green layers is increased to allow for the absorption of these colours by masked colour negatives. If CN111 were used with masked negatives, heavy filtration would be required and exposures would be impractically long. MCN111 can, however, be used with unmasked negatives if a mask substitute filter is included in the filter pack. This filter has the orange colouring of the negative mask. MCN111 can, therefore, with some justification, be called a universal paper.

Both papers require special darkroom lighting. CN111 requires the Agfa safelight filter 09 and MCN111 uses filter 08. The safelight lamp should be 15 watts and the distance between safelight

148

and paper should not be less than 70cm (30in). The paper should not be exposed even to this lighting for prolonged periods The maximum time permissible is three minutes. Any longer exposure will produce a pronounced blue cast in the lighter areas of the print. Such a partial cast cannot be eliminated.

Storage of Agfacolor papers

Agfacolor papers must be stored in cool, dry conditions. The high-sensitivity MCN111 paper, in particular, should be stored in a refrigerator. Before use, it should then be kept for at least two hours in normal room temperature before opening the package.

Once opened, the package must not be returned to the refrigerator unless all air can be expelled from it and the package resealed. Otherwise warm air trapped inside the package will condense on the paper, make it damp and so reduce its keeping qualities. In fact, in these conditions, it will have a shorter life than paper stored outside the refrigerator.

Agfacolor processing chemicals

The Agfa company supply kits for chemicals in small quantities for amateur use. The chemicals include colour developer, stop-fix, bleach-fix and stabilizer. The made-up developer will keep for about four weeks if unused but only for a few days once it has been used. Freshly made up developer is unsuitable. It must stand for about twelve hours.

The last stage of Agfacolor paper processing is a stabilizer bath. Formalin has to be added to this bath. A formalin solution of about 30% can be obtained from photodealers or chemists. About 80cc of this formalin solution should be added to one litre of stabilizer. The formalin keeps the white parts of the print clear and also allows prints to be heat-dried at up to 80°C.

Processing methods for Agfacolor paper

There are two processing methods—the normal and the warm. The normal process is carried out at 68°F (20°C), whereas the warm process temperature is 77°F (25°C). The following table shows the steps in the two processes.

It is vital with both processes that prints are not washed *after* the stabilizing bath. The final wash comes before the stabilizer.

Processing of Agfacolor paper by the normal process

Bath	Time (min)	Temp (°C)	Capacity (9 × 13 cm sheets per litre)	Keeping time for fresh solution
1 Developer	5	20±½	50	4 weeks
2 Wash	2½	17±3	—	—
3 Stop-fix	5	20±1	150	3 months
Normal lighting can be used after this bath				
4 Bleach-fix	5	20±1	150	3 months
5 Wash	10	17±3	—	—
6 Stabilizer + formalin	2½	20±1	150	3 months

Processing of Agfacolor paper by the warm process

Bath	Time (min)	Temp (°C)	Capacity (9 × 13 cm sheets per litre)	Keeping time for fresh solution
1 Developer	3	25±½	50	4 weeks
2 Wash	2	17±3	—	—
3 Stop-fix	3½	23±2	150	3 months
Normal lighting can be used after this bath				
4 Bleach-fix	3½	23±2	150	3 months
5 Wash	6	17±3	—	—
6 Stabilizer + formalin	2	23±2	150	3 months

Agfacolor printing filter sets

The filter set for Agfacolor paper consists of eight filter foils of various densities in the colours yellow, magenta and cyan. Two of the densest foils in the set are supplied in each colour to enable a variety of combinations to be made. The filters are marked with two-digit numbers to indicate their density. The sequence is 05-10-20-30-40-50-99-99.

The filters must be very carefully handled and protected against dust, fingermarks, excessive exposure to light and high temperatures in the enlarger.

There are also filter sets available in which the foils are placed

between glass plates. These have a different range of densities, as follows:

05-10-20-30-40-50-60-70-80-99

There is an accepted method of quoting colour print filtration. Densities are always expressed by two-digit numbers. Hence the highest value is shown as 99 instead of 100. The colours, when referring to a single filter are expressed by the single letters Y for yellow, M for magenta and C for cyan. When the composition of a filter pack is mentioned, however, the letters can be omitted because the filtration is always stated in the same order: yellow, magenta, cyan. Thus 40 20 10 means 40Y 20M 10C. This would actually be quoted, however, as 30 10 —, or 30 10 00, because 40 20 10 contains an excess 10 density of each filter, which does nothing but dim the light.

Making the zero print

The first experiment in printing can be a so-called zero print in the form of a test strip. This uses no filters and simply serves as an indication of the exposure time and the type of filtration likely to be required.

To make the zero print, the colour negative is placed in the enlarger and the required image area is focused on the baseboard. A generously-sized strip of colour paper is cut from a sheet, placed on the enlarger baseboard and exposed piece by piece so that it receives exposures of say, 3, 6, 12, 24 and 48 seconds, i.e. doubling the time at each step. The strip is fully processed and examined to decide which part received the correct exposure.

It is unlikely that the zero print will show satisfactory colouring. The usual result is an all-over colour cast. The task then is to decide on the nature of this colour cast. At first, the answer may not be obvious but, with practice, the determination of a colour cast becomes easier. It is also simplified if a comparison can be made between a known colour in the original and its reproduction on the print. The object is to determine whether the colours in the print contain too much red, green or blue, yellow, magenta or cyan. Having decided that, we can consult the table on page 143 to obtain the colour of the correcting filtration required.

Then we have to make a further test to determine the density of the filter.

The first test strip with filters should give a result at least approaching the result required but some further correction may still be necessary. The filters used may not be strong enough, or they may be too strong, or they may be unbalanced, i.e. one correct

but one too strong or too weak. The result may be a cast of a different colour which the experienced printer may know how to correct but which may require the beginner to make yet another test.

Eliminating "grey value" filters

As these tests proceed you must remember that you should never use filters of all three colours together. When you do that, you have the equivalent of one "layer" of filtration consisting of equal densities of all colours, on which another layer is superimposed containing two filters only. The component of this filtration consisting of all three colours does nothing but dim the light because it represents a neutral grey density that has no effect on the colours. So, when your tests indicate that all three filters are necessary, you subtract the filter values representing this excess grey and use the two filter densities remaining, as follows:

Filtering indicated by test	30	10	20
Deduct grey value	10	10	10
Practical filter values	20	—	10

Filter density and exposure

As all coloured filters absorb light, the exposure time ascertained by means of the zero print now has to be recalculated according to the density of the final filtration. Tables are usually available with the filter sets or printing paper but a rule of thumb makes darkroom work easier:

If the density of a filter is raised in steps of 10, then for each increase, the exposure time is increased by about 5 per cent with a magenta filter, about 10 per cent with a cyan filter and nil with a yellow filter.

If you overdo the filtering and use a filter that is too dense, the nature of the colour cast changes, becoming complementary to its original colour. This should not lead you to introduce a filter of the colour of the new cast but to reduce the density of the filters in use.

Is colour processing worth the effort?

These last two chapters have been devoted to a discussion and explanation of colour processing methods. The aim, however, has not been to recommend that the amatuer should undertake all these processes himself. We have merely indicated the nature of the work involved so that the individual can decide for himself where his interests lie and how much of the work he thinks it is worth doing for himself.

Above all, we must emphasize that these chapters are not intended to contain precise instructions for the use of particular material. It is vital that anybody undertaking colour processing of any kind, follows the detailed instructions supplied by the manufacturers of the materials he uses. These chapters have explained the nature of and the reasons for the various steps in the processes so that the user can understand what he is doing and thereby maintain his interest.

They may even lead him on to make experiments for himself. There is plenty of scope in colour processing for individual initiative but before you can exercise that initiative you have to know how the process works. That has been the aim of these chapters and, indeed, of the whole book.

Glossary
of Technical Terms

A

Absorption

An object on which light falls, absorbs part of the light and reflects the rest. It is the nature of the reflected light that determines the colour of the object. When no light is reflected, i.e. all light beams are absorbed, the object appears black. When the various wavelengths of the incident light are absorbed differentially, the object appears to have a definite colour.

Accessory shoe

Many cameras are fitted with a flat, lipped plate which is primarily designed to hold a flashgun or flash head. Sometimes it has a centre contact wired to the shutter so that flashguns designed for the purpose can be connected to the camera without the usual synchronizing lead and socket.

Aerial perspective

Distant views frequently show a bluish haze that enhances the perspective effect but tends to obscure detail in the distance. In some colour photographs this haziness is thought undesirable and is eliminated or reduced by the use of a skylight or haze filter.

Angstrom unit

The wavelength of light is sometimes measured in Angstrom units, of which there are ten million in one millimetre, and ten in a nanometre (10^{-9}m), which is now tending to become the universal unit. The eye absorbs light only in the region 400–500nm.

154

Angular field

Lenses are designed to cover (i.e. produce a sharp, undistorted, evenly illuminated image of) a certain area which subtends an angle at the lens largely dependent on the focal length. The angle covered influences the description of the lens as standard, wide-angle or long focus. The angle is usually expressed on the diagonal of the film format to avoid the confusion of two angular fields for rectangular formats. The standard lens has an angle of 40–50°. Anything much larger is regarded as a wide-angle lens. A lens with a narrower angle of view is regarded as long-focus or telephoto.

Aperture

The aperture of a lens is a diaphragm forming a variable opening which controls the amount of light allowed to pass through the lens to the film. Although the opening is usually infinitely variable, it has, on most cameras, several fixed settings marked by numbers from the series 1, 1.4, 2, 2.8, 4, 5.6, 8, 11, 16, 22. The smaller the number, the more light the lens transmits and at each of these settings it transmits twice the light passed at the next smaller (larger number) setting.

Reducing the size of the aperture also increases the depth of field, i.e. the distance between the nearest and farthest points in the subject reproduced sharply in the focal plane.

Artificial light

Various meanings are attached to this term in photography. Literally it covers all forms of light not provided by the sun, moon or other natural phenomen. It tends to be more narrowly used, however, to indicate studio lamps, photofloods and, perhaps, domestic lamps used in a photographic set up. Flash is generally regarded as a form of lighting in itself and domestic lighting, street lighting, etc, is likely to be grouped with other normally encountered, not very brilliant forms of light as "available light". Colour films for artificial light use are made in two forms: Type A for photoflood lighting, which has a colour temperature of 3400K and Type B for studio lamps which has a colour temperature of 3200K. The difference is greater than these figures might seem to indicate and the use of a 3200K film in 3400K lighting generally leads to a noticeable colour cast.

ASA

Originally the initials of the United States national standards association, ASA is still used to indicate the system approved by that association for measuring the sensitivity of photographic emulsions.

Automatic diaphragm

Most modern lenses for SLR cameras have a diaphragm control that links with the shutter release. This allows the lens to remain at full aperture for

155

focusing and viewfinding but to close down to the preselected shooting aperture just before the shutter opens. When the shutter closes, the diaphragm automatically reopens to full aperture.

Automatic focusing

Some slide projectors feature a mechanism which automatically adjusts the focus of the lens for colour slides in mounts of differing thickness or when a slide "pops" under the influence of the heat from the projector lamp. Such projectors often also incorporate remote control of slide changing.

Automation

The automatic camera has a built-in light meter coupled either to the lens aperture or to the shutter. In most circumstances, this ensures trouble-free colour photography. In unusual lighting conditions, however, it is better to disengage the automatic control and revert to calculation of the exposure required.

B

Bulb or Brief time

A setting of the shutter which causes the shutter to remain open for as long as the shutter release is depressed.

Bacteria

Dampness in colour films mounted between glass can lead to the growth of bacteria, mould, fungi, etc. If these attack the emulsion, there is no cure. If they are merely on the surface, a proprietary cine film cleaner may remove them.

Ball and socket head

Many tripods are fitted with ball and socket heads to facilitate camera movement. The ball has a small platform and tripod socket screw to which the camera is attached. The camera can then be moved through a wide range of positions without moving the tripod.

Bellows attachment

With the help of a bellows attachment, the camera extension (distance between lens and film) can be lengthened to allow extreme close-up photographs to be taken. The bellows fits between the lens and the camera body and can, therefore be used only on interchangeable-lens cameras. Extension tubes serve a similar purpose and can even be used in conjunction with bellows.

156

Bleach bath

In processing, colour films first produce both a metallic silver and a dye image. The bleach bath removes the silver image so that only the dye image remains in the emulsion. The bath is sometimes combined with a fixer to provide a bleach-fix.

Blur

Any attempt to photograph moving objects at too slow a shutter speed (exposure time) results in blur, which must not be confused with unsharpness caused by bad focusing.

C

Cable release

A cable release is used to operate a camera shutter whenever it is vital to avoid any camera movement, i.e. in extreme close-ups or when a long exposure is necessary. The cable should not be too short and should never be held taut between shutter button and hand.

Camera shake

It is not as easy as it may seem to release the shutter of a camera without causing some movement of the camera itself. Any such movement causes some unsharpness in the picture. Naturally, the risk of camera shake is greater at slower shutter speeds and the evidence of it on the film is more pronounced with longer focus lenses. At any shutter speed slower than 1/125 sec it is advisable to take special care to hold the camera steady.

Capacitor

All modern flashguns use capacitors, once known as condensers, to store the electrical current required to fire the tube or bulb. The advantage of the capacitor is that it can build up its potential to give the high rapid discharge the flashgun requires. A battery, on the other hand, begins to lose its power immediately it goes into use and is soon unable to give a high-power discharge on demand.

Card mounts

The simplest method of mounting colour slides is to place them between sheets of thin card with openings cut in them so that the film is held between the cards by the edges and only the picture area shows. These mounts can be purchased in single units scored for folding across the middle and coated with a tacky adhesive. The outer measurements of the 35mm card mount are 2 × 2 inches, the standard size for slide projectors. Card mounts were once the more-or-less standard mount in which manufacturers returned processed films. They are now tending to be replaced by plastic versions of various designs.

Cartridge

The container in which 35mm film is loaded into the camera is sometimes called a cartridge. It is now more usual, however, to reserve this term to the larger construction used to house the instant-loading 126-size film. The 35mm film container is more often referred to as a cassette.

Cassette

Unlike rollfilm, 35mm film has no paper backing and has to be packed in a light-tight container known as a cassette. The cassette is loaded into the camera and, after all the film has been exposed, it is generally wound back into the cassette for unloading and storage before processing.

Chainpod

There are various substitutes for the tripod and the chainpod is one. It is simply a chain attached to the camera via the tripod socket. The bottom portion of the chain is allowed to lie on the ground and the photographer puts his foot on it, pulling upwards on the camera to obtain a steady hold.

Circular magazines

Some slide projectors are fitted with magazines in circular form which rotate as the slide is changed. With automatic slide-change facilities, they can thus provide a continuous show, as may be required for publicity purposes. The magazine must, however, be kept full.

Coating of lenses

All modern lenses have a microscopically thin coating on lens/air surfaces to increase the ratio of transmitted to reflected light. The coating is visible as a purplish or straw coloured tinge when the lens surface is viewed obliquely. This, however, is an interference effect and the coating is not actually coloured. It has no filtering effect on the lens.

Colour cast

Sometimes a colour photograph shows an overall bias towards a particular colour. This is a colour cast and can be due to unsuitable lighting, use of the wrong type of filter, reflection from a strongly coloured surface, etc. Reflections of this nature can also cause partial casts, as when a broad brimmed hat reflects its own colour on to the wearer's face. This type of cast cannot be eliminated except by removing the cause but overall casts can be combated by the use of filters, such as the UV filter to reduce the effect of ultra violet radiation in very clear air, or a conversion filter to allow artificial light film to be used in daylight.

Colour films

Two types of colour film are generally available: colour slide film, also known as colour reversal or colour transparency film; and colour print film, also known as colour negative. Some colour slide films are also available in two versions: one for use in daylight, the other for artificial light. The artificial light version may be intended for use with photofloods (Type A) or studio lamps (Type B). Each film has its own colour rendering and the user has to find the film that accords with his ideas of "good colour". Tastes differ in this respect. Colour film is generally slower (less sensitive to light) than black-and-white film, the popular versions having a speed of 50–80 ASA, but there are some faster versions available.

Colour memory

The average person cannot remember colours accurately. He is quite able to accept renderings of colours that depart considerably from the true colour if he has not the original in front of him for comparison. This is largely because we are used to seeing colours in various forms of lighting and to making mental adjustments that enable us to see those colours as we expect to see them. In tungsten lighting we accept white paper as white, although it is, in fact, distinctly yellowish.

Colour print film

Also known as colour negative film, this produces an image on the film that is negative both in tone and colour. Dark tones are light and vice versa and colours are represented by yellow, magenta and cyan instead of red, green and blue. There may also be a yellow or orange mask, overlaying all the colours.

The colour print film is subsequently printed on to a three-layer colour sensitive paper to produce colour prints.

Colour temperature

The colour quality of a light source is usually stated in kelvins. The range of colour temperatures normally used in colour photography is from 3200K for studio lamps to 5500K and upwards for daylight. Artificial light colour slide films are designed to be used in 3400K light, which is the type given by ordinary photofloods, or 3200K light, which is that given by studio lamps. Daylight films are designed for use in light of about 5500–6000K, although the colour temperature of daylight can go a great deal higher than that. Colour print films are usually supplied in only one version—for about 6000K. Electronic flash units generally give light of about that colour temperature and are particularly suitable for use with daylight colour slide and colour print films. If colour film is used in light of a different colour temperature from that for which it is designed, a conversion filter must be placed over the light source or camera lens to change the colour temperature of the light. This is quite practicable when using artificial light film in daylight but is not advised for the reverse process owing to the density of the filter required.

Condenser

Slide projectors and enlargers use a form of lens known as a condenser to collect light from the lamp and concentrate it into a beam which both adequately illuminates the film and completely fills the rear glass of the lens with light.

Contrast

Differences in tonal values are often called contrast. In photography, contrasty really means an image in which tonal values are compressed so that there are only a few well-defined steps between white and black. The colour picture does not generally contain significant areas of white or black and contrast is in that sense, less pronounced. Too much contrast is, in any event, undesirable in the colour picture, because the colours cannot be reproduced accurately throughout a wide brightness range. Contrast is inherent in the subject to a greater or lesser degree and can be controlled by lighting. Direct lighting, whether by sunlight or lamps can create high contrast but can be controlled by adding light to the shadows via reflectors, additional lamps or flash. When the minimum contrast is required all lighting should be indirect.

Converging lens

Any lens that is thicker in the middle than at the edges causes light rays passing through the lens to converge and thus brings light rays from one plane in front of the lens to a focus in a plane behind the lens. The distance from the focal plane to the optical centre of the lens when a very distant object is focused is the focal length of the lens.

160

Converging verticals

Although the eye will accept converging horizontal lines in a picture (such as long straight roads, railway tracks, etc) it does not take so kindly to converging verticals, such as the sides of buildings or two separate perpendiculars like telegraph poles, lamp posts, etc. These are caused by tilting the camera away from the horizontal, as is common practice when shooting high buildings. There is no remedy with ordinary cameras unless the viewpoint and/or lens can be changed to avoid the necessity for the tilt. The remedy with specialist cameras is to use the camera movements (tilt and swing or rising back and/or front) or, in one 35mm camera, to use a special perspective control lens, which gives the effect of a rising front.

Copying stand

To facilitate copying of documents, photographs, etc, various stands are available, consisting basically of a camera support, usually on a vertical column, and a baseboard often fitted with lampholders. The camera is used with special close-up equipment or extension tubes or bellows.

Cropping

Colour slides and Polacolor prints are generally shown in their full size, as originally recorded by the camera. Any trimming to exclude unwanted material reduces the size of the picture. Composition and framing should, therefore, be carefully observed at the time of shooting. Colour prints allow enlargements to be made from a part of the image but such enlargements require individual treatment and can be expensive. Machine-produced prints do not generally allow for selective enlarging.

D

Darkroom lamps

When working with light-sensitive materials, the only light that can be used for illumination is that of a colour to which the film is not sensitive. Colour film and colour paper for the production of colour prints are sensitive to light of all colours and must normally be handled in total darkness.

Dawn and dusk

These are suitable times for obtaining striking colour pictures but the beginner is not recommended to operate at these times. The light is totally reflected, is low in intensity and often unusual in colour. It needs some skill and experience to use such light effectively in colour photography.

Daylight film

The popular form of colour slide film is designed for use in daylight and will not give correct colour rendering in other forms of light except electronic flash

161

and blue flashbulbs. Many films are supplied only in a daylight version and a filter has to be placed over the camera lens if other forms of light are used. Some films, however, have a special artificial light version.

Depth of field

In theory a lens forms a sharp image in the focal plane only of objects lying within one particular plane in front of the lens. In practice, the images of objects in front of and behind that plane are so very nearly sharp that the eye is unable to distinguish their unsharpness. This is simply because no lens can in fact reproduce a point as a point. It is always a disc of finite size and, when the disc is below a certain size, the eye cannot distinguish it from a point.

Depth of field is the distance between the nearest and farthest object that the lens reproduces with equal sharpness. It varies with shooting distance, the focal length of the lens and the aperture of the lens. Short distance, long focal length and large aperture all tend to reduce depth of field. Long distance, short focal length and small aperture tend to increase it. Most lenses are fitted with scales that indicate the depth of field and tables are also often included in instruction books and other publications. These are of limited value because, naturally, depth of field can easily be calculated for the image on the film but it is difficult to take account of the magnification of the final image and the viewing distance.

Developer

A photographic developer is a solution containing a reducing agent which changes the exposed silver compounds in the emulsion into black metallic silver, thus, in normal film processing, giving a negative image. This happens even with colour slides but the colour slide film goes through a second (colour) developer of different composition which releases the dyes in the parts of the emulsion not affected by the first developer. Thus a positive colour image is formed. Colour print film goes through the colour developer only and therefore gives a negative colour image to be printed to a positive on colour paper.

Developing tank

Light-trapped container in which the film is placed for processing. It usually consists of an outer shell housing a removable spiral construction into which the film is loaded in the dark. Processing can then take place in full daylight if necessary.

DIN

Initials of the German standards organization *Deutsche Industrie Norm*, used in photography in conjunction with a figure, i.e. 18 DIN, to indicate film speed. The system is logarithmic, an increase of 3 in the DIN figure indicating a doubling of film speed.

162

ASA and DIN speeds compared

ASA	ASA log	DIN	Relative exposure
640	7.5	29	1
500		28	1.25
400	7	27	1.6
320	6.5	26	2
250		25	2.5
200	6	24	3.2
160	5.5	23	4
125		22	5
100	5	21	6.4
80	4.5	20	8
64		19	10
50	4	18	12.5
40	3.5	17	16
32		16	20
25	3	15	25

Dioptre

A unit of the strength of a supplementary lens directly related to its focal length. Focal length is obtained by dividing the dioptre number into 1 metre. Thus a 3-dioptre lens has a focal length of 333mm or about 13 inches.

Diverging lenses

Any lens that is thinner in the middle than at the edges causes light rays passing through it to diverge and so be incapable of forming an image unless intercepted by a stronger converging lens. Camera lenses are generally formed from a mixture of converging and diverging lenses computed to work together to provide an image free from distortion and other undesirable characteristics.

Double-exposure prevention

The movement of the film through the camera is now commonly coupled with the tensioning of the shutter to form a double exposure prevention device. Unless the film is wound on, the shutter remains untensioned and, therefore, cannot be released. On many cameras this device can be side-tracked by operating the film transport lever while holding down the rewind button.

Double shadows

The use of two or more lamps when taking a photograph can lead to the appearance in the picture of double or multiple shadows. These are rarely

attractive and are often unpleasant, especially in portraits. They should be avoided by careful positioning of the lamps so that the fill-in light is not so strong as to create its own clearly-visible shadows.

Drying marks

If a film is dried by the uneven application of heat there is a danger that small areas of the emulsion will dry much more slowly than others. This results in stresses that cause irreversible local distortions of the emulsion which print or project with varying density. More commonly, marks appear on the "glassy" side of a film after drying owing to deposits of impurities in the water. These can be polished off with a very soft moist cloth. The trouble is more frequent with black-and-white films because colour films normally use a stabilizer bath as the last step.

Duplicates

The colour slide is essentially a "one-off" product. Duplicates are obtainable commercially, however, and are not difficult for the user to make. Slide-copying equipment is available from many manufacturers. It is also possible to make colour prints from colour transparencies, either via an intermediate colour negative or on colour reversal paper. Both are skilled operations, and colour reversal paper is very expensive.

E

Emulsion

The coating on a film is an emulsion (suspension) of silver halide particles in gelatine. A colour film has three separate emulsions, each sensitized to a separate primary colour. These emulsions are in superimposed layers so that the three images combine after processing to produce a full-colour image.

Exposure

Colour photography demands accurate exposures, particularly with colour slide films. The reversal processing of these films causes even minor errors in exposure to affect the colour rendering and colour saturation significantly. Colour print films can stand slightly larger departures from the ideal. A basic rule is that colour print film is exposed for the shadows and colour slide film for the highlights but that, of course, depends on the nature of the subject and the type of picture required.

Exposure latitude

All films have some tolerance (or latitude) to incorrect exposure. Colour films, however, have very little latitude. Colour slide films, especially, must be correctly exposed to obtain reasonable colour fidelity.

164

Exposure meter

The required exposure is best determined by the use of an exposure meter. Such an instrument reads the strength of the light and translates it into an exposure recommendation expressed in shutter speeds and *f*-numbers. The meter can be a separate instrument or it can be built into the camera. In the camera, it is usually coupled to aperture or shutter controls to give more or less automatic working.

Exposure values

Some cameras still carry exposure value scales which allocate a single number to all camera settings giving the same exposure. Thus a setting of 1/30 sec at *f*11 will have the same exposure value number as 1/60 sec at *f*8, 1/125 at *f*4 and so on.

Extension

The camera extension is the distance between the lens and the film. It varies as the lens is focused, equalling the focal length when the lens is focused for the far distance (infinity) but becoming greater as the lens is focused on nearer subjects. Usually, if the subject is very close, extension tubes or bellows are used to supplement the limited movement built into the lens.

Extension tubes

The focusing range of most camera lenses is limited and few lenses focus closer than 2–3 feet. With lenses that can be removed from the camera, it is possible to place extension tubes between the lens and the camera, so enabling the lens to focus at close range only. In theory, there is no limit to the length of tube that may be so used. In practice, the loss of light along the tube length makes very long extensions impracticable unless very strong lighting can be used.

F

Film speed

Films have varying sensitivities to light, i.e. some films need less light than others to produce an image. The sensitivity is generally known as the speed of the film and is expressed as a single figure followed by either DIN or ASA, according to whether the European or more widely used American system of film speed rating is used.

Filter factor

All filters except the UV filter absorb some visible light and therefore upset any normal exposure calculations. The extent to which they so affect exposure is generally expressed by a filter factor such as 1.5X, 2X, 2.2X, etc. The normally

indicated exposure has to be multiplied by these figures. Thus, an exposure of 1/125 sec at f8 becomes 1/60 sec at f8 or 1/125 at f5.6 when a 2X filter is used. The factors are very often mechanically calculated and are meaningless in practical terms. The factor of 2.2 above, for instance, can only be construed as 2.0 or 2.5.

Filters

The most commonly used filters in colour photography fall into two classifications: conversion filters and correction filters. Conversion filters are used to alter the colour characteristics of the light source to suit the film. Thus, artificial light film can be used in daylight if the appropriate conversion filter is placed over the lens. In theory, the converse is also true but the density of the filter needed to use daylight film in artificial light is so great that such a conversion is not generally practicable. Correction filters are comparatively rarely used in colour photography, being generally confined to the UV, haze and skylight variety. These are used to eliminate any tendency to blueness caused by an excessively blue sky, distant haze or UV radiation. There are many other filtrations possible but they are generally used only by commercial photographers who have to obtain the truest possible rendering of a particular colour. The rendering of other colours in the picture may well suffer in the process.

Fixed-focus lens

Inexpensive cameras are often fitted with a lens with an aperture of about f11 or smaller that is focused at about 25 feet. This generally ensures that all objects

in front of the lens from about 6 or 7 feet to the far distance are rendered with more or less the same degree of sharpness. The only possibility of altering the focus of these lenses is the attachment of supplementary lenses to enable photographs to be taken at closer range.

Flash

There are two types of flash equipment. One uses expendable glass bulbs which give only one flash per bulb. The other has a gas discharge type tube which can give many thousand flashes before needing renewal. This is the electronic flash tube. Electronic flash is generally of a suitable colour for use with daylight colour films. Most of the smaller flashbulbs are now also blue-coated for the same purpose. Clear flashbulbs are not suitable for use with daylight film and are no longer recommended for use even with colour print film.

Flash duration

This is the time during which a flash unit or bulb emits usable light. Flash-bulbs have a build-up time and a "tail" during which the flash is dying out. The usable flash is from about half way into its build-up to about half way into the fade. These are known as half-peak points and the time between them is generally about 1/50 sec. Electronic flash, on the other hand, is virtually instantaneous and has almost no tail. Its duration varies with the design of the individual unit but with most amateur units is in the region of 1/500 to 1/800 sec.

Focal length

All photographic lenses have a focal length, which is the distance from the lens to the image the lens forms of a distant subject. In a camera, this is the distance between the film and the lens when the focus is set to infinity.

Focal plane

When a lens is focused on a subject, it projects all in-focus points on to a plane on the other side of the lens. Out-of-focus points actually come to a focus in planes in front of or behind the focal plane, so that their image in the focal plane is unsharp.

Focal plane shutter

This type of shutter comes in various forms but consists essentially of two blinds which, when the shutter is released, follow one after the other across the film, the distance between them determining the amount of light that reaches the film. The film is thus exposed piecemeal and not all at once, as in the case of the blade shutter—an arrangement which can cause difficulties with flash synchronization and with fast moving subjects. The focal plane shutter can generally, however, give faster speeds than the blade shutter.

Focusing

There are some cameras with lenses prefocused on a certain plane and with no facility for refocusing. Most cameras, however, have a focusing mechanism which allows the lens to be moved towards or away from the film. Moving the lens away from the film causes it to focus closer. If you want to go *very* close, however, you generally have to use extension tubes or bellows, or supplementary lenses, because the amount of movement that can be conveniently built in to the lens has certain physical limits.

Focusing is often aided either by a rangefinder which presents a disjointed or double image in the viewfinder when the lens is defocused, or by a screen on which the lens projects its image. In the single-lens reflex camera, the image projected by the lens reaches the eye via a mirror, a pentaprism, a screen and a magnifying eyepiece. The image is large and easily focused but the screen nevertheless also often contains a central rangefinder area.

Front-cell focusing

The general method of focusing a lens is to move it bodily nearer to or further away from the film. Some lenses, however, are made with the rear part of the lens at a fixed distance from the film plane and the front part movable. Focusing of this type of lens really amounts to changing its focal length. To change focus from distant to closer subjects, the focal length is progressively shortened. Because the lens to film separation is fixed, the change in focal length results in closer focusing, i.e. the extension becomes greater than the focal length.

Fumes

The dyes used in colour photographs and the emulsions of light-sensitive materials can be affected by various fumes. Neither exposed nor unexposed films should, therefore, be stored near any paints, varnishes, chemicals or even mothballs.

G

Grain

All photographic images are of a granular construction because the emulsion is composed of a suspension of silver halide grains in gelatin. The image is first

formed by the blackening of these grains after exposure and development. When the image is enlarged the granular structure shows because the minute grains tend to overlap at different depths in the emulsion and thus form clumps large enough to be seen. Grain tends to be less noticeable in most colour films because, although the emulsion is thicker, and the bottom layer relatively fast (which means larger grains) the blackened silver is removed in processing and the final image is composed only of transparent dyes.

Guide numbers

Flash exposures are usually determined by guide numbers published for individual electronic flash units and for flashbulbs. The guide number depends on the power of the light source, the speed of the film and, with flashbulbs, the shutter speed. Exposure is determined by dividing the distance between the lamp and the subject into the guide number to obtain the lens aperture. Thus, if the guide number in given circumstances is 80 and the flash unit is 5 feet from the subject, the aperture required for correct exposure is *f*16.

H

Halation

Heavily overexposed images of lamps or other bright sources of light can produce a halo effect around the light source. This is caused by reflection from the film base back into the emulsion. It is generally minimized in modern films by using a neutral coloured base or coating the base with an anti-halation layer to absorb the unwanted light.

Heat absorbing filter

Some enlargers and most projectors have a colourless special glass construction known as a heat-absorbing filter to protect the film from the heat of the projection lamp.

Highlight

The brightest parts of a subject or its reproduction are commonly referred to as highlights. One of the prime aims of most photography is to expose the film in such a way as to retain detail in the highlight areas.

High-speed colour film

Most colour films in popular use are of relatively low sensitivity in comparison with black-and-white films. There are, however, one or two special emulsions, particularly Kodak's Ektachrome HS and Ansco's 500 ASA film that are designed to give much higher speed. The colour rendering and grain structure of these films are inferior to those of the slower films but are acceptable when

169

reproducing low-light conditions. Kodak also issue specific instructions for altering the processing of Ektachrome HS to give the effect of even higher speed.

I

Image distance

This is the distance between the optical centre of the lens and the focal plane. If the lens is set to infinity, the image distance is equal to the focal length of the lens.

Image field

The image field of any lens is circular but it is masked in the camera so that a square or rectangular field is formed conforming with the film size. This field is known as the image format and its diagonal is approximately equal to the focal length of the lens regarded as standard for that format.

Image scale

The size of the image on the film in relation to the size of the object.

Incident light measurement

Exposure meters are sometimes used to measure the light falling on the subject instead of the light reflected from it. This is carried out by pointing the meter from the subject position towards the camera. The meter must be fitted with a special diffuser over the light sensitive cell.

170

Indirect light

Many photographs are taken by totally reflected or indirect light. Photographs outdoors without direct sunlight are indirectly lit. If indirect artificial light is required, all lights are directed on to reflecting surfaces and no direct light is allowed to fall on the subject. A typical example of indirect lighting is "umbrella flash" where the flashgun is aimed into a white umbrella. The effect of indirect lighting is to reduce the intensity of shadows so that they retain almost full colour and to create a generally light and airy mood.

Interchangeable lenses

A common feature of many modern cameras is the ability to remove the lens and replace it by another. This allows lenses of different focal lengths to be used to obtain the effect required and also allows various other attachments, such as extension tubes or bellows to be used between camera and lens.

K

Kelvin

Colour temperature, or colour quality, of light is measured in kelvins, once known as Kelvin degrees. The Kelvin zero is absolute zero, equal to −273°C.

Key light

When lamps are used to light the subject, one of them usually forms the main, key or modelling light, being so positioned as to create the shadows necessary to show the shape or character of the subject to best advantage. Other lights are subsidiary, serving to lighten the shadows, create additional effects, light the background or pick out special features.

L

Latent image

An exposed but undeveloped film contains a latent image. This image is invisible and has to be subjected to development before it can be seen. It is believed that the latent image can fade if there is too long an interval between exposure and development. This is the reason for the recommendation that colour films should be processed as soon as possible after exposure. If the latent image is affected by time if would probably be differently affected in each layer, upsetting colour reproduction.

Lens hood

Also known as a sunshade, the lens hood is designed to prevent non-image forming rays of light from striking the lens and setting up reflections which can

171

reduce the brilliance of the image. It can be of some service, too, in protecting the lens from rain, sea spray, etc.

Light fluctuations

Daylight varies in intensity and colour quality throughout the day and in some areas it can undergo rapid changes in quite short periods. This makes an exposure meter an essential piece of equipment so that the light can be checked from time to time. Artificial light (photofloods, tungsten halogen lamps, etc) should not vary significantly in the short period but does need to be checked occasionally because the aging of lamps and variations in the electricity supply can affect the light output. This is probably most important in colour printing and a useful acquisition is a voltage controller to keep the supply voltage constant.

Lighting

One of the basic conditions of colour photography is that the light by which the photograph is taken must be the type of light for which the colour film is designed. Many colour films are available in daylight and artificial light versions and each must be used with the correct type of light if correct colour rendering is to be obtained. Colour print film can be used in most ordinary types of lighting, but not in mixed lighting i.e. part daylight and part artificial. Exceptions are electronic flash and blue flashbulbs which approximate to daylight and can be mixed with daylight on daylight type film. Filters are available to allow daylight type colour slide film to be used in artificial light and vice versa but they should be used only as a compromise.

172

Magazine

Most slide projectors now use magazine loading, the slides being loaded into a grooved, open-sided box from which they can be fed into the projector by a simple manual movement or by an automatic mechanism. The magazines are relatively inexpensive and the slides can, with advantage, be stored in them so that they are always ready to be shown in a particular order.

Measuring flasks

An essential part of any darkroom equipment is a measuring flask marked in fluid ounces or millilitres to ensure accuracy in compounding solutions, etc. Photographic types are readily available in various sizes. The plastic variety are adequate and durable.

Macrophotography

Very close range photography producing magnified images on the film is sometimes known as macrophotography. It can be carried out with any inter-changeable lens camera by using extension tubes or bellows, possibly in conjunction with close-up lenses. The extra distance between lens and film means that more exposure is needed than at normal extensions. A suitable exposure factor is calculated from the expression $\left(\dfrac{E}{F}\right)^2$ where E is the total extension used, i.e. focal length of lens plus length of tubes or bellows and F is the normal extension or focal length of the lens. The normally indicated exposure is multiplied by the factor so calculated. This does not apply, of course, where an exposure meter reading is taken through the camera lens.

Mounting slides

There are various types of mount into which colour slide film can be put for projection and for preservation. The simple card mount (see page 58) is popular but there are also plastic and metal types of various designs, some incorporating cover glasses and some glassless. Some workers prefer to mount their slides in a paper or foil mask between 2×2in glass sheets and to bind the edges with tape. This can be a dangerous procedure if the mounting is not very carefully carried out in a dry atmosphere and with completely dry masks, film and glass. The effect of binding moisture *in* can be quite disastrous. It is, however, the only method which guarantees *perfect* flatness of the film within the mount, coupled with absolute protection if the mounting is properly carried out. Slides are inserted into the projector with the emulsion side towards the screen and the image upside down. It is common practice to mark the top right-hand corner of the slide in that position with a spot to indicate the correct orientation. This position is the bottom left-hand corner of a slide which, when held in the hand, shows an upright, right-way-round image. Those frames which are made from two halves, one light-coloured and one dark, should be

used with the light-coloured side towards the projector lamp. The idea is that the light colour reflects heat instead of absorbing it.

M-synchronization

Flashbulbs can be used with the higher shutter speeds on a blade shutter if it is M-synchronized. This type of synchronization delays the opening of the shutter until sufficient time after the flash contacts have closed to allow the flashbulb to reach half its peak intensity at the slower speeds and almost full intensity at the fastest speed. Thus, at the fastest speed, much less of the light from the flash is used than at the slower speeds. This is reflected in the guide numbers printed on flashbulb packets. Electronic flash cannot be used on an M-synchronized shutter, but there is invariably a separate X-synchronization setting.

N

Neutral density filter

It can occasionally happen that the light is too strong for photography at the camera settings available or necessary. This is more common with cine photography but it is conceivable that, even in still photography, it might be necessary for the effect required to shoot at the widest possible aperture. If, in such cases, the shutter speed is also restricted by the circumstances, the only solution is to use a filter to reduce the light intensity. Coloured filters cannot be used with colour film so a grey filter, known as a neutral density filter, is used. Such a filter absorbs light of all colours equally and therefore has no effect on colour rendering.

Newton's rings

Concentric irregularly shaped rings can sometimes be seen on the screen when slides bound between two glasses are projected. These are Newton's rings, caused by just less than perfect contact between the film and the glass, probably because of microscopic irregularities in the thickness of the glass. The solution is to use special glasses designed to combat this nuisance or to insert foil masks between the glasses.

O

Overexposure

Overexposed colour slide film creates too much density in the image created by first development and therefore leaves too little light-sensitive material to be affected by the fogging stage and colour development. The result is a thin transparency with weak colours. Overexposure, within limits, is not quite so disastrous with colour print film, but can cause some colour distortion.

P

Panning

A technique for shooting fast moving subjects is to swing the camera along the line of movement so as to keep the subject "stationary" in the view-finder. This is known as panning the camera and is a skill that is not too difficult to acquire with practice. The trick is to swing the body from the hips while keeping the hands and arms still. The swing must start before the shutter is released and continue after it. There is a tendency to stop swinging as the shutter release is depressed. The slower the shutter speed and the faster the pan, the more blue and impression of speed in the background.

Parallax error

When an object is viewed from two fixed separate points (such as a view-finder and camera lens) and the image is presented within a restricted frame, the two views will differ. The difference is very slight in the case of distant objects, but the closer the camera approaches the subject, the greater the discrepancy. It can be readily appreciated, for instance, that a small object placed very close to the lens could be out of sight of the viewfinder. This

175

trouble is encountered by all cameras other than single-lens reflexes and older or studio type cameras with a straight-through view to a focusing screen that is removed to accommodate the plate or films. Various methods are used to overcome parallax error, from lines indicating the displacement of the image area in the viewfinder to automatic compensating movements in the viewfinder optical system linked to the focusing mechanism.

Pentaprism

A specially shaped prism used in single-lens reflex cameras in conjunction with a mirror to present a correctly oriented image on the viewfinder screen.

Photocells

The light sensitive materials used in exposure meters are often called photocells. There are two types in general use: selenium and cadmium sulphide (CdS). The selenium type generates an electrical current according to the amount of light striking it. The CdS type changes its resistance to electrical current according to the amount of light falling on it. The CdS type therefore needs a source of electrical current so that variations in current can be registered by a small meter. The needle of the meter is made to move across a scale calibrated to give exposure readings. In cameras with automatic exposure control the needle movement is linked to the aperture and/or shutter speed control. The CdS type meter can be more sensitive, size for size, than the selenium type and tends to be favoured for meters built into the camera. It is essential for meters reading through the camera lens.

Photofloods

The normal photographic lamps for amateur use are photofloods, which are ordinary tungsten lamps but with filaments specially designed to be overrun at normal mains voltage. The result is a brilliant light but a short life. The No 1 photoflood consumes 275 watts but gives light equal to about 800 watts. It has a life of about two hours. The No 2 photoflood consumes 500 watts, gives light equal to about 1500 watts and has a life of about six hours. The colour temperature of these lamps is 3400K.

Polarizing screen

Light is reflected by most objects at random, i.e. the light waves travel in all directions. Some polished or highly reflective surfaces, however, cause the reflected light waves to travel in only one direction. This is polarized light and such light can sometimes be prevented from reaching a camera lens if a polarizing screen is placed between the source and the lens (usually over the lens, as with filters). The most common use for the polarizing screen is to subdue or eliminate reflections in windows, from furniture, on glass in picture frames, etc. It has another use in colour photography in that it can sometimes intensify a blue sky.

176

Positive

Generally indicates a print on paper but can mean any image in which the tones are correctly related to those of the original. The colour slide film is specially processed to provide a positive image.

Projection lamps

A wide variety of lamps of various voltages and power ratings is available for the even wider range of slide projectors. It is important to use the lamp specified for the projector. Most modern projectors use the newer low-voltage tungsten-halogen lamps in place of the mains voltage versions. Tungsten-halogen lamps are said to give a whiter light and to run cooler than the higher-voltage types. All projection lamps are rather fragile when hot and care should be taken not to jolt the projector or to move it until the lamp has cooled down.

Projection lens

Standard projection lenses are generally of rather greater focal length than the camera lens and are suitable for use in average-sized rooms, where a throw (projector to screen distance) of about 10 feet can be arranged. In more confined spaces, a shorter focal length would be necessary to give a reasonably large picture with a shorter throw. Many projectors are now fitted with zoom lenses, which allow the focal length to be varied to suit long or short projection distances.

Projection screen

Colour slides must be projected to be seen at their best and they must be projected on a proper screen or prepared surface. An old, creased sheet or table

cloth will not do. The best format is square, even for 35 mm or other rectangular image films because it allows both vertical and horizontal views to be presented entirely within the screen area from the same projection position. Various types of screen and screen surface are available. A brighter image can sometimes be obtained by special screen coatings but usually at the cost of narrowing the angle from which the screen can be viewed and therefore the number of viewers.

Projector

There are very many types of slide projector, especially among those designed for the popular 2 × 2 inch slide. Points to be watched for when buying a projector are the brilliance and "colour" of the light source, cooling arrangements, efficiency of slide changing mechanism with all types of slide mounts, electrical insulation, and coverage of image area, both in illumination and definition. View the corners of the projected picture critically. They should not be significantly less bright or less sharp than the centre.

Projector stand

A projector can be stood on a table, or a stepladder, a stool, chair or any other makeshift stand. Specially-designed projector stands are available, however, and are quite useful. They often provide room for the projector with a shelf underneath to hold slides or magazines.

R

Rangefinder

The rangefinder can be a separate instrument or it can be built into the camera, where it is usually coupled with the focusing mechanism of non-reflex cameras. There are two common types: coincident image and split image. The coincident image shows a complete double image of the rangefinder field (usually a small part of the viewfinder image) until the meter or the lens is set to the correct distance. The principle of the split image is the same but the rangefinder image area is divided into two and a single image is discontinuous across the border of the two halves until the rangefinder and lens are set to the correct distance.

The single-lens reflex camera also usually includes a rangefinder spot of various designs in the centre of the focusing screen.

Reflector

The term is used to describe both the dish or bowl-shaped, usually metal, shade into which photographic lamps are commonly fitted to throw the maximum amount of light forward, and any reflecting surface used to throw light back on to the shadow side of the subject.

178

The lamp reflector can be of various shapes according to the type of light required. Some photographic lamps have reflectors built in behind the filament and need no external fitting.

Reflex cameras

There are both single and twin lens reflex cameras. The SLR uses only a single lens both for viewing and taking the picture. The view through the lens is projected on to a mirror and thence to a focusing screen. In the popular 35mm SLRs the screen image is viewed via a pentaprism and a magnifying eyepiece to present a large rightway-round image. The mirror swings out of the way as the shutter is released, momentarily blacking out the viewfinder, and then returns automatically to its original position. The TLR has two lenses, usually one above the other on a common panel. The top lens throws an image on to a focusing screen in the top of the camera via a fixed mirror. The image is reversed right to left. The second lens takes the picture. The TLR can therefore have parallax problems not encountered in the SLR.

Remote control

Various types of remote control can be used on cameras to enable the shutter to be released at some distance from the camera. There are air-operated devices and complicated electrical mechanisms using a solenoid to press the shutter release. Remote control is more common on projectors, allowing armchair control of slide-changing and focus.

Resolution

This is generally taken to indicate the ability of photographic lenses and emulsions to reproduce the lines and/or patterns of a test chart.

Refraction

Light rays are said to be refracted when they pass through a transparent medium (glass, water, etc). The effect is a change in speed and direction. In other words, the light ray is bent. The degree of bending varies with the medium and can be expressed as a refractive index. The glasses used in photographic lenses have varying refractive indexes and it is the careful selection and blending of their qualities which sets the quality of the lens.

Reversal film

Colour slide film has to be reversal-processed to give a positive image and is often, therefore, known as reversal film. Reversal processing involves a first development stage which produces a negative image, followed by a fogging stage, either by light or chemicals, to make the remaining emulsion developable in a special colour developer. The blackened silver images are later removed.

Ring flash

To provide virtually shadowless flash lighting, various units are available with flash heads containing circular tubes which fit around the lens mount.

S

Sabattier effect

If unsafe light falls on an exposed photographic material during development, partial or complete reversal of tones may occur. This is a pseudo-solarization effect that has come to be known as the Sabattier effect. It can give startling results in colour but the effect is generally unpredictable. With colour materials, there are innumerable possibilities; the re-exposure can be made during the first development or during the colour development and the effect can be more or less confined to one layer of the emulsion by using coloured lights.

Self-timer

Some camera shutters are fitted with a delayed-action device which allows the shutter to be set for release some 10–15 seconds in advance of the actual release. Thus, the photographer can include himself in the picture.

Sensitivity

The sensitivity of a film to light is usually expressed as a DIN or ASA figure. These figures mean nothing in themselves but enable the sensitivities of various emulsions to be directly compared and supply a basis for the calibration of exposure meters and compilation of exposure tables and other guides.

Shadows

Shadows can be a curse or a blessing in colour photography. They can create interesting effects or disturbing features. They are controlled by the lighting. Artificial light can be diffused or the lamps rearranged to reduce the depth of shadows. Or the lighting can be bounced from reflecting surfaces, so that none reaches the subject direct. A similar technique can be used with flash and even with daylight by taking the subject out of direct sunlight.

Sheet film

Many colour films are available in larger sizes than 35mm and 120 rollfilm. These larger sizes are invariably in single sheet form for loading into special holders.

Shutter

There are two basic forms of camera shutter. The focal plane shutter is

described under its own heading. The other form has various names, such as blade, leaf and between-lens. It is formed by thin, overlapping metal blades which open outwards rapidly to uncover the whole lens almost instantaneously at any shutter speed.

Skylight filter

A weak, pinkish filter on the camera can eliminate the blue cast often caused by an excessively blue sky or sometimes in daylight pictures taken in the shade. It may be called a skylight or haze filter and may sometimes be straw-coloured instead of pink.

Slave unit

To fire more than one flash unit from the same camera generally requires a cable for each unit. The slave unit contains a light-sensitive cell to eliminate the need for a cable. Only the master flashgun is connected to the camera. When it fires, the light-sensitive cell connected to the other units picks up the light and actuates a switch to fire the flash. Any number of slave units can be operated from the one master provided there is a direct "line-of-sight" between their cells and the master flash.

Slide synchronizer

A device designed to enable taped commentaries or background music to be synchronized with the slide changing mechanism.

Soft-focus

Special attachments similar to filters can give "soft" effects in colour photography, blending light and shade in a particularly characteristic manner. The effect is difficult to use in colour photography and satisfactory results call for some skill by the photographer.

Solution temperatures

When developing colour film, it is essential to keep solution temperatures at the levels specified by the manufacturers. The developers, in particular, must be kept within $\pm\frac{1}{2}°C$ to avoid possible distortion of colour rendering.

Spotlight

The ordinary photographic lamp gives a wide beam of light to cover a relatively large area. Where a small, concentrated light is required, a spot-light with a lens in front of the lamp is used. The larger units give some control of the size of the spot so that it can be used either as a hard main light or as a small effect light on hair, etc.

Stabilizer

Most colour slide films go through a stabilizer bath at the end of processing to "fix" the colours. The conventional fixing process is not used and it is important that no washing is undertaken after stabilization.

Storage of slides

Colour slides must be protected against dust and damp. There are various storage methods available, most of them depending on the slide being mounted either in card or plastic mounts or between glass. The mounted slides can then be stored in specially constructed boxes, which should be reasonably dust and damp proof. Protection against damp can be obtained by placing small bags of silica gel in the boxes. Colour slides should not be exposed to strong light more than is necessary. The dyes are not permanent and will keep better in the dark.

Storage of unexposed materials

Unexposed colour film and paper should preferably be stored in its original packing in a refrigerator (not in the freezing compartment). If it is so stored, however, it must be brought to room temperature before being opened. Failure to observe this precaution causes the warm air in the room to condense into water droplets on the cold material, with probably disastrous results. Colour materials stored in this way can be expected to have a much longer life than those stored at normal temperatures. All colour materials are usable long after the expiry date printed on the packets but the colour rendering can then not be guaranteed for quality or consistency.

Supplementary lens

The supplementary lens is generally a single-glass lens that is attached to the

camera lens in the same way as a filter. Its effect on the camera is to decrease the focal length of the lens without affecting the extension, i.e. the separation between lens and film. The combined lens can thus focus closer than the unaided camera lens. In fact, with the camera lens set to infinity, the supplementary lens focuses at its own focal length. The power of the supplementary lens is usually expressed in dioptres. The focal length is calculated by dividing the dioptre number into one metre. Thus, the two-dioptre supplementary lens has a focal length of 500mm. Supplementary lenses can be used with any type of camera but are particularly suitable for fixed-lens cameras, which cannot otherwise be used for close-range work. They may be used with cameras with interchangeable lenses, even in conjunction with extension tubes or bellows, because they cause no light-loss effect.

Surge current

When a lamp is first switched on, it is cold and its resistance to electrical current is low. There tends to be a strong initial current surge which can damage a weak lamp filament or blow a fuse. Projectors often contain special anti-surge resistors to withstand this initial heavy current flow.

Sync lead

Flashguns are usually connected to the camera by a synchronizing lead which plugs into a socket. Extension leads are also available to allow the flashgun to be placed at a distance from the camera. This is generally more satisfactory than the flash-on-camera position, which gives poor modelling and heavy background shadows close to the subject.

System camera

A few cameras are essentially designed as part of a whole range of equipment consisting of various lenses and attachments for copying, macro and micro work, scientific applications and so on. These are system cameras, distinguished from ordinary interchangeable lens cameras by the range of equipment actually made especially for the one camera.

T

Table top

Table top photography offers almost limitless opportunities for those with an imaginative approach. It is simply the photograph of objects that can be placed on a table but does not normally include such subjects as arrangements of flowers, bottles, fruit, etc. The term is usually reserved for miniature scenes constructed with models and substitute materials such as flour, salt, crumpled silver paper, etc., to represent snow, sand, water and other natural features.

Telephoto lens

To obtain a reasonably large image on the film of an object at some distance from the camera, a long-focus lens has to be used. This acts somewhat like a telescope, giving a narrow angle of view and therefore enabling a relatively small object to be rendered larger than by the eye or the normal focal length lens. In fact, the size of the image on the film is in direct proportion to the focal length of the lens. A 150mm lens gives an image of any particular object three times larger than that from a 50mm lens. The term telephoto lens is now applied indiscriminately to any long-focus lens but it actually describes a lens of special construction, with a back-focus (distance between lens and film) shorter than the focal length.

Title slides

Presentations of series of colour slides can benefit from a title slide, indicating the subject matter of the series. Title slides can be purchased in various stereotyped forms or they can be made by shooting the title in close-up against a background scene or projected picture.

Transparency

The colour slide is also known as a transparency, meaning simply that the image is transparent but also implying that it is in positive form. The transparent negative image is not generally referred to as a transparency.

Tripod

For long exposures, the camera must be rigidly supported and the usual form of support is a tripod. It is essential that the tripod is sturdily built; lightweight, spindly-legged tripods can cause camera movement rather than prevent it.

U

Ultraviolet

Just beyond the blue end of the spectrum of visible light lies the ultraviolet (UV) band of rays, invisible to the human eye but capable of affecting photographic emulsions. The result with colour films can be an excessive blue coloration. UV radiation is most commonly encountered where the air is clearest, i.e. at high altitudes and near large stretches of water, and photography on such occasions is usually carried out through a UV filter.

Universal film

Colour print film is sometimes known as universal film because it can easily be used to produce black-and-white prints as well as colour. The black-and-white prints should preferably be produced on special panchromatic bromide paper to give reasonably correct tonal rendering.

UV filter

Strictly speaking the UV filter should be called a UV-absorbing filter but its popular name is now well established. It is used to prevent excessive blueness in colour pictures brought about by the action of ultraviolet radiation. In fact, any glass absorbs UV rays to some extent and the UV filter should not be used indiscriminately whenever conditions seem to demand it. The camera lens may absorb sufficient UV without further aid.

V

Viewers

There are various types of hand and table viewer which give slightly enlarged images of colour slides. They are usually powered by small batteries and simply consist of a light source, diffusing screen and magnifying lens. The slide is placed in front of the diffusing screen and illuminated from behind.

W

Washing

The washing or rinsing periods in colour film processing are carefully calculated and should be strictly adhered to. In some cases a reasonably thorough wash is required while in others a quick rinse allows for some reaction with the following bath. It is particularly important that no unprescribed final wash is given because most colour films now have a stabilizer bath as the final processing step and further washing would nullify the effect of the stabilizer.

Wetting agent

A wetting agent reduces the surface tension of water so that it runs freely from shiny surfaces instead of forming droplets. It is, therefore, a useful addition to the final wash of processed films.

Wide-angle lens

When shooting in cramped conditions, such as small rooms, narrow streets, etc, it may not be possible with the normal lens to include as much of the view as is required. The solution, with interchangeable lens cameras, is to use a wide-angle lens, which is a lens of shorter than normal focal length and, therefore, wider angle of view.

X

X-synchronization

Nearly all cameras are now synchronized for flash use and the type used is usually X-synchronization. This causes the flash to fire immediately after the

shutter reaches its fully open position and is thus suitable only for electronic flash, which has no build-up time, or for flashbulbs at a shutter speed sufficiently slow to allow the bulb to attain peak brilliance before the shutter closes again. This limiting shutter speed varies with the type of shutter but is most commonly about 1/30 sec.

z

Zoom lens

A lens the focal length of which can be altered at will by a simple adjustment while retaining focus on the same plane is known as a zoom lens. It is particularly useful in colour slide work because subsequent trimming or cropping of the image on projection is not practicable.

Creating with Colour

Colour creation is colour control. The photographer must always control the colours in his picture. When the colours are allowed to run riot, the photography is no longer creative.

Colour can be controlled in various ways. The choice of camera position is, perhaps, the easiest method, although it is often some-what restricted by the conditions. Control is necessary because the colours present in any scene are often in excess of what is required for a single subject and colour consciousness must be deliberately cultivated to assess the effect of the various colour combinations.

Unconscious selection

Living cheek by jowl with colours, we often have predetermined ideas about them. At the wheel of a car, for instance, we concentrate on red, amber and green. When the fruit grower picks his apples, he is aware of the colour of the fruit beforehand.

The camera is not so selective. It registers everything it sees. So the photographer must make the choice and not allow his camera to lay equal emphasis on all colours. The schematic arrangement on page 189 shows how the choice should be made.

Selection is important

The angular field of the lens determines the selection to be made by the camera. The photographer can make his selection either by choice of lens or by the distance focused upon. He can thereby concentrate on certain colours and obtain a specific result by making sure that the colours in the selected area are accurately recorded.

If, for example, he chooses a green meadow with blue sky above (see Figures 1 and 2 opposite), he can arrange his camera position so that neither colour predominates. It then only remains in such a picture to provide a contrast for the dominant colours. This is done by including a flowering tree reaching skyward (Fig 3).

Colours at the picture edge

Colours near the edge of a picture appear cut off. So bright colours, such as yellow, orange or red, should not be placed there (Fig 4). It is better if they are placed in the centre of the picture (Fig 5).

Individual colours should not be so balanced in number and area that no colour dominates. The wave pattern (Fig 6), for example, reflects the blue of the sky, making the blue colour dominate the picture. Near the red ship, however, the blue is absorbed into the red reflections and its dominance is weakened. A long-focus lens (Fig 7) brings up only the ship and so makes the red far too dominant. So picture composition is important.

When several colours are combined to form a neutral background, any contrasting colours stand out prominently (Fig 8).

Black picture elements between the colours hold the colour composition together (Fig 9) as can so often be seen in a stained glass window.

Intermediary colours

Complementary colours are rivals (Fig 10). Colours that are close to each other in the colour circle can act as intermediaries (Fig 11).

Our eyes always add to a colour its surrounding colour. Thus, grey appears cooler on a blue background than on a red background (Figs 12–13).

Sometimes colours can be used in a relatively weak composition with no strong contrasts. The result is more like a monochromatic rendering of light and shade (Fig 14).

In bad weather, colours are weakened and black tends to predominate. The remedy is to include a brilliant patch of colour to add life (Fig 15).

These are some of the endless possibilities of colour control but many more can be deduced from the basic rules.

1

2

3

Green and blue are related colours which lie close to each other in the colour circle. When they appear simply as a green meadow and blue sky, the result is monotonous. We must seek a colour contrast, such as a flowering tree.

Areas of warm colour should not be allowed too near to the edge of the picture (4) but should preferably be placed toward the centre (5).

4

5

6

7

8

9

10

11

12

13

Colours should not be evenly distributed through the picture in area and strength (6). Telephoto shots of details tend to make one colour predominate (7). Contrasting colours on a neutral background stand out (8) and black lines within the picture aid the composition. When complementary colours are combined with colours that lie between them in the colour wheel the intermediary colours serve to lessen the contrast.

14

Grey on a red background (12) has a warmer effect than grey on a blue background (13). An arrangement of colours that are closely related and make no violent contrasts can add up to a harmonic whole (14).

In these schematic presentations, we see several vivid splashes of red. This device is used frequently, not only to form a compositional anchor point but also to bring life to an otherwise dull scene.

15

Cool and warm colours

The pictures in this book were selected not only for their intrinsic quality but because they also show different kinds of colour composition in a form that allows them to be compared with one another. And they have been presented in a logical arrangement to give a balanced introduction to the wide field of composition in colour. Additionally there is some instruction, by analysis and, so to speak, synthesis. An analysis can be found in the text preceding each pair of pictures, and the pictures are synthesized in the line drawings, which demonstrate their colour "structure".

Text, pictures and drawings therefore form a single unit to be studied together. Generally, the drawings on the left-hand pages relate to the pictures on the following left-hand page and the drawings on the right-hand pages relate to the pictures on the right-hand pages.

Now let us pass to our theme of cool and warm colours. For psychological reasons, we tend to regard the short-wave colours (toward the blue end of the spectrum) as cool, and the long-wave colours (toward the red end) as warm. Moreover, cooler colours give the illusion of receding and so fade into the background of a picture. Warmer colours seem to advance, and, are often chosen for use in the foreground to reinforce the effect.

These are not, of course, rules to be followed slavishly. An unorthodox approach, such as by reversing the perspective positions of these colours in the picture, can give surprising, even satisfying results.

Colour control

Although in the first pair of pictures, one has blue and the other red as the dominant colour, in each case the colour has been applied in presenting the subject matter according to the general rule just mentioned. When working with colour, the subject itself counts just as much as an awareness of colour in the scene. The subject should not be sacrificed to colour rules unless that is clearly the intention.

The subject

You can use a camera to take such shots as you happen to find or you can set out with a certain definite purpose in mind. Photographs of the first type could include observation of people—on the sports ground, perhaps, at bus stops, in railway stations, in escalators or wherever else they may be, in sunshine or rain. The picture on the left-hand page was taken in bad weather and the rather cold-looking background gives the right atmosphere. Yet there are splashes of red at the edge of the picture, echoed in the face of the

Warm colours—foreground colours

Cool colour blue—background colour

Red splashes (see page 198)

passer-by, which add some cheer to a rather sombre scene.

The next picture, by contrast, is reminiscent of patterns remembered from childhood dreams. Dreamlike or not, however, this beautiful "flower" actually bloomed, bathed in polarized light, under the lens of a microscope—though only for a brief instant. The colour effects were produced by a filter placed in the beam of polarized light. The colours could not be determined in advance and many experiments had to be made, including careful selection of the microscopic specimen. This was actually a small part of the leaf of an oily willow, presented here as a flower with thrusting petals, the red parts pressing into the foreground. They combine with the deep blue of the background to give a quite extraordinary plastic quality.

Summary

Cool and warm colours present possibilities for expression in both form and mood. The mood is set by the dominant colour, while the form or shape of the colours creates the third dimension. Together with perfect presentation of the subject matter, these provide a means of expressing the photographer's conception of the original scene.

Shooting data

Left: Retina Reflex III, 85mm lens, Kodachrome II, 1/125 sec—*W. Köhler*, Kodak Archives. *Right*: 35mm camera on microscope, Agfacolor CN17, polarized coloured light—*Dr. Akira Asano*.

Red foreground colour

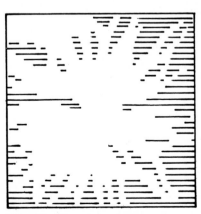

Blue background colour—area colour (see page 198)

Mid-distance colour (see page 194)

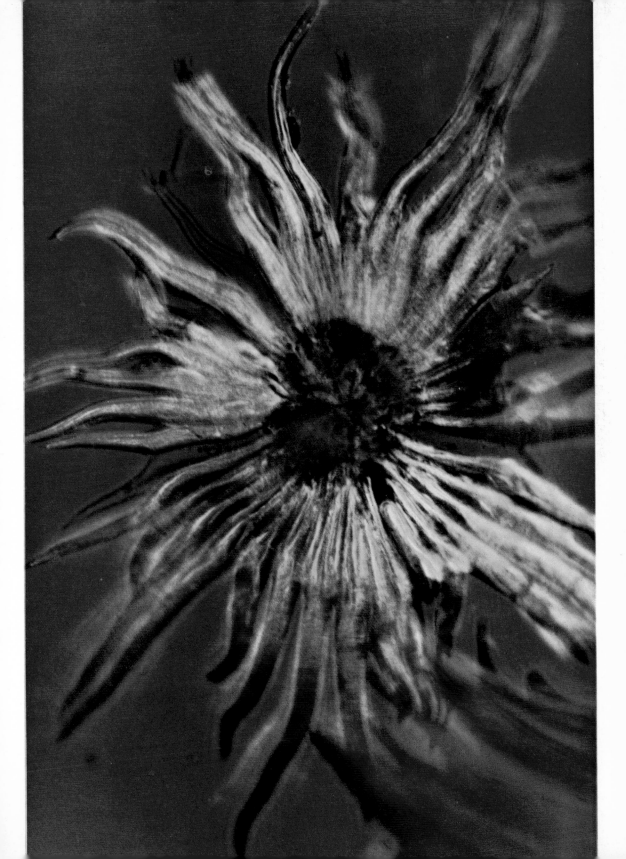

Colours between warm and cool

Between the extremes of warm and cool colours lie a mass of other colours. Green, for example, lies between red and blue in the daylight spectrum but there are two variations of green—blue-green and yellow-green. Blue-green is definitely a background colour but yellow-green is a mid-colour that can be used in extensive views as a connecting link between foreground and background.

Green is a useful colour in which to set a subject that has no particular depth. Green does not interfere with a subject set against it by appearing to advance or recede. It is a neutral colour and has a neutral depth effect. Placed among warm and cold colours it appears to occupy an area between foreground and background.

However, when using green there can be difficulties with adjacent colours, and particular care must be taken not to destroy the mood of the picture with bright colours that clash uncomfortably with the green.

Both colour shots on the following pages show people busy doing something—totally unaware of the photographer. They have other similarities. Both show couples, although in the first one of the partners is a boat, made prominent by its colour. The other similarity is accidental; both have light backgrounds emphasized by slight over-exposure brought about by basing the exposure on the darker foreground elements. The pictures do not suffer. They merely look sunnier.

Colour control

The colour construction of these pictures is noteworthy. Neither shows any harsh colour accent and both have backgrounds with a pale range of tones. There is a red-green contrast between the fisherman and his boat but it is not a harsh contrast. The picture of the two girls shows a similarly subdued contrast between the reddish-brown tones and the green of the door in the background.

Apart from the colours, another interesting point is that the main subject matter is darker in tone than the background. This is unusual but it merely emphasizes that although colour photography has many rules, breaking these rules often results in a more interesting picture.

The subject

Each picture is of an activity. The fisherman is working on his boat. The girls are concentrating on the newspaper. There is a unity that keeps the eye within the picture frame and maintains the interest of the observer. In each case, too, the light background remains neutral and does nothing to attract interest away from the main subject.

Mid-distance green. Dominant colour (see page 222)

Complementary colour red (see page 206). Warm colour (see page 190)

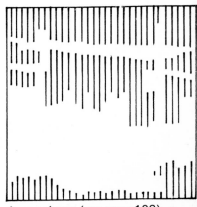

Area colours (see page 198)

Summary

These two pictures demonstrate
that good colour pictures do not
have to contain either striking
colours or extraordinary subjects.
Subdued colours and ordinary
situations can be just as effective.
Colour harmony such as this is
not easily perceived : it is a
matter of sensitivity. Once the
principle is grasped, however,
the world of colour itself is
better understood.

Shooting data

Left : Leica, Hektor 125mm,
18 DIN colour slide film,
1/100 sec. *f* 8. *Robert Häusser*.
Right : Leica, Telyt 200mm,
Agfacolor CT18, 1/250 sec, *f* 11.
Siegfried Hartig.

Warm colour (body colour) (see
page 190)

Economy in colour composition
(see page 230)

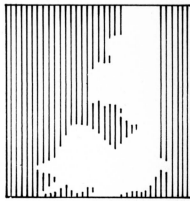

Area colours (see page 198)

Colour as mass or as accent

A colour may be used as a mass, or an accent, in a picture. In many pictures agressive or dominant colours may be distributed over the picture area as minor "highlights" here and there. In more extreme cases the colour may envelop the subject (a mass) or appear as a single small stab of colour (an accent) in an otherwise rather neutral environment. The difference between these two roles is particularly noticeable when the colour is red.

Whichever role a colour plays, it also has differences in tone and hue. All reds are not the same. There are bluish reds and yellowish reds. Red containing yellow is a warm colour but there is a cool atmosphere about the red with blue in it. Any colour can also be paler, according to its white content, or darker according to its black content.

Both the following pictures show marked differences in the amount of red used. That on the left is almost monochromatic. That on the right uses red purely as an accent. The red in the left-hand picture has a very slight addition of blue—just sufficient to set the atmosphere—and it spreads virtually all over the background. In the right-hand picture it is a warm colour and by its small size and positioning, fairly leaps out at the viewer.

Colour control

The differences in the use of the reds produces a variety of effects. The background red acts as a wall which, because of its colour, crowds in on the figure and pushes him to the front, where he cannot be overlooked. The girl's red blouse, on the other hand, acts as a focal point to which the eye returns again and again.

In each case, the nature of the red suits the subject. The slight blue content in the background is more suitable to the man's sombre dress. The yellow-red is more suitable for the youth and sunlight pictured on the right.

The subject

There are differences in the handling of these subjects. The Spaniard was captured by a chance shot : he happened to be there. The girl was posed—but carefully, to avoid any stilted effect. Her red clothing was the perfect foil to the otherwise rather monotonous colour scheme. It brings the picture to life.

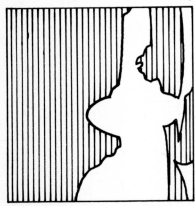

Mass colour. Dominant red (see page 222)

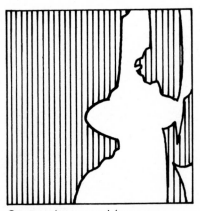

Gayer colour mood (see page 226)

Black picture elements (see page 189, Fig. 9)

Summary

The pictures do not follow any rigid colour rules. Yet they make their point and use colour well. Red is not a good background colour. Nor is it the ideal complement to the Spaniard's dress. But the figure undoubtedly attracts attention and the vivid red is not as distracting as theory might have considered it. On the right, we have pastel tones interrupted by a saturated colour. Yet, again, the result is striking and a satisfactory picture is created.

Shooting data

Left: Leica, Elmar 90mm, Agfacolor CT18, 1/50 sec. *f*4. *Fulvio Roiter.*
Right: Leica, Summicron 50mm, Kodachrome II, 1/100 sec, *f*16. *Hildegard Sandhusen.*

Accent colour

Economical use of colour (see page 230)

Red in front of a monotone background (see page 189, Fig. 8)

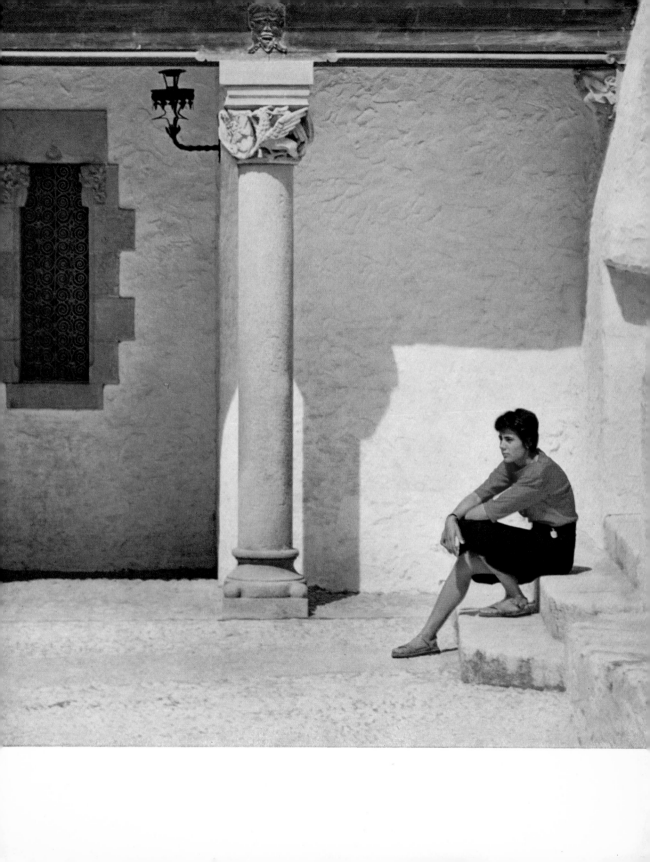

Two-tone colour harmony

It is said that colour photography is not coloured photography and it is worth bearing in mind that brilliantly coloured pictures are less likely to show good colour harmony than those with more subdued colour.

Pictures with only two basic colours usually have a strong theme. They attract more attention to the subject itself than do pictures with a wide range of brilliant colours. Two main colours are usually enough to give all the creative scope you need.

Shooting against the light helps to restrict the range of colours in the picture, as the following left-hand picture shows. Both pictures use subdued colours, with no accents to attract attention. This can destroy the whole picture if the general composition and arrangement of mass and tone are not carefully managed. The two-tone theme is not unnatural. Most scenes around us are less brilliantly coloured than we tend to think. Colours are largely man-made and where they appear in profusion they rarely make a satisfying picture.

Colour control

When colour contrast is not available, the composition of the picture follows similar rules to those for black-and-white photography. The shape and positioning of the main elements, the variations in weight brought about by light and shade, differences in size and similarities of line each have their particular effect.

The subject

The left-hand picture is an example of a well-organized shot, with carefully arranged horizontal lines leading like ladder steps to the blue-green background. The backlighting creates the strong horizontal lines, just sufficiently broken by the few verticals to avoid monotony. The right-hand picture shows a reversal of the theme. The green colours are this time in the foreground ; the brown rope, with its reddish tendency, seems closer to the figures than it really is and eliminates all sense of space.

Two-tone colour. Economy in the use of colour (see page 230)

Blue background (see page 190)

Subdued colour mood (see page 226)

Summary

Colour pictures do not have to be garish. Subdued colours can be as effective as brilliant colours. A bright colour accent is often useful but is by no means always necessary. The photographer is in charge and he makes the rules according to his view of the subject.

He can find subjects like this in many places—beaches, river banks, fields, forests and even in towns, where drab, almost colourless scenes are common enough. They can be presented as effective colour pictures if the photographer selects his viewpoint with care and forethought.

Shooting data

Left: Leica, Summitar 50mm, Agfacolor CT18, 1/100 sec, *f*8. *Ara Güler.*
Right: Leica, Elmarit 90mm, 50 ASA colour slide film, 1/250 sec, *f*5.6. *Laurent Caravelas.*

Two-tone colour: colour harmony

Green as mid-distance colour (see page 194), here in the foreground.

Warm colours (see page 190)

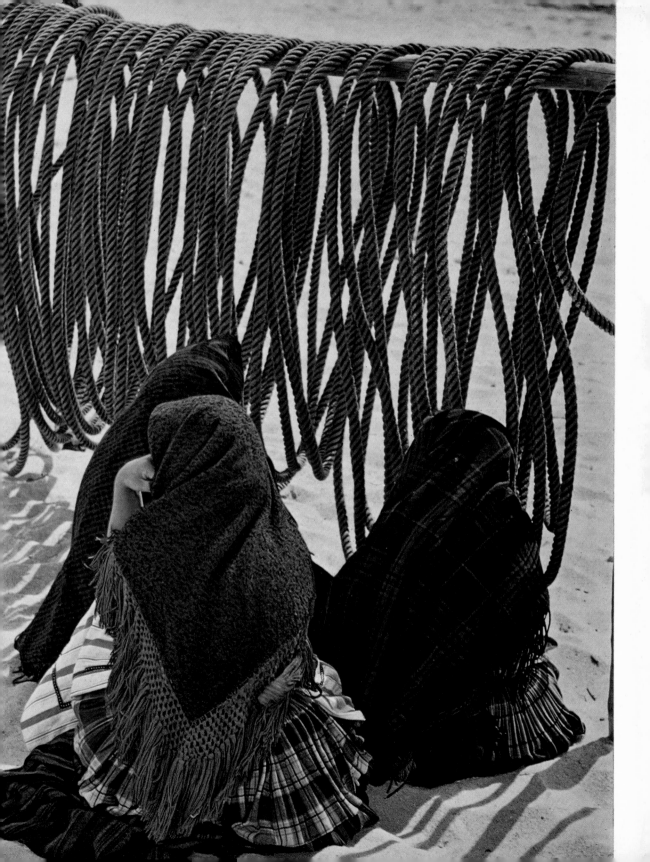

Contrasting and complementary colours

Colours contrast with each other, the nature of the contrast depending on the relationship between the colours. Colours lying close together in the colour wheel compete with each other when they are equally brilliant. Therefore, a dominant colour has to be created by greater brilliance, and possibly greater area, to avoid an unpleasant clash.

Complementary colours go particularly well together. These are the colours opposite each other on the colour wheel, such as red and blue-green, yellow and blue, green and purple, orange and cyan, yellow-green and violet. They offer a more pleasant form of contrast.

The red fruit on the following left-hand page is shot in close-up with very little depth of field so that it stands out prominently. The leaves become hazily decorative additions.

The plants on the right-hand page are not particularly carefully arranged within the picture area but the lens aperture used ensures that all important parts are rendered sharply if not critically sharp all over. The subject suggests a format, and the trim follows this. In this case the trims are quite tight. The background in all the pictures is thrown so far out of focus that there is no conflict with the subject matter; even colour is weakened when thrown out of focus.

Colour control

These pictures illustrate clearly the influence of colour contrast with complementary colours. The red fruit on the left is set in a background of bluish white with the leaves of almost neutral colour acting as a mediator between the two and damping the contrast. The pictures on the right-hand page show the contrasts evident in nature. The individual fruit stands on its complementary blue-green stalk against an even background. The blue fruit has the subdued orange leaves for contrast while the red fruit below again appears with its blue-green complementary. The contrasts in these pictures are softened by the intermediate yellows and greens appearing in the background and leaves.

The subject

Only colour film can produce true records of this type of subject, all of which are close-ups calling for tripods, bellows or extension tubes, etc. The most suitable camera is the single lens reflex, which presents the picture exactly as the film sees it and allows precise focusing and composition. It sometimes adds to the pictorial quality if rain-drops, frost, etc also appear on the fruit or foliage. But one should avoid strong colour casts from surrounding subject matter, which might disturb the general balance.

Dominant red (see page 222); foreground colour (see page 190)

Cool colour; background colour (see page 190)

Colour contrast

Summary

The colours in nature are generally harmonious. It is therefore only necessary to arrange the subject and choose the camera position to obtain the most pleasing effect. Close-up shots are particularly effective because they enable disturbing colours to be eliminated by selective focusing and tight framing of the subject.

Shooting data

Left: Picture from Kodak Archives *Right:* All with 35mm reflex, Xenar 105mm, Agfacolor CT18. (*Left*) 1/25 sec, f8. (*Top right*) ½ sec, f8-11. (*Bottom right*) 1/5 sec, f8-11. *H. G. Müller-Greiff.*

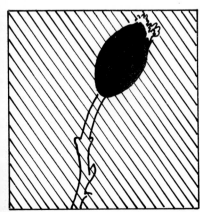

Complementary colours: red and green

Complementary colours: blue and orange

Dominant red (see page 222); foreground colour (see page 190)

Real and abstract colour

In straightforward photographs of ordinary subjects, colours take the shape of the objects photographed. But abstract colour shapes can be just as pleasing and need not be the product only of the painter. The photographer can produce them, too, if he keeps his eyes open. He may see pure colour compositions or a subtle intermingling of colours. By the seaside, for example, the receding tide often leaves curiously coloured objects on the beach. Weathered objects can also show interesting shapes and colour, while water offers opportunities for creating such effects artifically by dropping oil-based colours on to it.

These abstract colours are most successful in a picture when they fill the frame. It is better to concentrate on the really effective parts of the shapes and colours and be prepared to act quickly, because often it is just a matter of luck if you run across

such subjects and they may well change rapidly in character.

The natural arrangements of an abstract subject may not be enough in itself to make a picture. A photographer has to apply his experience and commonsense to take advantage of the opportunities offered. The following two pictures illustrate these points.

The painter in the left-hand picture is removing rust from the side of a ship. He himself, the board he sits on and the scraper he holds are all real objects not just shapes. But the colours on the ship's side make abstract colour shapes. It is a moot point which category the enormous anchor should be placed in.

The lighting is well chosen. Coming from the side, it emphasizes the rough metal structure and puts life into it.

The picture on the right is pure abstract, created by the effect of sea water on an old breakwater.

The incredible symphony of colour has enormous appeal.

Colour control

Pastel tones predominate in the background of the left-hand picture, with rich variations from yellow to blue-green but with no disturbing contrasts. The man's clothes provide the contrast and life the picture needs.

The right-hand picture is very different. It has almost all the colours of the rainbow, through red, orange, yellow, green and blue. The randomly placed dark growths bring life to the upper parts, while the marked vertical lines tend to impart a sense of balance and unity.

In each case, the colourful compositions are fortuitous, created by weathering and salt water corrosion. The photographer's job was to fill the frame with the most effective parts of the scene. The painter's arm helps the composition by

Abstract colour shapes

Complementary colours: blue and yellow-orange (see page 206)

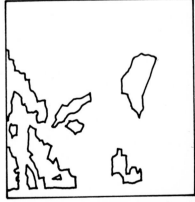

Warm colour : yellow orange (see page 190)

leading the eye directly to the sunsplashed yellow and blue-green patch above him.

The subject

The picture on the left is an everyday scene that could have been taken in almost any harbour. That on the right is more unusual but is probably not unique. Both, however, show harmonious colour arrangements which, existing in such unexpected, almost mundane forms, create quite an impact.

Summary

Both these subjects show fascinating colour composition. Unfortunately, however, this type of subject is rather overwhelmed in our colourful world of brilliant artificial dyes and pigments and often passes unnoticed. These two *were* noticed by an alert photographer and recorded to give us pleasure.

Shooting data

Left: 35mm SLR, Agfacolor CT18, 1/250 sec, f5.6. *Niklas Deak.*
Right: Leica, Summicron 50mm, Agfacolor CT18, 1/200 sec, f5.6. *Jürgen Newig.*

Abstract colour shapes

Warm colour : yellow orange (see page 190)

Black shapes : balance and co-ordination (see page 189, Fig. 9)

Colour planning

Even our photographic grandfathers planned their pictures. They used props to bring life to a "dead" landscape and they took pains to arrange them in a natural fashion so that they did not look out of place in the subsequent pictures. In this respect, nothing has changed. In fact, planning is probably *more* common in photography than you think. An apparently off-the-cuff picture is quite often laboriously put together by the photographer. Planning can be an aid both to composition and the creation of ideas.

Such interference with the natural order of things must, however, be in complete harmony with its surroundings. If it becomes obvious that there is something out of place, something that does not belong to the milieu in which the photographer has created his idea, the whole concept is destroyed.

This type of idea often has something of a fantasy, fairy story or dream world about it. But the various elements must still hang together and be suited to the surroundings in which they are placed. Both the following pictures have natural surroundings as their framework and they use those surroundings at least in part to help create the characters they idealise.

Colour control

Both pictures are dominated, in terms of quantity at least, by green, which is supplied by nature. The complementary colours—red, red-brown, blue—result from the photographer's organization of the picture content. Even the flesh colours are, of course, additions made by the photographer. They are always available as a counterpart to green and blue.

The warm colours are carefully placed in the mid-distance—

deliberately so, as part of the colour composition. They are, in fact, the basis of the planned picture content.

The subject

Maurice Baquet, a poet and musician, tried to express his two talents in the picture on the left. He used the birch tree in a green meadow as a romantic symbol of his poetic nature and suspended the cello in mid-air to symbolize his musical tendencies. Who is to say that it is out of place in such a fantasy creation?

In the other pictures, we are faced with a dream figure, intended to appeal to the child in us all. The complementary contrasts are barely hinted at by the skin colours and the dominant green, expressing a fairytale-like and impressionistic atmosphere, strengthened by the out-of-focus foreground leaves. The whole impression is one of fantasy.

Colour planning

Complementary colours (see page 206) ; green as colour mass (see page 198)

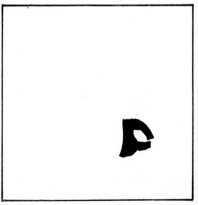

Red as colour accent (see page 198)

Summary

The organization of colour pictures requires more than an idea. There must be complete harmony between the idea, its expression and the environment in which it is placed. This calls for vision and an appreciation and understanding of the fantasy world, because that extra something these pictures possess owes everything to that essential touch of fantasy.

Shooting data

Left: Leica picture ; other data unknown. *Robert Doisneau.* *Right:* Agfacolor CT18, 1/125 sec, *f* 5.6. *Jochen Distler.*

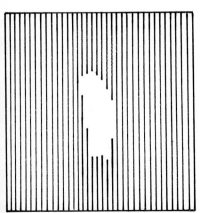

Green as colour mass (see page 198) ; dominant colour (see page 222)

Warm colour (see page 190)

Colour contrast (see page 206)

215

Colour composition

In a good colour photograph, the subject may often be of only minor importance while the colour plays the vital role. Nevertheless, the picture cannot live by its colours alone. It succeeds or fails on the colour composition—the way the colours are put together.

You must learn how to handle colours by studying and analysing as many good pictures as you can find.

The colour picture can become a battlefield on which many picture elements fight for supremacy ; but there must be only one message. You must control the battle so that the single message is put across clearly, and both subject and colour are combined into one unit.

The search for colour compositions is best pursued in the fields, the meadows, the woods, the hills and other natural surroundings. Travel alone preferably. You are not likely to have much success if you owe some attention to those who are with you. They are sure to destroy your concentration.

This type of photograph uses relatively subdued and restful colours to a great extent but does not necessarily exclude bright colours entirely. They are frequently necessary to give the picture a focal point. Depth is of some importance, too. We do not need to see into the far distance but we do need more than two dimensions.

Colour control

Depth can be shown effectively by a change of colour between foreground and background or by the interpolation of a bright area. Such bright areas must not be placed near the edge of the picture. They attract attention strongly and can lead the eye right off the edge if badly placed.

The subject

The following pictures have similarities and differences. They are both of forest areas, one Japanese and one European. They are both, basically, colour compositions but the mood and message is very different in each case. The Japanese picture uses colour contrasts to provide depth and a red splash is provided as a centre of interest, repeated in subdued mirror fashion lower down. The stag in the other picture stands in a bright area that immediately draws the eye into the picture without completely destroying the effect of the beautifully rendered foreground.

Long-focus lenses were used for both shots. On the left, the foreground leaves are thrown well out of focus to help the impression of depth and to make the picture essentially a composition in colours. On the

Warm colours (see page 190)

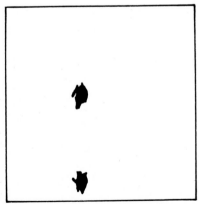

Red as accent (see page 198)

Colour contrast (see page 206) ; cool colour blue (see page 190)

right, the long focus lens has drawn the planes together, bringing the distant trees in as an effective "stopper" and background for the stag.

Summary

Pictures relying mainly on their colour composition must be restful, with no conflict between a strong subject interest and the interest that lies in the colours themselves. That is why such pictures are more likely to be found in the country than in the town; nature's colours are less garish and the atmosphere less sophisticated. A photographer has to train himself to see the colour combinations that abound in nature and it is worth repeating that the search is a job calling for concentration and is best pursued alone.

Shooting data

Left: Pentax, 200m lens, Agfacolor CN17, 1/125 sec, *f*8. *S. Nagao.*
Right: Leica, Hektor 135mm, Agfacolor CT18, 1/100 sec, *f*8. *André Fagneray.*

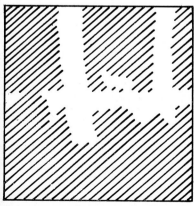

Green as a colour mass (see page 198)

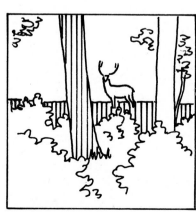

Colour harmony (see page 202)

Warm colours : yellow and brown (see page 190)

The dominant colour

Every colour photograph does not have to be a "riot of colour". Preferably, it should not contain a wide range of colours of equal area and brilliance, which compete with each other for attention. It is better to organize the picture so that one colour is dominant, making all other colours subservient to it and harmonious with it and with each other.

Every good colour shot depends on the dominance of a particular colour. This colour controls the whole picture, setting the tone and mood. You must realize this before releasing the shutter, because exposure and viewpoint both have an influence on the rendering and positioning of dominant colour. Scrutinize all the colours in the scene and their relative values so that you can seek to organize them satisfactorily in relation to the dominant colour.

The pictures on the following pages both have a dominant colour—blue on the left, red on the right. The blue of the man's clothing is echoed in the much paler sky colour. The small patch of red in the woman's dress is echoed in more vivid form in the foreground and reflected into the material she is holding.

Colour control

The dominant blue in the left-hand picture is immediately apparent as such. It coincides with the main subject interest, whether by accident or design, and it suffers no competition from the other, far less saturated colours. It also stands well forward of its natural background position as a cool colour.

The dominance of the red in the right-hand picture is more subtle. It saturates the foreground but has its influence, too, in other parts of the picture by reflection and repetition. The extensive blue and green areas contrast strongly with the red but never challenge its supremacy.

The subject

The pictures have strong similarities in that they portray similar locations, both deal with activities in the mid-foreground and both have dominant colours. They have been carefully organized by the photographer's choice of viewpoint and shooting distance so as to frame the pictures tightly and present them as complete units.

Dominant blue

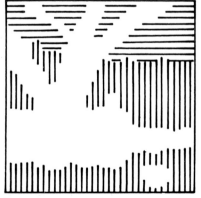

Colour as a mass (see page 198)

Colour as an accent (see page 198)

Summary

There is no need to travel to far-away countries to find a scene containing really vibrant colour. These colours exist everywhere. The main aim, having found them, should be to use them selectively enough to produce a picture whose dominant colour can survive its surroundings and form a pleasant harmony with them.

Shooting data

Left: Leica, Elmar 90mm, Kodachrome. *Emil Schulthess.* *Right:* Retina Reflex, Ektachrome, 1/125 sec, *f* 8. *P. Kroehnert,* Kodak Archives.

Dominant red; foreground colour (see page 190)

Abstract colour shapes (see page 210)

Complementary colours green and red (see page 206)

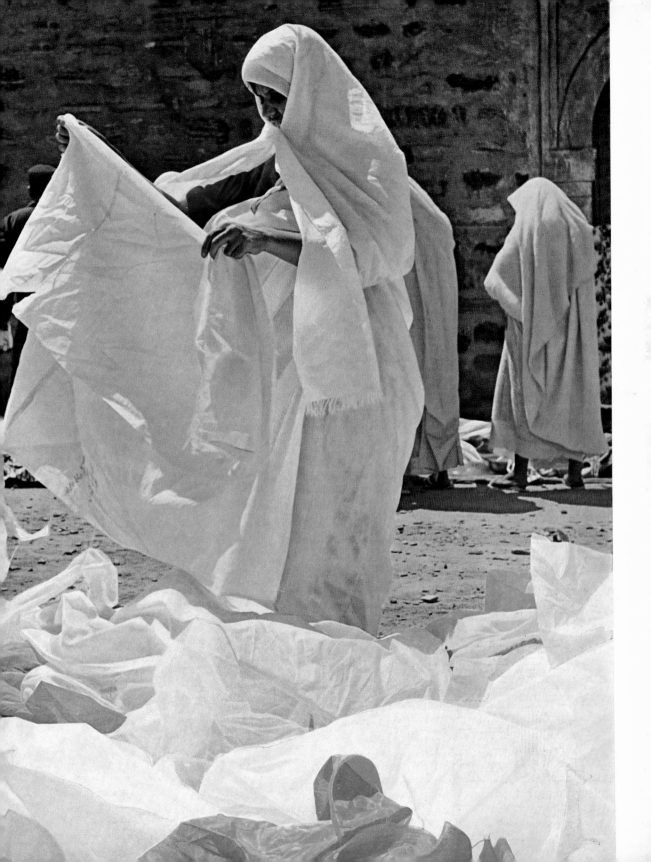

Colour atmosphere

Each colour tells its own story. It has its own mood or atmosphere. This could be expressed in tabular form but that would overlook the fact that each colour also has countless variations. A yellow-red, for example, has entirely different connotations from a blue-red.

Every colour picture has some sort of atmosphere or mood. It may not be particularly obvious, but it is there. We think of a certain yellowish red as typical of the sunset but the same colour appears in many other things. We tend not to notice that and indeed only when we look into the smaller things, the trivia of life, do we make real colour discoveries.

Colour atmosphere stems from a single, dominant colour that controls the picture. It may be a foreground or background colour or one of the intermediate colours depending on the mood or message of the picture. The colour photographer can

search for mood in the scenes around him or he can so arrange his pictures to create the mood he requires. In the one case, the mood is already there and he has to choose his viewpoint to present the picture to the best advantage. In the other case, he may see a picture that lacks atmosphere and he has to place flowers, drapes, cushions, etc, in the right position or change his viewpoint to include a back-ground or foreground of more suitable colour.

Colour control

Picture composition and the selection and placing of the colour are inter-dependent. In the left-hand picture overleaf flowers in the window impart a warm sensation, emphasized by the contrasting blue in the background and the black steel shutter.

The particular rendering of the blue in the right-hand picture

strikes a melancholy note—a disturbing colour with a question-mark attached to it. It attracts attention to itself but remains somewhat enigmatic, inviting closer examination to discover its exact purpose.

It is such fascinating colours as this in the smaller details of a picture that create the greatest interest. There are many such colours, creating their own, distinct mood and atmosphere, giving particular pleasure when found so aptly applied to the subject.

To capture such elusive colour qualities you only need to release the shutter—provided, of course, the colours are appropriately positioned in the frame, and not lost by a careless choice of camera position.

The subject

It was no doubt simple to arrange the flowers just where they were wanted, but to get a cat to

Colour atmosphere : warm impression

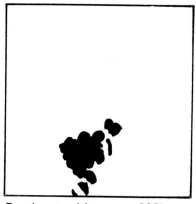

Dominant red (see page 222) ; foreground colours (see page 190)

Background colour blue ; cool colour (see page 190)

sit in the right place is no easy task. The colours are not too difficult to organize in the picture, provided you know just what effect you are after.

To see and then reproduce is the first aim of colour construction. To see and to condense might be the next. Both pictures show how the photographers have concentrated attention on a few details. By choice of camera viewpoint they have selected particular parts of the subject to convey the required mood.

Summary

Colour atmosphere can often be created by quite small touches. To position a suitable bunch of flowers or to notice a significantly coloured cover on a chair to put the final touch to the atmosphere required is a relatively minor effort in colour organization, but a rewarding one when it turns out so successfully.

Shooting data

Left: Leica, Elmar 50mm, Ektachrome. *Robert D'Hooghe.* *Right:* Leica, Elmarit 90mm, Adoxcolor C18, 1/125 sec, *f*4. *Ludwig Friedel.*

Melancholy colour atmosphere

Dominant blue (see page 222)

Economical use of colour (see page 230)

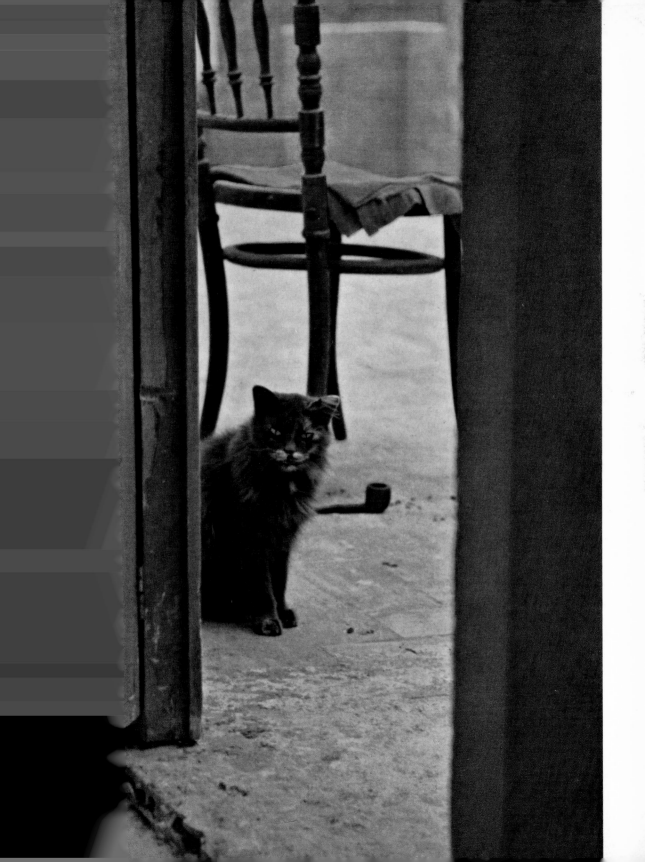

Economical use of colour

Colours sometimes have a high black content which subdues the hue considerably. This form of colour usage is, unfortunately, too often overlooked. There are just as many opportunities for expressing mood and atmosphere with subdued colours as with brilliant ones.

Restrained use of colour is often linked with economy in subject matter: one main subject may appear with just a detail or two. The two pictures on the following pages are outstanding examples. They also illustrate the folly of the one-time belief that colour photographs can be taken only in fine weather. Both were taken in extremely dull conditions.

A colour photographer has to have a "nose" for this type of picture. He must be a believer in the unspectacular—the type of picture that exists everywhere, and have the skill to make the most of it.

The following pictures both came from the animal kingdom and natural settings. The animals occupy large parts of the picture, bringing them fully to life. The natural, undisturbing colour quality adds to the air of actuality

The branch included with the doe tends to give it perspective, while the rest of the picture area is virtually empty. In fact, no further addition could have improved the picture.

The bird in the right-hand picture is framed by the silhouetted branches. These add balance and solidly counteract the dynamism of the bird's image.

Colour control

It might seem that colour control can hardly apply to such pictures as these. But, of course, the same rules apply whatever the nature of the colours. The brownish body of the doe is echoed in the background—a repetition which helps to hold the picture together. The bird and the branches in the other shot are black. Colour appears only in the sky and the hint of ground area below, where there are traces of warm colour. Such a vague, almost toneless background is quite enough in the right circumstances to complete a colour composition and on a factual level suggest a location.

The subject

Such moody pictures are hard to achieve in warm sunny weather. But when the sun goes down or slips behind clouds, when it is raining or snowing, or in other dull-light conditions, there are abundant opportunities. Exposure is likely to be rather tricky and one half stop or so more than the meter recommends may be advisable where detail is required in the deeper tones. But over-correction can ruin the tonal scale

Economy in the use of colour

Warm colour : foreground colour
(see page 190)

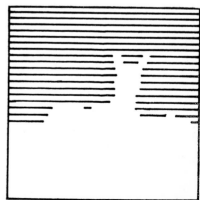

Cool colour : background colour
(see page 190)

can only be followed in a relatively small number of cases.

The subject

Red is unfailingly effective as an accent in almost any picture. The problem is to arrange the red suitably against the other colours surrounding the subject without losing its striking quality. Very strong reds are less likely to be "drowned" but are more difficult to harmonize.

Very different shooting techniques were required for these pictures. That on the left needed a quick trigger finger to arrange the elements in the order required. The right-hand picture was a more leisurely arrangement, every effort being made to place the berries in the perfect position within the frame.

Summary

The effectiveness of colour accents in the picture composition depends very much on choice of camera viewpoint and positioning the accents in the frame. The screen or viewfinder image should be studied carefully and various positions tried to obtain the best possible effect before shooting.

Shooting data

Left: Leicaflex, Elmarit 135mm, Agfacolor CN17, 1/125 sec, *f*5.6. *Hans Rudolf Uthott.*
Right: Leica, Hektor 135mm on Visoflex and extension bellows, Kodachrome II, 1/10 sec, *f*11. *Rudolf Link.*

Colour mass (see page 198) ; background colour (see page 190)

Dominant red (see page 222) ; picture construction : accent (see page 234)

Rising diagonal (see page 246)

235

Optical lines—triangular construction

Where many points in a picture appear not as groups but as separate shapes the eye tends to trace a line between them. This is an optical line. The line may be straight or curved, making a circle, ellipse, or parabola. Three points or more that are not in a straight line will generally form an optical triangle. Even where only two of the lines are obvious, the eye creates the third as an optical line. Thus, a triangle can be both actual and optical. Such an arrangement can be found in a walking person, as in the photograph on the following left-hand page.

Such shapes are frequently found with other moving subjects. Where these shapes are clearly defined, they are often only formed momentarily, so you have to shoot quickly. If several subjects can be included, so much the better. Then, with prints at least, you can select which parts to use at a later stage.

Picture structure

The six bullfighters walking into the arena create a natural left-to-right movement which has a purposeful rhythm. The picture on the opposite page shows the bullfighter in action. The long-focus lens concentrates on the really important features and allows no superfluous details to appear. Inside the curved shadow of the arena it brings out a triangular effect formed by the action and the shadows.

Colour control

Although the left-hand picture contains an extraordinary number of colours it cannot be regarded as chaotic. Just as the movement of the six figures is seen to be rhythmical so is the colour arrangement. They all wear red stockings, the same headgear, the same shoes and there are similar patterns on their clothing. The surface on which they move

is of a single neutral colour that does not draw interest from the bullfighters, who are the main subject.

The right-hand picture is full of action and colour. The red cape dominates the scene and keeps catching the eye. But the brilliantly lit bullfighter is by no means overpowered; his own colours stand out strongly in marked contrast to the startling cape and the neutrality of the arena.

The subject

Both pictures, but particularly that on the left, show the advantage of the high viewpoint in separating many figures in a scene. This is a point worth remembering in any picture containing parts that might be obscured by others or appear to be joined on to them. They are also good examples of how to use the whole picture format, leaving virtually no wasted space. This

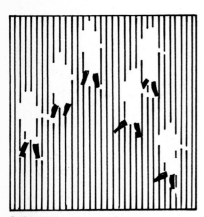

Colour as mass—colour as accent (see page 198)

Optical triangle

Angle (see page 262)

very often calls for a careful choice of lens and/or viewpoint.

Summary

These pictures are examples of action brilliantly caught at just the right moment. The left-hand picture depended on the relative positions of the individual figures. It is rhythmic rather than dynamic. The right-hand picture is dynamic in the extreme and presents both man and animal in typical stances of grace and force. The shutter was released at precisely the right moment, with the man's face visible and his cape almost clear of the bull.

Shooting data

Left: Leica, Hektor 125mm on Visoflex, Agfacolor CT18, 1/500 sec, *f*8. *Ludwig Friedel*. *Right*: Leicaflex, Elmar 135mm, Agfacolor CT18, 1/60 sec, *f*4. *Anton Kaiser*.

Dominant red

Triangle

Angle (see page 262)

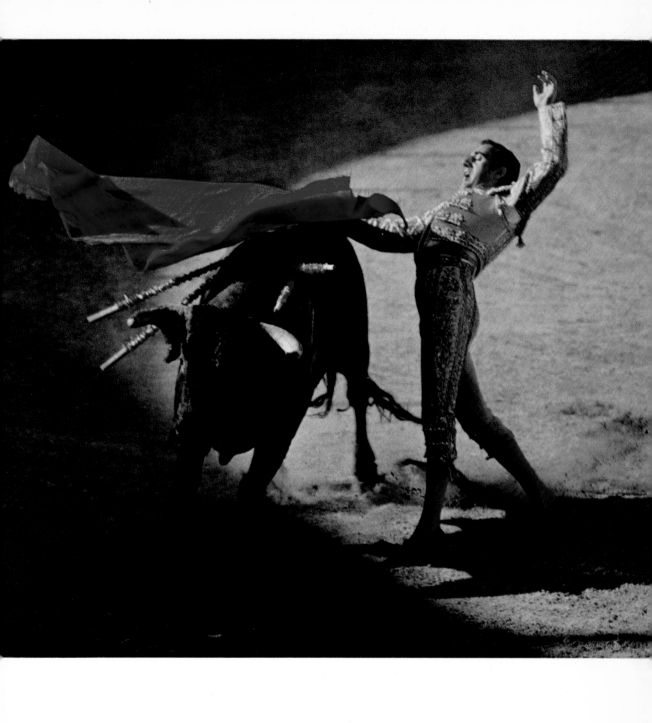

Horizontal and vertical lines

Lines can be an aid to picture construction or they can play the chief role. This does not mean that the construction should be worked out mathematically but that the lines can be so strongly emphasized as to dominate the picture and give it a special theme or atmosphere. This applies mainly of course to the subject but can also apply to colour.

The horizontal line expresses an atmosphere of harmony and quiet. It is normally used in a horizontal format but can also convey a widening effect in an upright picture especially when several lines are included to split the picture into many small rectangles. The use of many horizontal lines can, at the same time, give an illusion of depth in the scene.

A vertical line has the opposite qualities. It acts as a fence over which it is impossible to climb and destroys the impression of depth in the subject. When used in an oblong picture, vertical lines give apparent added height.

Picture structure

The following left-hand picture contains emphatic horizontal picture elements, while the right-hand picture is dominated by the verticals. The central horizontals are particularly strong and stretch right across the picture. They are prevented from cutting the picture in two, however, by several repetitions. The window frames in the background create horizontal lines which are rhythmically unbroken. Thus the shot gives a very marked impression of depth.

The shot opposite shows a lot of vertical lines of a curtain, deliberately made hazy to prevent them from appearing so dominant as to kill the interest in the background. A gap has been left at one side of the picture, however, to present one strong vertical and so set the theme of the picture.

Colour control

The outstanding colour feature of the left-hand picture is the thick yellow boom, which presents a warm yellow with just a trace of red. The red splash in the foreground creates harmony and a spatial orientation with the row of houses in the background. The blue horizontal area in the upper part of the picture not only gives support—and harmonic support at that—to the horizontal lines but also fits in as part of the linear picture construction.

The picture from Venice on the opposite page has no particularly emphatic colours in the foreground. It is only behind the curtain that bright colour spots show here and there. A definite strong colour is shown only in the blue water. Attention is therefore not contained behind

Dominant yellow (see page 222); warm colours (see page 190)

Cool colour blue (see page 190)

Horizontal line

the curtain but is drawn out into the background.

The subject
Neither picture is drowned in a myriad of colour details, although many colours are present. Nets and curtains are excellent aids to damping the effect of main details. But all haziness disappears when, as in both pictures, gaps are left in the diffusing materials. It is remarkable that in both cases the gap is at the edge of the picture and is not particularly prominent.

Summary
Line elements mainly serve to set the mood of the picture. The left-hand scene is basically quiet and peaceful, while that on the right is busy with action. Nevertheless, the action is observed from behind a sort of diffusing screen which damps down the vigour a little and makes a compromise in both colour and mood.

Shooting data
Left: Ektachrome-X. Other details unknown. *D. Geyer*, Kodak Archives.
Right: Leica, Elmar 90mm, 1/150 sec, *f*8-11. *Ludwig Friedel.*

Cool colour blue ; background colour (see page 190)

Red colour as accent (see page 198)

Vertical lines

The diagonal

The diagonal is an expression of vitality, but it should not be so strong as to divert attention from the picture itself. Its aim should be to support the horizontal or vertical elements in the picture composition, not just to conduct the eye off to the corner of the picture.

A diagonal in a composition can be either rising or falling. From bottom left to top right, it is considered as rising, and is a positive cheerful line according to psychological theory. The falling diagonal gives a marked impression of movement, but with a negative or downhill feeling. The effect of diagonals can be weakened by vertical or horizontal lines or by counter diagonals.

Picture structure

The pair of pictures on the following pages show both kinds of diagonal. The left-hand picture is dominated by many rising diagonals and that on the right-hand side by a strongly marked falling diagonal. In both cases, however, there are counter lines. The rising diagonals are countered by falling diagonals in the carrier at the top and across the carrier in the foreground as well as the less strongly marked lines in the cheeses and the road surface. The strong rising diagonal made by the cheeses is also broken by the leg positions of the two men.

The direction of the body of the melon seller is a falling diagonal interrupted by breaks in her dress and balanced by the strong horizontals of the melons themselves and the boards on which the woman crouches.

Colour control

In the picture on the left, the ubiquitous red spot is found in the headgear of the man in the foreground. It is an eyecatcher, contrasting admirably with the considerably more drab clothing of the other men and balancing the mass of warm yellow provided by the cheeses.

Violet is a difficult colour. It always catches the eye but demands a very precise choice of colour with which to harmonize. The green of the melons and the colour of the wooden boards are excellent choices. The skin colour on the arms mediates between the diluted green and the colour of the wood. The violet is the most arresting colour in the picture but it is not so brilliant that it outweighs the others.

The subject

The picture on the left-hand page illustrates two technical points of note. It shows that brilliant sunshine is by no means necessary to picture a colourful scene. And it demonstrates the value of a careful choice of viewpoint and lens. A long-focus

Complementary colours red and green (see page 206)

Rising and falling diagonals

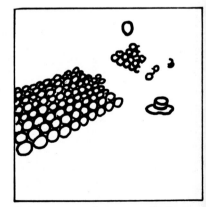

Colour accent (see page 234)

lens from a high viewpoint excluded all inessential details and framed the exact picture the photographer wanted. He was also able to shoot without attracting attention. The other photographer, shooting from behind, also with a long-focus lens, was in no danger of being seen and could wait for the best moment to shoot.

Summary

It is nearly always possible to create a line in a picture by choice of viewpoint. The main thing is to make sure that the line suits the subject. The cheese handlers could have been shot in such a way that the lines were predominantly either horizontal or vertical. Neither would have created the right atmosphere of cheerful activity.

Shooting data

Left: 180mm lens, Agfacolor CT18, 1/125 sec, *f*5.6. *Hans Kanne.*
Right: Leica, Telyt 200mm, Agfacolor CT18, 1/500 sec, *f*4. *Dr. Karlheinz Andres.*

Dominant violet (see page 222)

Falling diagonal

Circles (see page 254)

The S-line

One of the best-known of all forms of composition is the S-line. The idea is that it leads the eye into the picture in a gentle, leisurely fashion and eventually finishes up in an area of major interest. It must not lead straight off the edge of the picture.

The S-line is a rather stylized form of expression and should, therefore, be echoed in the whole atmosphere and construction of the picture. It is not static, but is rarely found in really dynamic pictures. One of its most useful functions is to heighten the impression of depth in the scene.

Picture structure

Both the following pictures are dominated by an S-line leading into the depth of the scene reinforcing a suggestion of the third dimension. But the two lines differ. One is taken from a high viewpoint and presents a full, curving S, while the other, from ground level, has a flattened, more angular line.

The woods in the upper part of the left-hand picture act as a barrier to the S-line travelling right across the picture area. The eye is thus kept within the picture frame. In both examples the line is broken in the distance by a heightening of the colour which brings the eye back to the middle of the picture.

The cyclist is well placed. He provides both a starting point and an eventual resting place after the eye has taken in the whole scene.

Colour control

The colour in the left-hand picture strengthens the S-line. The yellow-grey road is bordered on both sides by green lines, which contrast with the yellow content and intensify the optical effect of the light road surface.

The structure of the right-hand picture is also supported by its colours. The orange-flecked bollard in the foreground is echoed by the building in the distance, a stopping point for the S-curve. Between the two, the bend in the foreground is strengthened by more orange. The bluish snow through which the water runs contrasts with this orange and gives it added brilliance.

Both pictures show how composition and colour can complement one another.

The subject

In the early spring there are many scenes like the left-hand picture for those who take the trouble to get out of town and find them. They do not, of course, have to contain the human figure that this picture uses so well. You may need patience waiting for a suitable subject to turn up. And then the moment the figure reaches the right spot, you must be quite ready to take the picture. Alternatively, you could arrange

Dominant green (see page 222)

S-line

Verticals (see page 242)

all this with your subject beforehand and try several shots with his assistance.

The right-hand picture, taken in the Wexford district of Ireland, needed some "assistance" from the photographer himself. To provide a contrast between the relative scale of foreground and background and to give depth (albeit exaggerated) to the picture, he used a short-focus lens. Without it, he would not have been able to get both the nearby and distant parts into sharp focus or in such perspective.

Summary

The S-line is such a well known gambit that the photographer must be careful not to overdo it. He does not create a picture simply by creating an S-line. He could, in fact, ruin his picture by paying too much attention to the line and overlooking the fact that it leads attention away from the major point of interest or, indeed, that there is no other point of interest in the picture. The line by itself is unlikely to be able to sustain the role of the main subject.

Shooting data

Left: Leica, Telyt 200mm on Visoflex, Agfacolor CT18, 1/125 sec, *f*8. *Carl Bremer.*
Right: 6 x 6 SLR, 56mm lens, Agfacolor CNS, 1/125 sec, *f*8. *Heinz Gottert.*

Warm colour orange—foreground colour (see page 190)

S-line

Rightangle, rectangle, triangle (see pages 258, 262)

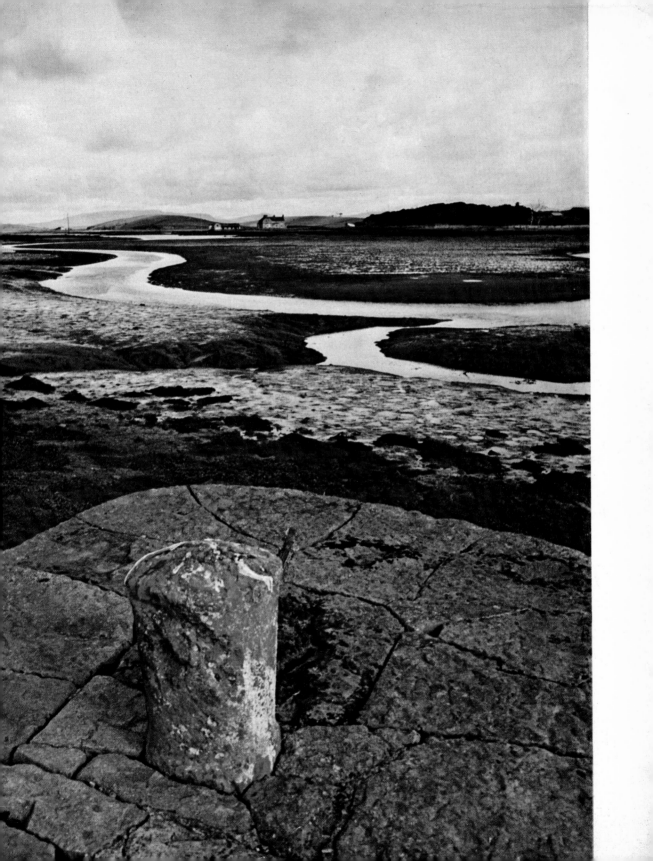

The circle

Curved lines give a sense of grace and serenity. They take the eye through the picture elements in a harmonious and leisurely fashion. When the curves turn back on themselves to come full circle they can have a variety of meanings. There is a sense of fullness, of completion, as implied in the expression "seen in the round".

The circle is a symbol for infinity, with no beginning and no end. It can be enigmatic, complete and yet infinite. Circles can appear singly, in groups or linked together to form a chain, implying strength or related ideas.

The circle can be split into half circles and quarter circles—forms often seen in architectual details, where they round off a structure or soften the harshness of more angular or uncompromising lines.

Picture structure

There are countless opportunities for discovering the circle in composing the picture. It appears naturally in many scenes—from the sun and the moon to the beachball and the dustbin lid. Intentional halation from bright lights or even out-of-focus images of them can introduce a single circle or a pattern. The sweep of a bay can be shown in semi-circular form. The wheels of carts, farm implements and even the helmsman's wheel have formed motifs in many pictorial compositions.

Artists have used the circle and parts of it in innumerable pictures both old and modern, from the halo to the abstract pattern. Stained glass windows use them extensively, as the examples on the following pages show.

These windows are in Chartres cathedral and they draw vast crowds of visitors from all over the world every day. Many of these people carry cameras but most of them fail to capture the real beauty of these masterpieces. They can be photographed satisfactorily only with a telephoto lens (to increase the shooting distance and so minimize the upward shooting angle to the window surface), or from a scaffold specially erected close to the windows—a solution which is out of the question for most people.

With such subject matter, the photographer's influence on the picture content is confined to his selection of an area that makes the most satisfying composition. Then he has to concentrate on reproducing it on his film in such a way that no detail is lost.

Colour control

The colours themselves were settled by the original artist. All we can do is to select an area and then reproduce its colours as faithfully as possible. Colour slide film is generally preferable because it comes close to a

Dominant blue (see page 222)

Circle

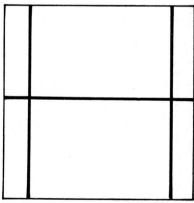

Horizontals and verticals (see page 242)

representation of the brilliant, transparent colours of the original. The print on paper inevitably loses some of this brilliance, as, indeed, do the illustrations in this book.

The subject

Accurate reproduction of the colours in a stained-glass window is not easy to obtain. It is not even easy to decide what accuracy is, because the windows look different according to the light shining through them. Brilliant, direct sunlight is certainly not the best light by which to photograph such subjects. Far better is the bright light from a slightly overcast sky.

Exposure determination can be tricky. If a meter reading can be taken from a position that allows the window to fill the measuring angle of the meter, a straightforward reading is likely to be satisfactory. Nevertheless, it is a good idea to take a number of shots giving different exposure times which will give more chance of success.

Use a tripod if possible. Not only are exposures likely to be too long for shake-free hand-held shots, but a sharp rendering of detail and subject outlines is of vital importance in this type of picture.

Summary

If you can visit Chartres, you have 173 windows to choose from, but stained glass windows are not rare. Generally the most subtle and beautiful colours are to be found in medieval glass rather than that of later periods. Such windows are also often of the highest order from an artistic standpoint. There are, of course, exceptions to this generalization—many modern windows show a sensitive use of colour, or a compelling brilliance. Many windows made in the last century are rather garish, and of commonplace design.

Shooting procedure is the same in most cases, the essentials often being a tripod and a long-focus lens. Shooting from closer range at a more-or-less acute angle to the window distorts the figures in a way that is usually totally unacceptable.

Shooting data

Both photographs: Leica, Telyt 400mm, Agfacolor CT18. *Mgr Roger Michon,* Bishop of Chartres.

Foreground colour red background colour blue (see page 190)

Circle

Square (see page 258)

Square and rightangle

The square is a blunt, strong, uncompromising shape, standing solid and immovable. It is not really very common in photographic composition for these very reasons. It tends to stand aloof from other shapes, unable to mix with them harmoniously until it has been at least slightly elongated into a rectangle. Even though we sometimes shoot on a square format, we often trim it down to a rectangle in the final slide or print.

When the square is brightly coloured it is a complex character, offering a contrast within itself between the stolidity of its shape and the gaiety of its colour. Its character changes, too, when its sides are not parallel with the picture edges. It then becomes rather less immovable, less uncompromising, with its points heading simultaneously in several directions.

The rightangle is a much more common construction, being used frequently to reinforce or repeat the picture edges. It can take two aspects, according to whether the horizontal or the vertical arm dominates. Then it takes on some of the character of these lines in addition to its own. Basically, the rightangle acts most frequently as a frame, support or boundary, containing or balancing the picture and keeping the eye within the frame.

Picture structure

Both the following pictures show an abundance of rightangles. The Chinese letterboxes repeat the picture format time and again, and form in themselves a lively pattern of shape and colour. The squares at top left sit in splendid isolation as if they were barely on speaking terms with the rest of the picture.

Long rightangles predominate in the right-hand picture—

vertically oriented to put life and vitality into the scene. The door on the left acts as a counterbalance, introducing more acute angles. The squares in this picture have lost most of their normal character owing to the angle at which they are placed, their bright colours and the softening of their angles by the curved pillar.

Colour control

The positioning and colour of the yellowish letterbox make it the most dominant feature. The red paint prevents it from being thrust into the background by the neighbouring red boxes, to which the eye is carried by the linking shape of the envelope.

The key interest in the right-hand picture is the pillar with its brightly coloured posters. The central poster is virtually signposted by the lines of the door and the violently contrasting slab of colour on its right. As a

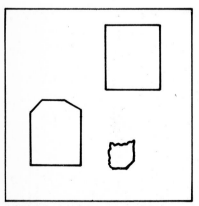

Dominant red (see page 222)— warm colours (see p 190)

Complementary colours red and green (see page 206)

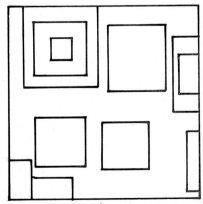

Squares and rightangles

result, it immediately attracts the eye and holds it, despite the enormously greater area of other colours in the picture.

The subject

These two pictures are typical of the type of subject that most people pass by without a second glance. Only a photographer with a sense of form and colour would see the possibilities. Then he has to choose his viewpoint with the greatest care to frame his subject tightly, eliminating all unwanted parts.

Summary

These subjects are found in all sorts of odd corners. They are essentially compositions of shape and colour. The objects are of minor importance—and often of no importance at all. The result is an abstract of familiar items, with shape and form in harmony but colour more inclined to brilliant contrast. Framing is important

and the photographer with an interchangeable lens camera, particularly on SLR, is at an advantage.

Shooting data

Left: Leica, Summicron 35mm, Agfacolor CT18, 1/125 sec, *f*4. *Dr. Karlheinz Andres.* *Right:* Ektachrome X. *E. Kraus,* Kodak Archives.

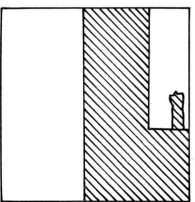

Dominant purple (see page 222)

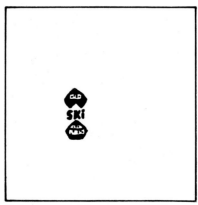

Colour accent (see page 198)

Rightangles

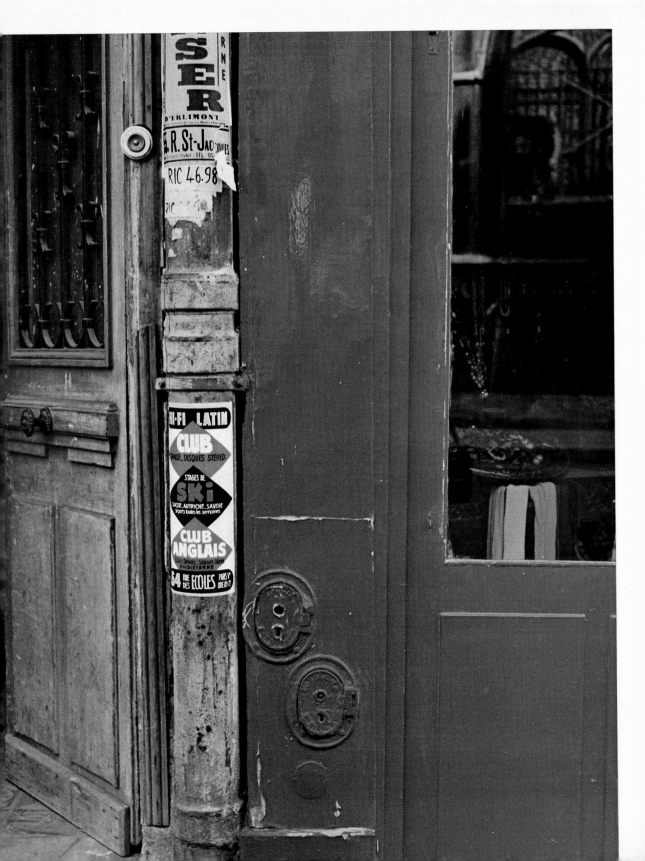

Triangle and angle

The triangle is an active shape. Its arrowhead formation makes it a natural pointer to indicate the direction in which the eye should travel. It can thus create movement or reinforce any directional indications in the rest of the picture.

There are innumerable forms of triangle and triangular composition. The more acute one of the angles becomes, the greater the dynamic effect, or illusion of activity. The flatter the angles, the less the movement until it approaches the stolidity of the square.

The angle of a picture is indicated by the first line in the foreground. This line leads the eye into the background and has a significant effect on the extent of the three-dimensional appearance.

Angles, too, vary in character according to their shape. The acute angle has vitality, the blunt angle is more akin to the gentle nature of the curve. Between the extremes there is a variety of effects that can be used for contrasting or harmonic effects.

Picture structure

The left-hand picture shows women repairing nets and part of the picture at least is a composition of repeating triangles. The seated women are themselves triangular and parts of their dress form triangles within the triangles. And, merely because the three of them are not in a straight line, they are in triangular formation.

The nets form the angle of the picture and, by their converging lines interrupted by the diminishing figures, give a very strong three-dimensional effect. The woman at the top of the picture acts as a perfectly placed stopper to prevent the eye wandering right out of the picture area.

The right-hand picture has a prominent rightangle formed by the man's body and the coil of rope. This repeats the edge of the picture and has a marked framing effect. Its dominant position in the foreground dwarfs the approaching figures and creates a noticeable third dimension.

Colour control

The picture of the net-menders shows extreme economy in the use of colour, giving unusual dominance to the light blue dress of the woman in the foreground. It is, after all, not a very exciting job the women are doing and bright colours might look pretty but would hardly be in keeping with the atmosphere of the subject.

There is scarcely any more colour in the other picture except in the brilliant blue of the sky. This, however, helped by the white line of clouds, contrasts strongly with the animals, which

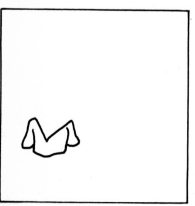

Dominant blue (see page 222)

Triangles (see page 262)

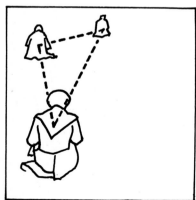

Optical triangle (see page 238)

are carefully placed to balance the right-hand figure and strengthen the impression of depth.

The subject
The sunless conditions for the left-hand picture may or may not have been intentional but they suit the subject. Fishing nets have been the subject of many a picture and the "old salt" net mender is a well-worn cliché. He may, indeed, be shown in brilliant colour and wizened sunburn, but here are the realities of the job.

By contrast, the other picture is full of movement, shown particularly by the leaning body and the opposed curves of arms and rope in the foreground. Here, too, is a routine job, though in less familiar surroundings, turned into a dramatic picture by careful choice of viewpoint and by waiting for the most suitable moment to shoot.

Summary
Both shots show a strong perspective effect and it is an odd coincidence that both were taken with the same type of wide-angle lens. In the right-hand picture this allowed shooting close to the foreground figure while still retaining focus throughout the required depth.

The left-hand picture suffered a little in this respect from the less brilliant light and consequent larger aperture, but in this case the slight fall off in sharpness is of no importance.

Shooting data
Left: Leica M2, Summicron 35mm, Agfacolor CT18, 1/125 sec, *f*6.3. *L. Friedel.*
Right: Leica, Summicron 35mm, Agfacolor CT18, 1/125 sec, *f*11. *Paul Laurent.*

Dominant blue (see page 222)—background colour (see page 190)

Rightangles (see page 262)

S-line (see page 254)

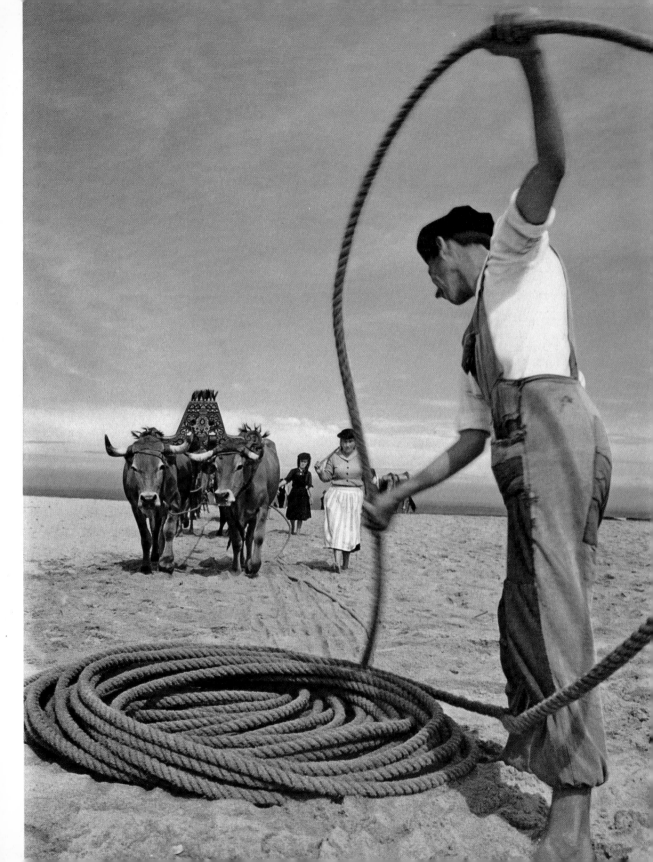

Abstract forms

The shapes we have dealt with so far have been geometrical. They can be defined by length, breadth, angle, radius, arc or various other mathematical means. There are similar shapes in nature and these too, have been used and interpreted by photographers.

There are other shapes, however : shapes of indefinite form not easily measured or reproduced. These have no regard for symmetry or the golden section (see page 270). They are the abstract shapes of the ink blot, the reflection in rippling water, the shadow on an irregular surface and so on.

Abstract shapes can be static or dynamic. Static shapes are found, for example, in tree bark or in lines in the sand. Dynamic shapes are those formed in moving water, by living organisms under the microscope, etc. The shape constantly varies and some skill (and sometimes, luck) is needed to capture the most visually satisfying shape. If the water moves rhythmically and the object reflected is static, the shapes are formed in a similar rhythm. The photographer may then observe the shapes as they are formed and wait for the repetition that must come.

Picture structure

The nature of the reflected object is immaterial and it is, in fact, usually best that it should not be recognizable. Only the reflection and its colours are important.

Both the following pictures show reflections of ships' sides but nothing is recognizable. The appeal lies in their random shapes and colours which seem in total disarray, with no organization, plan or structure. Yet they achieve a certain balance and harmony.

In each of these shots, the photographer chose to include a recognizable object in the foreground. It might be argued that these pictures are essentially two-dimensional and that such objects are out of place. But abstracts are personal interpretations and you are free to present your own ideas in your own way.

Colour control

The idea in the left-hand picture was evidently to balance the patch of reddish colour on the left by the blue. The diagonal division already formed by the green-brown and black is emphasized by the rope. The random black and white shapes, basically horizontal, tie the main shapes together and add life to the composition.

The right-hand picture is predominantly a horizontal construction in "sandwich" form with the black at top and bottom containing and restraining the pattern of orange, red, blue and green in the middle. This is a calmer, less "busy" picture, with less marked contrast over most of its area.

Warm colour red—cool colour blue (see page 190)

Abstract shapes

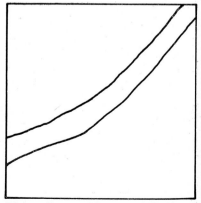
Rising diagonal (see page 246)

The subject

Reflections in water are not difficult to find but it needs a practised eye to see the pictorial possibilities in them. Try watching them from river bank or harbour. A relatively high viewpoint is generally necessary but *any* reflection will repay study.

For focusing on reflections the general rule is to set a distance equal to that from the camera to the reflecting surface plus that from the reflecting surface to the reflected object. When abstract shapes are required this may not be the best solution. It may be best to focus on the water surface so that the outlines of the reflected object are diffuse and even false. Or it may be necessary to focus even closer, as when the surface shows strong light reflections or has identifiable flotsam on its surface.

Summary

To present abstracts successfully, you must see what most people fail to see. If everybody sees the subject in the same way, it cannot really be described as abstract. The camera can, in fact, produce shapes that the human eye cannot see. The skill of the photographer is in having an "eye" that can imagine such results and in so manipulating his camera that it produces the result he wants.

Shooting data

Left: Leica, Elmar 135mm, Kodachrome. *Dr. F. Bode.*
Right: 135mm lens, Kodachrome-X. *W. Köhler,* Kodak Archives.

Warm colours red and orange—cool colour blue (see page 190)

Abstract shapes

Vertical (see page 242)

The Golden Section

A long-standing theory states that there is just one way of dividing a line into two unequal parts to provide the most aesthetically pleasing proportions. This division is known as the golden section. The line is cut so that the smaller part is in the same proportion to the larger part as the largert part is to the whole. Expressed mathematically : if a is the smaller part and b the larger, $a{:}b :: b{:}a+b,$ which works out roughly to $a{:}b :: 3{:}5$ or, to put it back into plain language the smaller part should be about three-eighths of the larger.

The golden section was used frequently by masters of the classic forms of art and architecture. It gives a particular harmony to the composition or construction and introduces a sense of balance and recognizable style.

Naturally, the golden section is not a golden rule, to be slavishly followed at all times and indeed deviations from the concept may often lead to a more dynamic result. They must, however, suit the subject. Where you need harmony and a quiet, restful atmosphere, there is little reason for deliberately departing from the rule. Where the subject is in a disruptive or harsh mood, there is no good reason for sticking to it.

Picture structure

The golden section cannot be interpreted in strictly mathematical terms. When dealing with areas and colours, it must be recognized that they can have different "weights" according either to their own nature or to their importance in the picture construction. An area important to the subject or its interpretation, or an area of bright light colour can seem larger than it really is.

The left-hand picture overleaf shows the operation of the golden section in the placing of the figures at the right and the division between the horizontal lines in the lower part and the predominantly vertical construction above.

The right-hand picture shows similar proportions between the sizes of the heads and the distances of each head along the diagonal to the bottom of the picture. This is a mixture of design by the original artist and careful selection by the photographer of the area reproduced.

Colour control

The left-hand picture shows rather more organization of the colour content than might have been thought possible. The photographer has made use of the reflections in the foreground to put some contrast into a rather heavy base. He has chosen an asymmetrical composition to include a large area of brightly

Cool colour blue—background colour (see page 190)

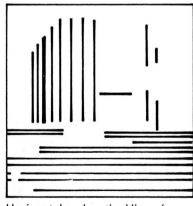

Horizontal and vertical lines (see page 242)

Golden section

coloured window set off by the darkness of the opposite corner. The influence of the golden section is again in evidence in the proportions of these two areas.

The right-hand picture offered little opportunity for colour control as far as we can see. The colours are essentially those provided by the original artist, with due allowance for any distortions produced by time, the lighting conditions and perhaps some cast reflections.

The subject

The main interest in the left-hand picture may well have been the 15th century statue of Mary with a modern chapel built around it—one of the results of the Second World War to be seen in the much-bombed city of Cologne. The photographer has succeeded in contrasting the old and the new, helped by the contrast between the yellowish light bathing the statute and the brilliant daylight streaming through the window on to the modern parts.

The Madonna and Child on the right is placed rather high up in Rottenbuch church. Shot from normal range it would be rather distorted, so the photographer stood well back with a 200mm lens and placed his camera on a tripod.

Summary

The influence of the golden section is often well in evidence in churches. It is as well, therefore, to look out for it and to try to compose the picture around it. Choice of camera viewpoint is an important consideration. It can produce a picture that takes advantage of the original artist's skill and vision or one that completely obliterates it.

Shooting data

Left: Rolleicord, Agfacolor CN17, 1/8 sec, *f*4-5.6. *Klaus-Dieter Fröhlich.*
Right: 200mm lens, Agfacolor CT18, 1 sec, *f*11. *Dr. Gerhard Mikulaschele.*

Warm colours (see page 190)

Triangle (see page 262)

Asymmetry (see page 274)

Symmetry and asymmetry

Most photographs of the pictorial, traditional or representational form (call it what you will) have a more or less ordered composition—the way that the picture elements are distributed in the area available. The arrangement of picture elements can take various forms. The two we are concerned with here are symmetry and asymmetry.

A truly symmetrical form shows two halves of the picture joined together, mirror fashion, on a horizontal, vertical or diagonal axis. Weight and interest is evenly distributed over the picture area.

In the asymmetrical form, there is no central axis; the main interest spreads across the centre line with a more subtle type of balance.

Picture structure

With any art form a symmetrical structure does not necessarily show a strict mirror image. It is more likely, especially in paintings and photographs, to be a balance in "weight": a small patch of brilliant colour on one side of the centre line is balanced by a larger mass of less bright colour on the other side. Or a vertical area is balanced by a small mass, and so on. Various methods are used but balance between one side and the other is the end product.

The asymmetrical picture is not unbalanced: it has a different *form* of balance. There is more "weight" on one side of the centre line than on the other. In many cases the division is made according to the golden section, the greatest weight being about three-eights in from the picture edge. Generally, however, it depends on the photographer's "feeling" about the weight of the main subject and its positioning is a measure of his skill.

Colour control

Symmetry is easily destroyed by a bad arrangement of colours. If, in an otherwise symmetrical composition, an area of marked colour stands alone, it can disturb the sense of balance and create confusion.

But in an asymmetrical composition on the other hand, a strong individual area of colour could be completely in keeping with the presentation of the subject. Finding the best placing for colours and masses is much more subjective for the asymmetrical than for the symmetrical picture.

The subject

The left-hand picture overleaf is a very obvious symmetrical arrangement—almost the complete mirror image. Neither the subject nor the colour is sensational. In fact, it would be difficult to find a more prosaic

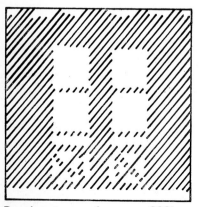

Dominant green (see page 222)

Symmetry; verticals and horizontals (see page 242)

Rightangles (see page 258)

subject or more subdued colour. It is the presentation that makes the picture : the precise framing, the exclusion of distracting detail —and the exact symmetry.

On the right, we have almost the same subject—a window— but the approach is very different. Here, an irregular area of the window occupies about half the picture area. The other half could not be more different. In this asymmetrical construction the group of bottles are placed in the exact off-centre position to balance their weight in the area as a whole.

The symmetry is usually rather less obvious, masses and colours being balanced rather than individual details. Likewise, the asymmetrical construction may place important picture elements off centre but it rarely leaves the rest of the picture area empty. It tends to balance a small major point of interest with a larger mass of less immediate importance.

Summary

In photography, there is no rigid line between symmetry and asymmetry. The pictures on the following pages are clear-cut examples but very often the division is blurred. Most pictures have some form of order or balance but the totally symmetrical type overleaf is rare.

Shooting data

Left: No data available. Kodak Archives.
Right: Leica, Hektor 135mm and Visoflex, Agfacolor CT18, 1/5 sec, *f*16. *Hermann Roth.*

Economical use of colour (see page 230)

Asymmetry ; golden section (see page 270)

Verticals (see page 242)

The third dimension

So far we have dealt with pictures as they really are—two-dimensional representations of the living scene around us, which is three-dimensional. The real scene has depth and we often need to make our pictures convey an impression of that depth. There are various ways of doing it, some easy and others not so easy.

It is not difficult, for example, to show a street, particularly if it is tree-lined or has telegraph poles or lamp posts in it, in such a way that it appears to have depth. The impression can be strengthened or weakened by choice of viewpoint and of lens.

We are talking here about physical perspective, which is basically the apparent reduction in size of more distant objects. But there is also aerial perspective, a term which describes the softening of contrast, and loss of detail with distance. And there is colour perspective, some colours being natural background colours and others more suitable for use in the foreground (see page 190). This is linked with aerial perspective because in nature the paler and colder colours are normally associated with distance.

Picture structure

The influence of the camera position is clearly shown in the following two pictures. On the left is a symmetrical construction with the camera set in the middle of a straight, tree-lined path. The converging lines formed by the bases of the trees and the reducing size of the trees themselves convey a pronounced impression of depth. On the right, the camera was placed to one side of an evidently similar path and the impression of depth is considerably reduced.

Contributory factors to the differing impressions of depth are the figures in each picture.

The sheep offer no barrier to the eye, whereas the two figures on the right almost obscure the path and the bases of the more distant trees.

Colour control

The left-hand picture was very carefully organized to present a pattern. The long-focus lens had drawn the trees together to form solid walls of relatively neutral colour with very little green visible between them. They outline a contrasting green wedge saved from complete emptiness by the sheep in the mid-distance. A further slight emphasis of the depth is given by the touch of blue haze in the distance.

On the right, the main interest is really the troubadours. The woodland path is incidental and therefore not prominently featured. The impression of depth is also, in fact, somewhat reduced by the blue clothing.

Dominant green (see page 222)

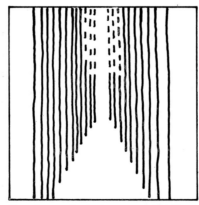

Depth ; verticals (see page 242)

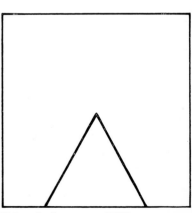

Triangle (see page 262)

The red cover gives the splash of colour the picture needs to fix the interest of the strolling figures.

The subject

There are innumerable methods of conveying an impression of depth in colour pictures. The left-hand picture shows the obvious method. Similar subjects can be found anywhere and can in fact be more or less "manufactured" by following basic rules. The approach is less obvious in the right-hand picture, but the photographer was probably not particularly concerned with depth.

As we have seen depth can be conveyed by the use of colour. Put a red patch on a blue area, for example, and the red seems to be in front of the blue, whether it actually is or not. It is not usually as simple as that in a pictorial representation (that is in a straight photograph of a real scene) but, as a general rule, it is unwise to include large areas of red, orange, yellow, etc. in the background if an impression of depth is required.

Summary

Ordinary physical perspective is easily stressed and even distorted by choice of viewpoint and/or lens. Exaggerated perspective can sometimes be pictorial but is very often merely a gimmick. It should not be habitually sought after merely for its own sake. Many pictures, however, need an impression of depth and the need must be recognized. A landscape generally looks unimpressive if there is no hint of the third dimension. This can result from too much overall sharpness, unwise use of filters to eliminate distant haze, lack of any prominent detail in the foreground and so on.

Shooting data

Left : Leica, Elmar 135mm, Agfacolor CNS, 1/125 sec, *f* 11. *Wim Nordhoek.*
Right : Leica Summitar 50mm, Agfacolor CT18, 1/100 sec, *f* 8. *Ara Güler.*

Dominant red (see page 222) ; colour accent (see page 190)

Verticals (see page 242)

Triangle (see page 262)

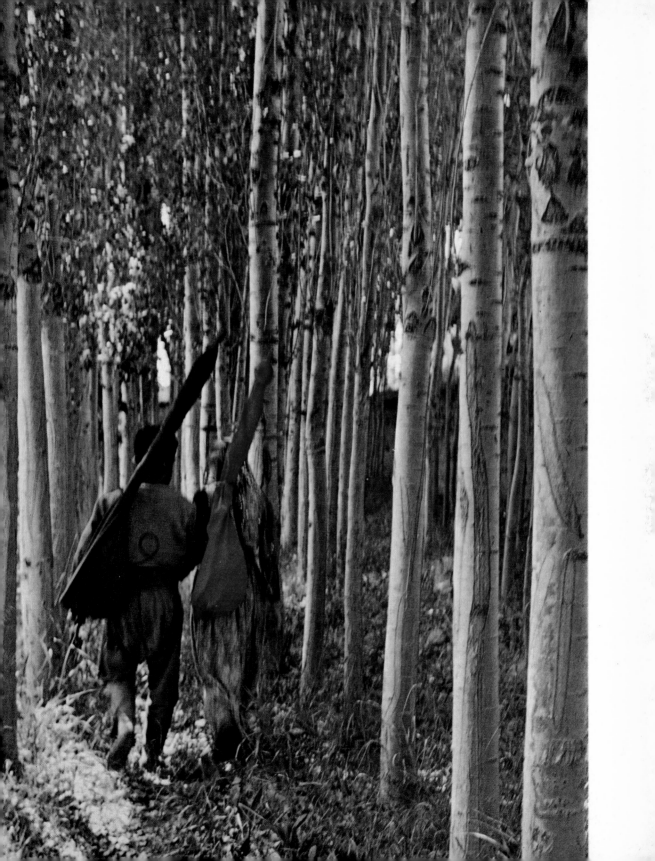

High and low viewpoint

Nowadays, because cameras used at eye level are so popular, most photographers are probably now taken from that position and most photographs are probably taken from that position and are still many cameras about which demand chest or waist level shooting, evidence of the lower viewpoint is rarely noticeable in the picture. Only when we shoot from *much* higher or lower than eye level does the view begin to look unusual.

A high viewpoint can change the appearance of the subject considerably and the effect is well known. It is rather surprising that the effect of a low viewpoint seems to be less well realized, because it is generally so much easier to shoot from.

In both cases, of course, we mean pictures for which the camera is tilted up or down. Where the camera is held with its back vertical, the view of the subject is unaffected by high or low viewpoint, except only the area covered.

A low viewpoint generally gives a very distorted view, chiefly because it is rarely possible with any but relatively close-range subjects or those that stand well above ground level. To avoid such distortion in portraits against the sky, for example, a lens of longer focal length than normal is best.

A high viewpoint is not so limited in application and frequently has practical value in isolating the subject, or removing it from an irrelevant or distracting background.

Picture structure

Neither of the pictures overleaf was taken from an extremely low or high viewpoint. The photographer bent his knees in one case and used a natural rise in the landscape in the other.

The left-hand picture is notable for its accentuated foreground. This called for a careful choice of aperture to gain extreme depth of field. The situation was rather similar for the right-hand picture but not so acute because the foreground does not reach so far forward.

Colour control

The left-hand picture is dominated by yellows and greens. The blue sky adds the complementary colour to the yellow. The colours here are those of nature. They are in harmony and the photographer has been content to leave them like that. There would have been no point in adding a colour accent.

The sky has been deliberately excluded from the left-hand picture leaving the yellows and greens, this time in a much more subdued form, as sole accompaniment to the church and its surrounding buildings.

Green as mediator (see page 189, Fig. 11)

Depth (see page 294) ; diagonal (see page 290)

Low viewpoint

The subject

Crops in the field are favourite subjects for pictures such as that on the left. The lines and patterns of colour are essential to such pictures. In this case, the lines create depth. The patterns create the interest in, and reason for, the picture.

On the right, the subject has been presented in unusual lighting so that it becomes more than just a picture of a church in a field. This is but one of the ways of adding interest to a subject.

Summary

Although neither picture goes to extremes of high or low viewpoint, each shows the difference that the shooting angle can make. The left-hand picture is given more foreground and a greater sense of depth. The higher angle on the right tends to cradle the church in its surroundings. From a normal viewpoint it would stand on the earth. Here it is part of its surroundings.

Shooting data

Left: Super Ikonta, Agfacolor CN17, 1/100 sec, *f*8. *S. Suzuki.*
Right: 200mm lens on 35mm film, Agfacolor CT18, 1/500 sec, *f*5.6. *Emil L. Mätzler.*

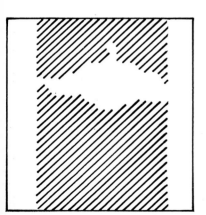

Dominant green (see page 222)

High viewpoint

Rising diagonal (see page 246)

The horizon

There is a general rule that the horizon should not lie in the middle of the picture. It is quite a good rule and can rarely be broken. The earth, or earth-based objects usually form the main interest and most pictures should therefore have a horizon line in the upper half—if they have a horizon at all ! It is by no means necessary to include the sky in all landscape pictures.

Another rule that can only be ignored for a very good reason is that the horizon should be truly horizontal. Yet another, not quite so important, is that the line should be broken by objects protruding into the sky area. Otherwise, the picture just divides into two separate parts.

Picture structure

In the left-hand picture overleaf a low horizon enables foreground objects to spread into the sky area where their colour and tone difference give a strong impression of depth. This is enhanced by the subdued colour and slight haziness of the view across the water and the blue haze on the distant hills.

Of the picture opposite, the photographer says, "It was terribly difficult to photograph the sheep so that the shepherdess was clear of the flock. A kingdom for a ladder ! Naturally, none was available, so a car roof had to serve. Not only did the sheep, taken against the light, look different from this viewpoint, the camera also gained greater freedom of movement. By tilting it slightly, I could place the horizon higher and allow the rather chalky sky just enough room to give an impression of space without weighing the picture down".

Colour control

Warm autumn colours run right through the left-hand picture. They appear strongly in the foreground leaves and are repeated in diminishing intensity in both buildings and sky.

The right-hand picture is not so dependent on colour. It would have been very good even in black and white, but the effect of the lighting on the backs of the sheep is to introduce a brilliant colour impression even though the colour itself is not particularly bright. It contrasts so greatly with the road surface, however, that the sheep stand out in a startling way.

The subject

The low horizon in the left-hand picture was not an obvious choice. Without the deliberately contrived foreground, in fact, it would have been wrong. The sky is attractive but not so full of interest that it could form the major part of the picture.

On the right, the sky and distant hills are of no interest at all. They merely serve to prevent the road

Red-orange foreground colours warm colours (see page 190)

Verticals (see page 242)

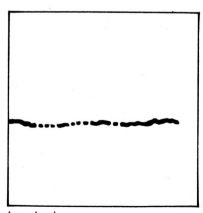

Low horizon

from leading the eye out of the picture. Thus, the horizon is taken as high as possible.

Summary

The horizon can play a very important part in landscapes. Altering its position can alter the whole character of the picture. Take particular care to study the viewfinder image before shooting, changing the camera angle slightly to judge the effect of different positions for the horizon. Always remember, too, that the sky can be eliminated from the picture if it has no real part to play.

Shooting data

Left: Ektachrome-X. *Toni Schneiders.*
Right: 35mm camera, 35mm lens, Agfacolor CT18, 1/125 sec, f8. *Walther Benser.*

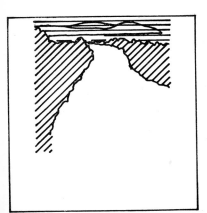

Mid-distance colour green (see page 194) ; background colour blue (see page 190)

High horizon

Depth (see page 278)

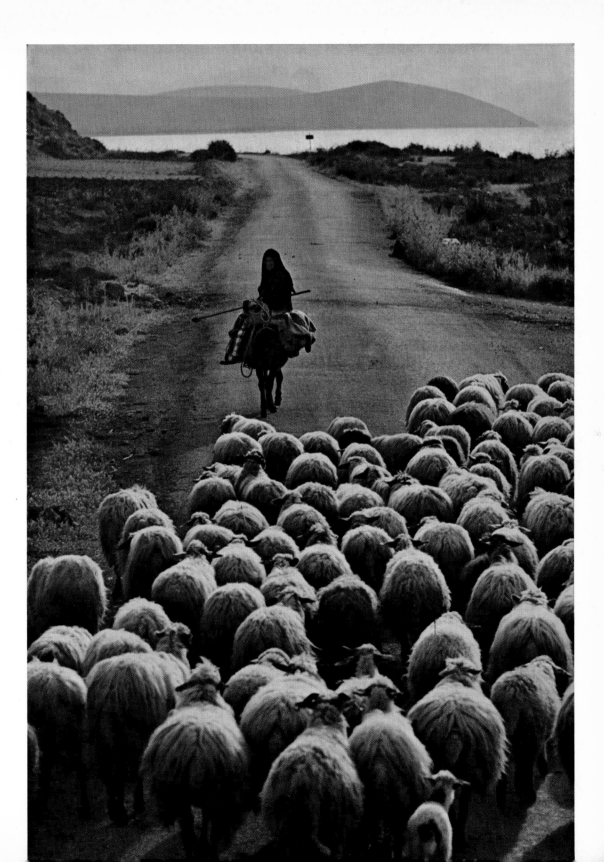

Interchangeable lenses

The size of the image on the film depends on the size of the object, the shooting distance and the focal length of the lens. Thus, to make the image of a given object larger or smaller, we can alter the shooting distance and/or use a lens of different focal length.

It is not always possible, however, to move the camera, either because of physical obstacles or because we do not want the altered perspective that goes with a different viewpoint. These are the main reasons for making cameras which can accommodate various lenses. With a range of lenses available, you can either maintain the same image size while altering the shooting distance and thus the perspective, or you can shoot from the same spot but obtain various image sizes.

The latter alternative is shown in the pictures overleaf. A table-top set-up has been photographed from the same distance with six different lenses. As the focal length increases, so the angle of view decreases. A smaller area is imaged on the film and the objects in that area are reproduced on a larger scale.

Picture structure

In any given scene there exists a variety of pictures, ranging from the limits that the widest angle lens can encompass to the extreme "close-up" given by the very long focus lens. The photographer's job is to choose the area that provides the required picture. But each lens also has its peculiarities. Very wide angle lenses may distort parts of the picture. Rounded or tubular objects (such as faces, figures, pillars, railings, etc) placed close to the edge of the picture may look wider than similar objects near the centre. Straight lines at the edges may curve or slope outwards. In extreme cases there is even vignetting (where the lens fails to illuminate the whole image area), causing dark corners in the print or slide.

The long-focus lens does not usually produce this type of distortion but it does tend to flatten perspective by making similar sized objects at very different distances from the camera look almost the same size, whereas the normal lens would show distant objects much smaller. It also has a rather limited depth of field, decreasing (other things being equal) as the focal length increases.

Colour control

The wide-angle lens tends to be used at close range and the long focus lens at long range. This is by no means a general rule : moderately long focus lenses are frequently used for portraits.

Colours are generally brighter when shot at close range than at long range, because at great distances the atmosphere can be

Colour as mass (see page 198)

Colour organization (see page 214)

Red accent (see page 198)

dense enough to dilute the colour. This looks quite natural when the diluted colours are in the background of a picture taken with a normal lens but when they form the whole of the picture taken with a long-focus lens the result can be rather disappointing.

The subject

Overleaf are some table-top subjects which demonstrate the effect of different focal length lenses. There are, of course, innumerable other uses to which such lenses can be put. The wide-angle lens is, naturally, very useful in cramped conditions, such as crowd scenes, small rooms, narrow streets and so on. It can also be used for very close range work. Many wide angle lenses for SLR cameras focus down to a few inches. The moderate wide angle (such as a 35mm lens on a 35mm camera) is extremely handy for rapid shooting—news or topical pictures. Its great depth of field means that it can be focused on about 15ft at a moderate aperture and be ready to shoot anything from three or four feet from the lens to the mid-distance.

The moderately long focus lens also has many applications, particularly where the photographer cannot, or does not wish to approach his subject too closely. The very long focus lens is really a specialist item, for use by some sports photographers and those shooting wild life, inaccessible architectural features and so on. It needs a tripod, very careful focusing and often has a relatively small maximum aperture calling for longish exposures.

Summary

A camera with interchangeable lenses is useful but not essential. The average photographer does not need a wide range of lenses. Most needs can be satisfied with one wide angle, a normal and a moderately long focus lens, say a 28mm, 50–58mm, and a 135–200mm for a 35mm camera. It would, in fact, be possible for most photographers to dispense with the standard lens and do all their work on a 35mm and a 90–135mm lens.

Shooting data

The pictures overleaf are from the archives of Carl Zeiss, Oberkochen. Lens and focal length are shown beneath each picture.

Optical triangle (see page 238)

Colour accent (see page 234)

Angle (see page 262)

Zeiss Distagon 25 mm/82°

Zeiss Distagon 35 mm/63°

Using interchangeable lenses

As can be seen in this series of pictures (all taken from the same viewpoint) lenses of different focal lengths create entirely new picture possibilities. Even when he has decided on his picture, however, a photographer may have to choose a lens to suit the circumstances.

In outdoor shots, for example, he may have to suit the lens to the camera position, because the ideal position with another lens is unattainable. When taking portraits he may want to shoot from a little distance to avoid distortion of features or figure. With colour slides, in particular, it is essential to frame the subject accurately to avoid subsequent masking, and that may call for a longer focus lens.

Many cameras nowadays have interchangeable lenses and, in the case of SLR cameras at least, the choice of lenses is very great. Focal lengths available for 35mm SLRs run from 8mm to 1000mm and more. As the ratio of reproduction (object size to image size) is proportionate to focal length, this means that a feature virtually invisible when photographed with one lens could be an inch high on the film when photographed with another.

Any camera that takes interchangeable lens can

Zeiss Planar 50 mm/47°

Zeiss Sonnar 85 mm/29°

Zeiss Sonnar 250 mm/10°

also be fitted with extension tubes and bellows for close-up work. The camera can be attached to a microscope or a monocular and can also use a special form of negative lens placed behind the camera lens to double or treble its focal length. Special attachments can be fitted for copying colour slides and other close-up subjects, with such cameras.

Long-focus lens

The long-focus lens is a lens of greater focal length than the standard lens. The standard, or normal lens generally has a focal length roughly equal to the diagonal of the picture format on which it is used. Thus the standard lens for the 35mm format is in the range of 50–58mm and for the 2¼in square format in the range of 75–80mm.

The longer focus lens has a narrower angle of view and thus images a smaller area on a larger scale. It can produce larger images of distant detail, increasing the scope of the camera for the colour slide worker who cannot satisfactorily enlarge a small portion of his picture.

This is not the only function of the long-focus lens. At comparatively close range it can give larger images of small objects. It can even be applied in real close-up lenses. Because it can give the same image size as a shorter focus lens but from a greater distance, it may, by keeping the camera far enough away, make more room for manipulating the lights.

A further advantage is that the long-focus lens gives less depth of field than the standard lens and can more easily throw backgrounds out of focus, and so make the main subject stand out sharply.

Picture structure

The Norwegian snowhound overleaf was photographed with a moderately long focus lens—just long enough to shoot at a distance that avoided undue distortion. To fill the frame with the standard lens, the photographer would have had to approach the dog so closely that its head would have looked much larger than its body.

The young roebuck is a timid animal and would not have remained still if the photographer had come very close. He was, in fact, shot from 60ft with a very long focus lens and this can easily be seen by the very shallow depth of field—both foreground and background are well out of focus. This shows what care must be taken in focusing such shots, even at moderate apertures.

This animal is particularly well placed in the frame. There is space in front of his body for him to move into—which he duly did at great speed as soon as he caught even the slight noise of the Leica shutter.

Colour control

Brilliant colour would have been out of place in either of these shots. The subject in each case is the animal and the colour is a secondary consideration. As it happens both have been well framed against out-of-focus green backgrounds that are natural and entirely suitable for the subject.

Economy in the use of colour (see page 230)

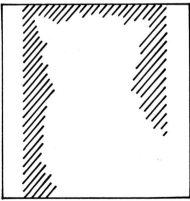
Colour as mass (see page 198)

Triangle (see page 238 and 262)

The snowhound is of a rather indeterminate colour but was made more interesting by the backlighting. This was helped by a white wall behind the photographer which reflected light on to the dog from the front.

The subject

Most people find animals interesting but difficult subjects. Domestic pets are notoriously unreliable as photographic models—either unapproachable because of their frisky playfulness, or so soporofic that they make a totally uninteresting shot. All animals also have a frustrating habit of concealing a leg, an eye or an ear when the camera points in their direction, which is unfortunate because they generally look a little unnatural without a full complement of these items.

Wild or semi-wild animals have to be studied carefully. The photographer who knows the animal's haunts, habits and behaviour pattern is far more likely to get good pictures than the chance snapshooter.

Summary

The long-focus lens is a valuable tool but it has to be used with a full understanding of its advantages and its drawbacks. Its advantages are obvious ; they are all associated with the fact that it gives a larger image and can be used satisfactorily at greater distances than the standard lens. Its drawbacks are not so obvious : it not only magnifies the image, it also magnifies errors in focusing, effects of camera shake and movement blur in the subject. A tripod is generally obligatory with very long focus lenses.

The reduced depth of field can be an advantage or a disadvantage, according to the result required. Perhaps the biggest disadvantage of all, however, is that the long focus lens often encourages shooting from a distance instead of moving in close to the subject. In many cases it flattens perspective and destroys the impact of what should have been a dramatic picture.

Shooting data

Left : Leica, Elmar 90mm, Agfacolor slide film, 1/40 sec, f 9. *Rosemarie Bode*.
Right : Leica, Telyt 400mm on Visoflex, Agfacolor CT18, 1/125 sec, f 5.6. *Julius Behnke*.

Warm colour brown (see page 190)

Verticals (see page 242)

Asymmetry (see page 274)

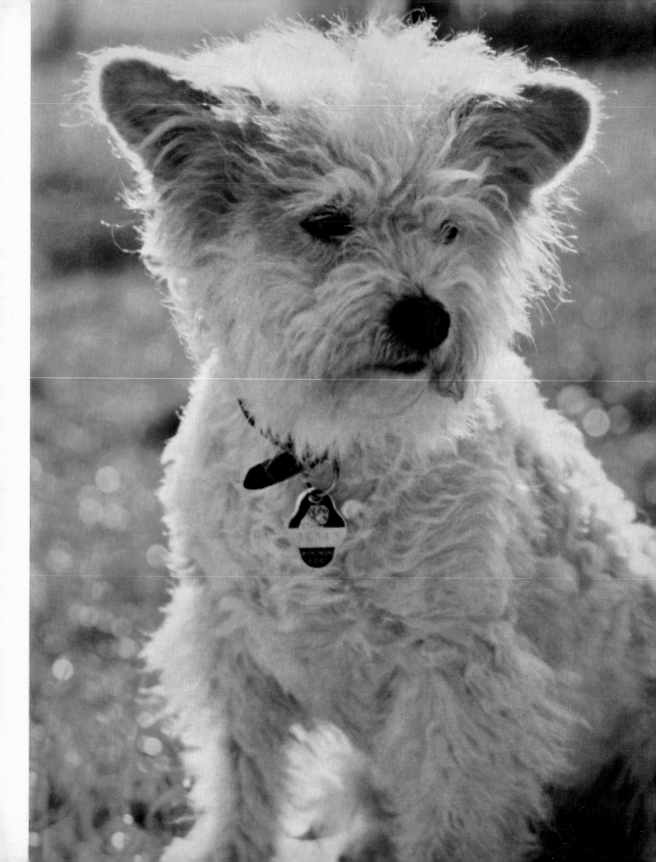

the picture. In this case, it may be unnatural but it is not out of place. Together with the blue of the sky it almost completely frames the main subject.

The subject

Night shots such as these are easy to find but not so easy to photograph. Rain, as the picture on the left shows, is a very great help in adding colour and light to what would otherwise be dark and uninteresting areas. The right-hand picture was taken before nightfall proper, while there was still some daylight about to help separate details from the sky. The streaks from the lights of passing cars are characteristic of long exposures in these conditions. Here, the high viewpoint ensured that they did not encroach too much on the main subject.

Summary

The wide-angle lens has a variety of uses apart from creating depth and allowing high buildings to be photographed. At very close range, it can eliminate the need for special close-up equipment. It can also be handy for interior shots where space is restricted. It can create false impressions of relative sizes of near and more distant objects and its close focusing facility can serve to introduce deliberate distortions for special purposes. Generally, however, the moderate wide-angle lens is a good, all-purpose lens for the photographer who likes, or who is forced, to work relatively close to his subject. It is not normally very efficient in long-range shooting, owing to its very small scale reproduction of distant objects. Landscapes shot with a wide-angle lens are often disappointing.

Shooting data

Left: Leica, Summicron 35mm, Ektachrome HS, 1/30 sec, *f*4. *Ludwig Friedel.* *Right:* Agfacolor CT18, 15 secs. *Hans Butz.*

Warm colour red-yellow ; cool colour blue (see page 190)

Verticals (see page 242)

S-lines (see page 250)

Bellows, tubes and close-up lenses

Camera lenses with focusing mechanisms can usually focus down to at least three feet, but there are now many standard and wide-angle lenses that can focus considerably closer. Nevertheless, for really close-range work, special equipment is generally required.

For cameras with interchangeable-lens facilities, extension tubes or bellows can be fitted behind the lens. These provide a far greater extension between lens and film than is available with the focusing movement of the lens and allow various sizes of image up to life size and greater to be produced.

The SLR is the most useful camera for this type of work because it eliminates parallax problems caused by the different viewpoints of lens and viewfinder. It also, in many cameras, allows exposure measurements to be made through the camera lens, so that no calculations need be made to determine the light loss caused by the added extension. Where such readings cannot be taken, the exposure recommended by the meter has to be increased by a factor of $\left(\dfrac{E+F}{F}\right)^2$, where F is the focal length of the lens and E is the length of the tube or bellows.

If the camera lens is fixed, close-up or supplementary lenses can be used. These attach to the lens like a filter and have the effect of decreasing the focal length while maintaining the same lens-film separation, thus allowing objects closer to the lens to be focused. Close-up lenses are available in dioptre strengths, the most commonly used being the 2 and 3 dioptre. With the camera lens set to infinity, they focus at one metre divided by the dioptre number, i.e. the 3 dioptre lens focuses at about 13 inches.

For most close-up work, a tripod or other firm camera stand is essential. Focusing is critical and not even the slightest movement toward or away from the object can be permitted between focusing and shooting.

Picture structure

The world of the close-up is limitless. Flowers or parts of flowers, insects, fabrics, stamps—even colour slides—are fairly obvious subjects. Almost anything can present an unusual appearance if it is photographed at very close range and the image is further enlarged on printing or projection.

The reduced shooting distance results in a very shallow depth of field so that if the subject is more than a few millimetres in depth, the lens must be stopped down considerably or the shooting distance altered. On the other hand, this characteristic can be used to isolate a subject against a completely defocused background.

Dominant green (see page 222)

Red accent (see page 198)

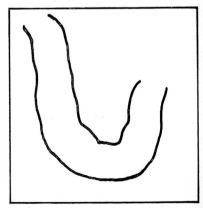
S-line (see page 250)

Colour control

Close-ups are rarely taken in a hurry and control of the colour composition is therefore almost absolute. Even where the subject is taken from nature, the background and surroundings can be artificially contrived if necessary because they are so easily made unrecognizable by the lack of depth of field. Suitable background colours can therefore be added if they are not present in the original. In the picture on the following right-hand page, for example, the background is completely neutral, with only the faintest touch of colour here and there. It could either have been put there by the photographer or any disturbing elements in the natural background could have been carefully pushed further back.

The subject

The close-up from nature often calls for incredible patience, skilful organization and a knowledge of the habits of the subject. The following two pictures are of this type, showing two stages in the life of a butterfly. Other subjects may call for different qualities, such as imagination, skill in arrangement, and careful lighting. A two-dimensional subject, for example, presents no depth of field problems but it must be evenly lit. Where texture or irregularity of surface is to be shown, however, side lighting is necessary but considerable fill-in from the front may also be required to avoid heavy shadows and an exaggerated effect.

Summary

The close-up must be sharp. Otherwise, it simply looks like a too-great enlargement of a more distant shot. Therefore it must be focused with the greatest care and, if supplementary lenses are used, it is advisable to stop down to at least $f8$. Where the range is very short it is frequently a good idea to reverse the lens in its mount, so that the back faces the subject. This is so that the lens is working with the short and long cones of light emerging from the lens surfaces designed for them— theoretically reducing the number of aberrations. Many manufacturers of SLR cameras supply special reversing rings for this purpose.

Shooting data

Left: Contarex with extension bellows. Zeiss Ikon Archives. *Right:* Leica, Hektor 135mm on Visoflex, Agfacolor slide film, electronic flash, $f16$. *Hermann Eisenbeiss.*

Colour accent (see page 198)

Triangle (see page 262)

Rising diagonal (see page 246)

Outdoor portraits

We meet people everywhere and many of them are worth photographing for a variety of reasons—their looks, their clothes, what they are doing, and so on. The object, however, should be to make the person unmistakably the main subject.

It does not often pay to shoot people from a great distance. It *can* be done, with a long-focus lens, but such shots often look remote and uninvolved, however large the image of the subject. The close approach carries a more intimate message, particularly if the subject is looking at the camera or even in its general direction. Nevertheless, you should not be too close or there will be some risk of distortion, evidenced by overlarge noses, shoulders, limbs, etc. A distance of between six to ten feet is often best and then, if a head or head and shoulders only is required a long focus lens can be used.

Picture structure
Probably the most important part of a portrait is the eyes and the direction of their gaze. Generally, communication between two people is improved if they look at each other. Yet, so often the photographer tells his model not to look at the camera. In effect, he is telling him or her not to look at the person who will eventually be looking at the picture. He is destroying communication between the two.

This is only permissible if there is a good reason for the model not to look at the camera. There can be several such reasons : the model may be involved in some activity and be obliged to look at something else within the picture ; the photographer may be trying to create a glamorous haughty, remote character ; he may be portraying a mood of depression, disinterest, etc. The eyes can do all these things.

The placing of the person within the frame is important. With a moving subject, there should be rather more space in front than behind, as in the picture on the following right-hand page. The eyes should preferably be above the centre line of the picture. If they look toward the picture edge, there should be room for them to look into. These are matters of balance. The picture generally looks better balanced that way, but, naturally, where there are good reasons for breaking the rules, there should be no hesitation in breaking them. Rules are for guidance in normal conditions not for rigid adherence in all circumstances.

Colour control
In most portraits, if not all, facial colouring is the most important. This does not necessarily mean that it has to be reproduced accurately, but it has to be natural. The other colours have

Dominant flesh tone (see page 222)

Complementary colour blue (see page 206)

Rising diagonal (see page 246)

to be a secondary consideration, but some control should be exercised to ensure that they are suited to the subject. A predominance of dark or degraded colours is rarely suitable in a photograph of a baby. Garish brilliance will usually look out of place in an old person's portrait.

The subject

The picture of the young boy is appealing mainly because of the alert, unselfconscious gaze. He looks straight at you and puts across something of his character. The pose is natural, unforced and alive. He might be talking to you. The surroundings are unimportant. He is just a boy—a type you might meet anywhere.

The picture on the right looks like a passing shot that could have been taken in any street. A pretty girl passes by and the photographer takes the opportunity to add her to his collection of people—a young lady with the hair style, the make-up and the dress of her era. He places her carefully in the frame and focuses precisely to locate her in an indeterminate outdoor scene.

Summary

Most people are interested in other people—what they look like, what they wear, how they act. Photographing people is a fascinating pastime, but is not for the shy photographer. He must be prepared to let himself be seen but he must be so proficient in the use of his camera that the model never "dies" on him. The photograph must be taken quickly, so that it looks spontaneous, natural and unforced. The subject of such informal pictures should not be given time to react or act up to the camera.

Shooting data

Left: Super Isolette, Agfacolor CT18, 1/125 sec, *f*5.6. *Wolfgang Fritz.*
Right: Ektachrome, Kodak Archives.

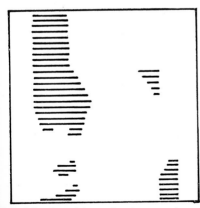

Cold colour blue—background colour (see page 190)

Dominant red (see page 222)

Verticals (see page 242)

People of other lands

The keen photographer takes his camera everywhere with him, whether he travels on business or for pleasure. He wants pictures of the interesting things he sees—buildings, landscape, animals, monuments, and so on. He should not forget the people. They are representative of their part of the world and can supply plenty of opportunities for interesting photographs. Anybody can see the natural and man-made phenomena in postcards, but pictures of the people are not so easily obtainable.

Some people he meets on his travels may not be so used to seeing cameras as he is in his own country. In such cases there may be some advantage in using a longer focus lens—say, 135mm on a 35mm camera—so that he need not approach too close.

Generally, however, the informal shot is most likely to be successful if it is taken quickly, so it is best to carry the camera already set for the lighting conditions and, if possible, for a zone of sharp focus that covers the most likely shooting distances. Then it is merely a matter of choosing the right moment to raise the camera to the eye and shoot in one swift movement before the realization of what is happening causes the subject to adopt an unnatural expression.

Picture structure

The person *is* the picture and must dominate it. The figure should be large in the frame and background detail kept to an absolute minimum. The people represent their country, so there is no need to try to include the country in the picture as well. Nevertheless, "props" can be included, particularly if the aim is to show a craftsman at work or certain habits or activities of the people. Such pictures easily become general-interest shots, however, and are no longer true portraits. If there is too much emphasis on the activity, it becomes the main subject and the people become merely the props.

Colour control

In temperate climates the skin tones and colours of a portrait are likely to contrast with those of clothing to some extent. In many warmer areas fewer clothes may be worn, particularly by children, and the skin tones are much more prominent. They are often much darker in colour, too and, in harsh, bright lighting, can cause some exposure problems. Nevertheless, skin tones still are the most important feature and, if the subject has to be photographed in sunshine, other colours must be left to look after themselves.

A little extra colour can help the picture along, as in the following

Warm colours (see page 190)

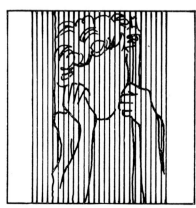
Economy in the use of colour (see page 230)

Verticals (see page 242)

right-hand picture. The little girl's bows and bangles add just sufficient colour to catch the eye and so add interest to the picture.

The subject

Walther Benser says of his picture on the left, "The Indian herdboy was shy—obviously afraid of the photographer. He was sheltering in a niche from the sudden cloudburst which often occurs in India during the monsoon. Under the protecting roof of the small rock temple, I had time to make a portrait of the small shape. Only his large apprehensive eyes moved while he hung on desperately to his shepherd stick."

Evidently, the little girl on the right had no such fear. She is, perhaps, a little too obviously aware of the camera but it is a happy picture, fully evocative of the child's happiness and her surroundings. The harsh light has been well handled, helped no doubt by considerable reflections from the water.

Summary

The travelling photographer should always reserve some of his film for photographing people in the countries he passes through. If he can make worthwhile portraits he may at least have something individual and perhaps unusual. He may well find that the people he meets recall a particular area to mind much more readily than shots of indifferent landscape or architecture.

Shooting data

Left: Leicaflex, Elmarit R 90mm, Agfacolor CT18, 1/125 sec, *f*4. *Walther Benser.*
Right: Hasselblad, Planar 80mm, Agfacolor CN17, 1/125 sec, *f*8. *Guido Mangold.*

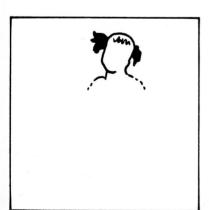

Colour accent (see page 198)

Colour mass (see page 198)

Verticals (see page 242)

Child portraits

Portraits, as opposed to pictures, of children, generally demand careful lighting. Whether the child is mischievous, frank, innocent, pretty or plain, harsh lighting is rarely suitable. Indoors, bounced flash or window light with suitably-placed reflectors is preferable. Outdoors, diffused light from a lightly overcast sky gives a similar result.

Apart from its suitability, an even flood of light has the additional advantage that it can be arranged before the subject is brought on to the scene. No adjustments are necessary during the sitting and the child need not be distracted by the mechanics of the operation.

The photographer should work quickly and try to retain the child's interest. How he does this will vary with the type of child. Very young children may need to be kept amused by toys or chatter. The older child may respond to more adult conversation on a subject that interests him.

Picture structure

The two portraits overleaf show similar techniques—diffused lighting, a plain background and a direct eyeball-to-eyeball approach. The child in each case is looking directly at the camera and thereby establishing contact with the eventual viewer of the photographs. The eyes are alive—evidence that the pictures were taken before the child's patience and interest were exhausted. No props were used in either case and the result is a straightforward likeness of the sitters, with some hint of the lively boy and the slightly timid girl showing through.

Colour control

Naturally, in such portraits, the skin tone is the most important colour area. This does not necessarily mean that it has to be absolutely accurately rendered. Generally, a tendency towards red is acceptable and may even be an improvement.

The accuracy of other colours has to be subordinated to the flesh tone but if the lighting is kept fairly even they will not normally suffer much distortion. Two approaches are shown here. The right-hand picture has some weight added to its base by the strong but not too bright colour of the boy's shirt. The contrast is in keeping with the boy's expression and apparent character. The portrait of the girl, however, is almost a vignette, with all the interest centred on the face. Any heavy tone at the base would, in this case, have added a harsh note to an essentially soft rendering.

The subject

This type of semi-formal child portraiture is probably best

Warm colours (see page 190)

Cool colour blue (see page 190) —colour accent (see page 198)

Golden section (see page 270)

undertaken in the child's home or in other surroundings familiar to him. Only the most extrovert of children is likely to show his true character during a short studio visit.

Moreover, parents often prepare their children immaculately and unnaturally for the studio whereas they can be persuaded to allow a less "glossy" appearance in the home.

Summary

Child portraiture is difficult but rewarding. The child does not stay a child very long and even in that short time its appearance and character are constantly changing. A record of this growing-up process is what so many parents strive to achieve.

Shooting data

Left: Hasselbald, 150mm lens, Agfacolor CN17, electronic flash, *f*11. *Gert Körner*.
Right: 9 x 12cm camera, 300mm lens, Agfacolor CN17, bounced electronic flash, *f*11-16. *Klaus Ott.*

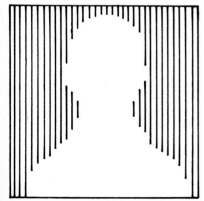

Homogeneous background area (see page 189, Fig. 8)

Triangle (see page 278)

Symmetry (see page 274)

Artificial light portraits

Artificial light generally means special photographic lamps, but the term also covers street lighting, theatre lights, candles, lanterns and other such man-made sources that provide enough light for photography. The term does not include flash, which is treated as a separate subject.

There are two types of film for use in artificial light : one designed to give correct colour rendering with photofloods, the other with studio lamps. Other forms of lighting lead to various kinds of colour distortion. Filters can be used to a limited extent (either over the light source or the camera lens) to correct the colour rendering when shooting under the "wrong" lighting. Such lighting can, of course, provide deliberate colour casts over part or all of the picture.

Some of the most interesting portraits are made by artificial light because it allows such a selective use of colour, either by deliberate choice of "unsuitable" lighting or by imaginative filtering of the light source or by placing a filter over the camera lens.

Picture structure

The following two pictures are examples of carefully stage-managed colours, the one relatively subdued to characterize the night-club singer, the other more garish with contrasting colours and full lighting on the mask-like face of the mime artist. The format is rather unusual for portraits and the placing of the figures is also unorthodox. Nevertheless, both are well balanced by the arrangement of the backgrounds.

Colour control

The left-hand picture shows how colours can be put into the picture by coloured light. The spot effect on the background and the red light on the singer's right side, together with the generally low light level, convey the mood of a night-club. The mime artist, on the other hand, has almost no colour in his face and typically dark make-up obscuring his eyes. Brighter colours are therefore used in the background to add life, but they are kept relatively subdued to contrast with the face without drawing attention away from it.

The subject

The amateur has an advantage over the professional in many ways, because he can choose his own subjects for portraiture. He does not have to take photographs to order and often has more control over the lighting and surroundings. Frequently, too, he can spend more time getting to know his subject and finding out how best to put across the impression he wishes to convey. He can

Warm colour red—cool colour blue (see page 190)

Red accent (see page 198)

Golden section (see page 270)— asymmetry (see page 274)

experiment more to find out just how far he can allow the quality of the light he uses to depart from the ideal without inducing a completely false colour rendering.

Summary

Artificial light colour portraits can take a variety of forms. The two examples here use fairly low level lighting of a type not particularly suited to the available films but careful selection of the subject makes any slight colour distortion unimportant. More orthodox portraits can be taken with brilliant studio lights or photofloods or even in domestic room lighting. In the last-mentioned case the yellowish cast that results sometimes looks natural to the circumstances. But it can be reduced by using a suitable bluish filter.

Shooting data

Left: Leica, Summarit 50mm, Agfa colour print film, 1/10 sec, *f*2. *Dieter Blum.*
Right: Leica, Summilux 50mm, Agfacolor CK20, 1/20 sec, *f*1.4. *Karlheinz Compère.*

Complementary colours red and green (see page 206)

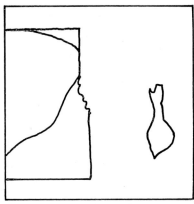

Abstract colour forms (see page 210)

Rising diagonal (see page 246)

People in diffused light and backlight

Too often outdoor portraits are taken only when the conditions are what the photographer considers to be "right". He waits for the sun to shine and perhaps also seeks a location such as a well-known landmark, a monument, building or statue to "add interest". Yet colour portraits can be taken in all forms of lighting and very often diffused light, backlight, sidelight, etc give much more attractive results. Nor are elaborate settings required. The person is the picture and too many props can only divide the attention.

Picture structure

Both the following pictures were taken in what the sunshine loving photographer would regard as unsuitable conditions. But why should pictures not be taken on a rainy day ? Diffused light is quite suitable for colour film and the slight tendency to produce a blue cast looks quite natural in the circumstances. On the other page, the camera side of the subject is completely in the shade but the silhouette effect in both figure and foliage forms a pleasing picture that is a radical departure from the usual stilted daylight portrait.

In both cases, the focus has been carefully set on the main subject and a large aperture used to throw the background well out of focus. This emphasizes the outline of the figures and gives a strong impression of depth. Both pictures are also asymmetrical, placing the figure to one side and balancing it by the foliage in one case and the wall in the other.

Colour control

The left-hand picture uses splashes of yellow in an interesting way to offset the generally subdued colours. They are not allowed, however, to dominate the scene, which is essentially a portrayal of a girl sheltering from the rain. The right-hand picture uses very little colour because the main subject is virtually colourless. Bright colours in the background would be very distracting. There is just enough detailless colour to avoid monotony.

The subject

These pictures could have been posed or they could have been chance shots. That is their strength. Pictures of people are generally more interesting when they are not obviously set up for the camera. There is no need to restrict your portraiture activities to friends and acquaintances. People are all around you and they can be photographed in sunshine, rain, snow and even fog. They live and work in those conditions, so there is no reason why they should not be photographed in them.

Diffused light

Warm colour yellow (see page 222)

Vertical (see page 242)

Summary

Daylight colour film is designed to give its best colour rendering in light with the colour quality of about midday sunlight. At any other time or when the sun is completely obscured by heavy cloud, colours may be distorted towards red or blue. Thus, in the early days of colour photography, many thought that sunshine was essential. Many seem still to hold this view but it is far from the truth. In fact, the most pleasing colour results are often achieved in slightly overcast conditions because shadows are then less pronounced. Accurate colour cannot easily be produced in shadow areas. But even greater departures from the ideal are easily tolerated with a carefully chosen subject. Where colours are relatively subdued and their true colour is unimportant the cast imposed by different types of daylight is hardly noticeable.

Shooting data

Left: Leica, Summicron 50mm, Ektachrome-X, 1/15 sec, *f*2. *Rosemarie Schenk*. *Right:* Leica, Summicron 90mm, Agfacolor CN14, 1/60 sec, *f*2.8. *Horst H. Baumann*.

Backlighting

Background colours blue and bluish-green (see page 190)

Rising diagonals (see page 246)

Domestic animals

The variety of domestic animals (using the term in its widest sense) is enormous and the opportunities for photography are correspondingly abundant. Animals are a part of nature and the more technical our lives become the more we are attracted to what we tend to think of as the peace and quiet of nature.

Domestic animals are used to human company and it is comparatively easy to approach most varieties closely to photograph them. It is even possible to communicate with them to some extent and to induce them to position themselves suitably. Household pets are the most popular subjects but there are plenty of other animals in the countryside, on the farm and often in the village streets.

Animal photography cannot be rushed. The animal generally has to be studied and its habits understood, so that the opportune moment can be chosen to present it most pleasingly. A moderately long-focus lens is advisable both for small and large animals—in the one case to present a sufficiently large image and in the other to permit a greater shooting distance to avoid distortion.

Picture structure

The following pictures are typical examples of exposures made at just the right moment. Both cockerel and horse are shown in characteristic poses. The viewpoints were well chosen, too, presenting the animals almost full frame and with the minimum of interference from the background. The cockerel is in rather unusual surroundings perhaps, but shooting from close by has made it stand out so brilliantly from the diffused background that we tend to overlook the incongruity.

Colour control

If any justification is needed for colour photography, the cockerel provides it. This picture would obviously be much less impressive in black and white. The same applies to many animal pictures. The colouring is characteristic of the animal and it often cannot be guessed. We can easily accept pictures of people without colour but there always seems to be something lacking in monochrome animal shots.

The viewpoint for the cockerel shot was carefully chosen to place the brilliant red of the comb against a part of the background that would display it best. The indeterminate colours of the figures, barely lit by the electronic flash directed at the cockerel, offer no competition.

The picture of the horse shows more subdued colour contrasts but tonal contrast is provided by the backlighting which serves to

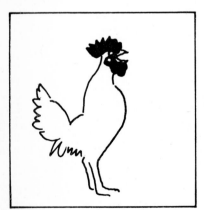

Red accent (see page 198)—dominant colour red (see page 222)

Complementary colour green (see page 206)

Rising diagonal (see page 256)

separate the animal from the background.

The subject

The cockerel is not often found perched on a wall in a typical crowing pose with town-dressed passers-by in the background. A situation like this was well worth the shot. But cockerels, horses and all sorts of other animals are readily available for the alert photographer. The horse, for instance, could have been in any field or forest. This particular one was rather timid and had to be shot with an exceptionally long-focus lens. The uncertain light also called for full aperture and careful focusing.

Summary

Animal photography demands concentration, an understanding of and preferably liking for animals, and fast reactions. It is best to use the fastest shutter speed possible, particularly with the smaller animals, because their movements can often be swift and unpredictable.

Shooting data

Left: Agfacolor CT18, 1/60 sec, *f*8-11, plus electronic flash. *Ernest Muller.*
Right: 400mm lens, Agfa colour print film, 1/124 sec, *f*5. *Hans Rudolph Uthoff.*

Economy in the use of colour (see page 230)

Warm colour brown (see page 190)

Triangle (see page 262)

Zoo animals

The variety of animals from all parts of the world seen at a large zoo often amounts to an embarrassment of riches. The natural inclination is to try to photograph every animal on show. This rarely provides very satisfactory results. As in all animal photography, the best shots are obtained by exercising a great deal of patience and then being able to recognize the right moment and shoot with lightning rapidity. It is better, therefore to try and decide in advance which animals are to be photographed and to depart from the plan only if it proves impossible to carry out.

It is advisable to carry a long focus lens for relatively distant shots of the smaller animals and for those in the larger cages or enclosures.

Picture structure

The pictures on the following pages are animal portraits, concentrating for the most part on heads only. To fill the frame, therefore, they called for long-focus lenses on the larger animals and close-up equipment for the smaller species. Backgrounds are kept as clear as possible and, in all cases, the aspects presented are characteristic. That is where the patience and quick trigger finger come in. Even a minor change in viewpoint can make or mar the picture when you are shooting in what are often cramped surroundings.

Colour control

Many zoo animals are highly coloured and that, naturally, is their greatest appeal to the colour photographer. He must do his utmost to present the colours as truthfully as possible and at the same time, to eliminate distracting colour from the background. This can sometimes be achieved by inducing or waiting for the animal to come forward into the light so that it stands out well from the darker tones at the back of the cage. Or it might be possible to shoot upwards against the sky or downwards to make the floor of the cage serve as the background.

The subject

Naturalists often hold the opinion that photographs taken in zoos should show that the animals are in captivity. In their particular world, they may be right but the average amateur photographer does not set out to deceive anybody. He wants an attractive picture and cage bars or netting rarely help to achieve that objective. It is, of course, possible to push the camera lens through the bars but that is not always advisable. Where the bars or netting are not too thick, however, the lens can be placed very close to them. At such close range, even quite stout netting and thin

Complementary colours blue and orange (see page 206)

Red accent (see page 198)

Rising diagonal (see page 246)

bars are so far out of focus that
they barely show in the picture.

Summary

Zoo photography is deceptively
simple. Some of the animals are
so unusual that it seems enough
merely to picture them as they
are first seen. On reflection,
however, you may realize that
such hastily taken pictures miss
some of the characteristic
features of the species. It is best
to study the subject carefully
before shooting to decide when
it shows itself to best advantage.
The lion, tiger, leopard, etc, for
example, generally look more
impressive on the move, or
eating, than simply lying
comatose like an overgrown cat.
The more exotic birds may show
better colouring from one
viewpoint than another.

Shooting date

Left: (*Top*) Kodachrome II,
H. Kleinstra. (*Bottom Left*)
Retina Reflex, 135mm lens,
Kodachrome II, flash. *W. Köhler.*
(*Right*) Retina Reflex, 135mm
lens, Kodachrome II, *W. Lummer.*
Right: (*Top left*) Retina Reflex,
85mm lens, Ektachrome-X,
1/125 sec. *W. Köhler.* (*Right*)
Retina Reflex, 85mm lens and
close-up lens, Ektachrome-X,
1/250 sec. *W. Köhler.* (*Bottom*)
Retina Reflex, 135mm lens and
close-up lens, Kodachrome II,
1/60 sec. All pictures from
Kodak Archives.

Dominant red (see page 222)

Complementary colours blue and
orange (see page 206)

Horizontals and verticals (see
page 242)

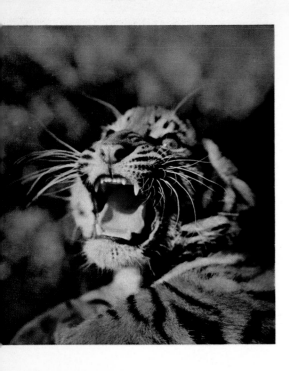

At weekends and on public holidays people stream into the zoos. The serious animal photographer stays away at those times. He needs freedom of movement and space to spare so that he can change his viewpoint rapidly when the need arises. He will do better to find out which is the least popular day for visitors and to do all his photography on that day.

If the zoo cages are not particularly well lit, one of the faster colour films should be used because, although wide apertures are frequently possible, the shutter speed has to be relatively fast to allow for unexpected movement. A moderately long-focus lens should always be carried because there are plenty of animals that cannot be approached very closely and also because selective focusing is often necessary. The photographer must be patient and determined. There are innumerable obstacles in his way, including the cage bars, patches of light and shade, other animals, visitors and so on. He has to wait until everything is right—the "pose", lighting, background, colour composition, etc, if he is to get more than very ordinary snapshots.

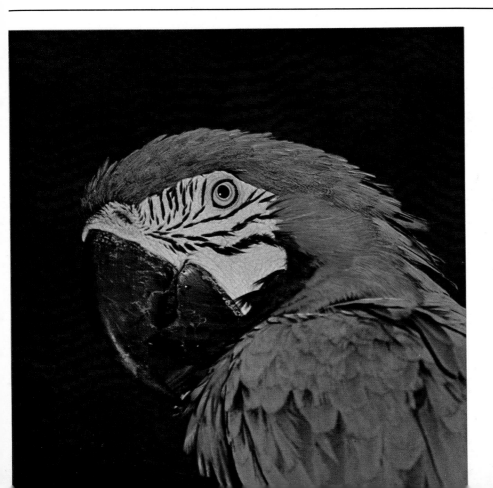

Flowers

Flower photography is largely concerned with flowers in two forms : those growing naturally and those arranged in vases, bowls, etc. It is not too difficult to photograph cut flowers—the greater skill is in the arrangement—but the result is not very satisfying for the botanist.

Flowers can be photographed in the mass but they generally look better as single blooms or small clusters in their natural environment. For this you need close-up equipment. Supplementary lenses are quite suitable, on reflex or non-reflex cameras, but undoubtedly the best combination is a single lens reflex with extension tubes or bellows. The picture can then be composed with certainty on the viewfinder screen with no parallax or focusing problems.

For extreme close-ups where focusing is critical it is a good idea to use a tripod. A further useful aid is a folding reflector which can be used either for its prime purpose of supplying fill-in light or as a wind-deflector.

Picture structure

Most flowers should preferably be shown with a generous amount of stalk and some foliage and the picture should contain some hint of the natural surroundings. There is no need to show a host of other stalks and leaves that are close by and, in fact, it may be advisable to prune the area. The reflector may, perhaps, also be used to shade off some light from the background so that the prime bloom is given prominence.

Colour control

Nature, fortunately, exercises a reasonable amount of colour control for us. Most flowers are relatively warm in colour—red, pink, yellow, orange and so on. Even the blues frequently have a tinge of red to them or there are yellows in the stamens, etc. Green stalks and foliage provide a suitable mid-background colour, especially if they are further backed by darker parts.

The subject

The pictures on the following pages show both flowers growing naturally in the open air and orchids cultivated in greenhouses. All give at least a hint of the natural environment. The exotic colouring of the orchids provides a vivid contrast with the more subdued natural blooms. Vivid colours can, however, be found in many flowers—in gardens, fields, hillsides and even rubbish dumps. Weeds have flowers, too, and some of them are quite attractive.

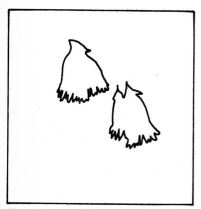

Dominant red (see page 222)— warm colours (see page 190)

Verticals (see page 242)

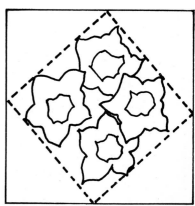

Square placed on point (see page 258)

Summary

Flower photography is quite fascinating and can be practised in a variety of ways. You can visit places where you know there are plenty of blooms, such as botanical gardens, flower shows, markets and so on. Perhaps the most satisfying method, however, is to take your camera out into the fields and search out the rarer varieties for yourself.

Shooting data

Left: Contaflex with close-up equipment. Carl Zeiss Archives. *Right:* Leica, Summicron 50 mm with close-up equipment, Agfacolor CT18, 1/125 sec, *f* 11. *Gerhard Bartz.*

Green as mass (see page 198)—dominant violet (see page 222)

Rising diagonal (see page 246)

Triangle (see page 238)

Correct focusing is half the battle when photographing flowers. In close-ups, depth of field is quite limited, even when the lens is well stopped down. It is, therefore, no use focusing on the nearest detail because parts even an inch or two behind may become quite fuzzy. It is generally best to focus on a plane between one-third to half the depth of the subject so as to make full use of the depth of field both in front of and behind the focused plane. It is nearly always possible to use a small aperture, even with extension tubes or bellows, because the flower stays still and long exposures are quite feasible. Where the viewpoint is not particularly close, however, a larger aperture may be preferable in order to eliminate any fuzzy detail in the background.

Landscape and seascape

A landscape picture is shaped by so many geological, geographical and climatic conditions that the opportunities created for the photographer are endless. Even within the same country, or perhaps within a single county or district, there can be landscapes ranging from flat fields to hills or high mountains, from forests to bush land, marsh to meadow, slag heap to river valley. Each can make its own particular type of picture and can, moreover, form different pictures at different times of the day and of the year.

The most remarkable feature of the landscape picture is the area it covers in width and depth. Thus, the camera position is important, because it governs the impression of space, and particularly depth, that the picture will give. The camera position should be so chosen that the foreground is not left looking empty. Recognizable features, such as trees, foliage, walls, etc, placed in the foreground, loom fairly large and can help to convey an impression of depth.

Picture structure

The structure of a landscape depends very much on this relationship between foreground and background. The foreground features often lead the eye into the background of the picture and bring it to a resting point. It must not be such a direct lead, however, that the rest of the picture is ignored. There are many types of rolling landscape or open seascape in which the eye must be induced to explore the whole area before coming to rest on a particular feature.

Colour control

Landscapes do not always follow the rules of foreground and background colour. In the following two pictures, for example, there are warm reddish tones in the background and green spots and flecks in the foreground. When evening light falls on mountain tops they can appear in brilliant red—yet they remain in the background. Nevertheless, they tend to reach forward and grasp our attention.

Sunset over water produces warm-coloured reflections in the foreground water. These reflections lead the eye into the picture and up to the clouds from which they originate. Such reflections act as a foreground and can obviate the need for trees, rocks, ships, etc.

Subject

The appeal of the left-hand picture is due to the climatic conditions. A storm is beginning to clear. The first rifts have appeared in the clouds and a weak sun is stabbing through to give an unusual lighting effect. The rain has cleared the air and

Two-tone colour harmony (see page 202)

Colour accent (see page 198)

Rising diagonal (see page 246)

the pinnacles in the background press forward, partly because of the clarity of the air and partly because of their colour.

The right-hand picture was taken from a motor boat and it might have been thought that part of the boat should be included to provide a foreground. In this case, however, it would have been out of place. Instead, reflections from the sunlit clouds form a more compatible foreground which gives an effect of depth, helped also by the wheeling gulls.

Summary

Every landscape has a character of its own and most landscape photographers tend to specialize in a particular type—mountains, perhaps, or seascapes, forest lands, agricultural areas and so on. There is good reason for such specialization because good landscape photography is not easy. The photographer needs to understand his subject and be able to foretell the varying effects created by different lighting or climatic conditions.

Shooting data

Left: 35mm camera, Agfacolor CT18, 1/60 sec, *f* 11–16, UV filter. *Michael Maier.*
Right: $2\frac{1}{4}$ sq in camera, Agfacolor CT18, 1/250 sec, *f* 11. *Hans Lauterbach.*

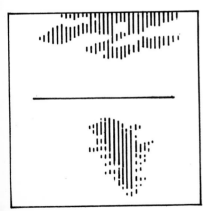

Colour control : dominant orange (see page 222)—warm colour (see page 190)

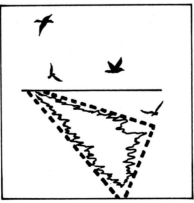

Picture structure : triangle (see page 262)

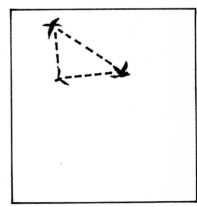

Picture structure : optical triangle (see page 238)

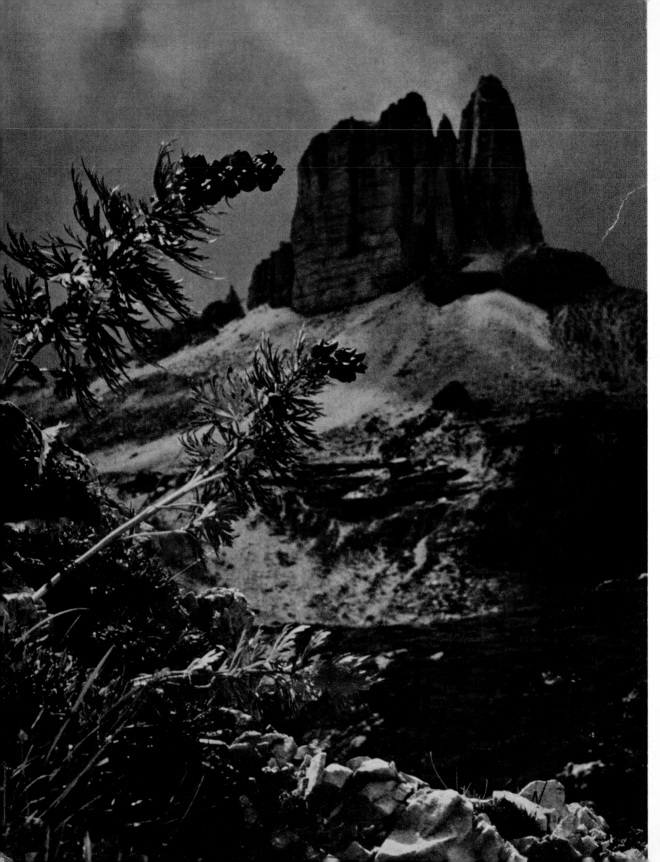

foreground and background to set his scale and has chosen a viewpoint to include trees and sky as a foil to the brilliant contrasts of the water and foreground rocks.

Summary

The wonders of nature can sometimes be frightening— because of their height, their power or, perhaps, the obvious inherent danger. The photographer should try to heighten this impression by choosing a viewpoint (or, by using a longer focus lens, an apparent viewpoint) that places the subsequent viewer of the picture just where the danger seems greatest or the frightening effect is most pronounced.

Shooting data

Left: Retina Reflex, Kodachrome II. *I. Scharf.*
Right: Retina, Ektachrome-X, 1/60 sec. *D. Meyer.*

Cool colours blue and green (see page 190)

Horizontal (see page 242)— high horizon (see page 286)

Vertical (see page 242)

Nature's details

There is a general opinion that everything in nature is beautiful. In fact, it is impossible to take a colour picture that does not, to some extent at least, contradict this snap judgment. There may be a muddle of themes, a series of unrelated shapes or a lack of harmony in colours.

For these reasons, concentration on detail is often the best way to ensure successful pictures. The photographer must, even if he is not a botanist or forester, learn to isolate the important parts of the subject. It is commonly said that the photographer must present the important and eliminate the unimportant—a formula that does perhaps look like a move in the right direction but quite often not correctly interpreted or acted upon.

Those who are attracted by detail will not normally have much difficulty in following this basic rule. They will find such pictures as those on the following two pages—pictures which exist everywhere but remain largely undiscovered.

Picture structure

In the search for such subjects, we meet both real and abstract shapes. It often does not matter what the objects are—we are after the pictorial effect. The structure is determined by the camera viewpoint, by which only just enough of the subject is included to provide the desired effect. With small detail, close-up equipment such as supplementary lenses, extension tubes or bellows are essential on journeys in search of this type of subject.

Colour control

Colours in natural details are often surprisingly varied. We are not accustomed to examining the objects around us very closely and we usually see small objects in terms of an overall colour. If we really look at them, however, we may well find that colours are present that we never thought possible. They may be only tiny flecks but, in close-up, a camera can give them considerable emphasis. Examine all parts of your subject very carefully before making the final selection, so that the most pleasing colour composition can be found.

The subject

The search for details such as those shown overleaf is an absorbing pastime. They can be found anywhere : in fallen leaves, tree bark, wild blooms, flotsam at the water's edge, and so on. The important thing is to study the subject carefully and choose the viewpoint that shows to best advantage the texture, colour, shape or whatever it is that creates the picture.

Bottom picture: abstract colour shapes (see page 210)

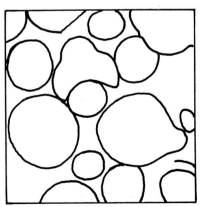

Top left: circles (see page 254)

Top right: rising diagonal (see page 246)

Summary

Perception, initiative and thoughtfulness are the qualities you need to discover such pictures. Perception is the ability to see what another person misses—to recognize the important detail in the mass. Initiative is the quality that seeks out the detail in places that might not be immediately obvious. With thoughtfulness the photographer can weigh up the possibilities of his discovery and show it in its most attractive form.

Shooting data

Left: Agfacolor CT18, 1/125 sec, f8–11. *Sitty Schwerdt.*
Right: Agfacolor CN17, 1/100 sec, f8. *Karl Frank.*

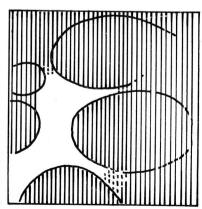

Warm colour (see page 190)

Circles (see page 254)

Asymmetry (see page 282)

Frost

Those who put their cameras away at the end of the summer season are missing a great deal. At the onset of winter, for example, morning frost begins to clothe the countryside and change its character completely. The brilliant colours of summer disappear, leaving the subdued greens, greys and browns of grass, evergreen foliage, tree trunks, twigs, etc. This colour shows through the frost and looks brighter by contrast. Unwanted details are obscured by the frost and sometimes by the selective focusing of close-up equipment.

The result can be a realistic picture with an ethereal quality or an impressionistic rendering of lines and patterns drawn by nature.

Picture structure

Light frost settles on the edges of leaves, twigs, branches, ferns, etc and emphasizes their boundaries and outlines. Thus, various compositions of verticals, horizontals, circles, ellipses, etc can be made. The object is to choose a part of the subject which combines these lines and shapes into a satisfying pattern and excludes irrelevant or disturbing detail. Naturally, each subject offers a host of opportunities and the various patterns presented should be studied carefully in the viewfinder to decide on the particular presentation that gives the most pleasing effect. A mere detail may provide the better picture and close-up equipment can then be used to isolate it from the surroundings.

Colour control

Frost pictures are quite effective on black-and-white film. With colour film we naturally wish to include colour in the picture.

As the picture is made by the frost and the pattern it creates, colour in frost pictures should merely supplement the frost and therefore be subdued rather than garish, particularly in a recognizably "natural" scene. Bright colours compete with the frost patterns for attention and therefore detract from their appeal.

The subject

The edge of a wood is a particularly good location for frost shots. Often the frost touches only the outermost trees, leaving those farther back in the wood much darker in tone. Frost-tipped areas can then be made to stand out against a dark background. A little weak sunshine is often helpful to brighten the frosty edges. In the absence of sunlight flash is a good substitute. Although the colour should not predominate, there is no harm in including a small area of warmer colour to add an accent.

Dominant green (see page 222)

Warm brown (see page 190)

Verticals/obliques (see page 242)

Summary

Brightly coloured sunlit scenes have undoubted appeal and the average photographer might be forgiven for feeling that there is little point in using colour film on virtually colourless scenes. Yet such scenes have a distinct appeal of their own and frost scenes are obvious cases in point. They must have some colour but it need be only enough to emphasize the whiteness of the frost and to add life to the scene.

Shooting data
Left: Leica, 135mm lens on Visoflex, Agfacolor CN17, 1/15 sec, *f* 5.6. *Horst Munzig.* *Right:* Agfacolor CT18, 1/125 sec, *f* 2.8. *Walter Rieger.*

Melancholy colour atmosphere (see page 226)

Verticals (see page 242)

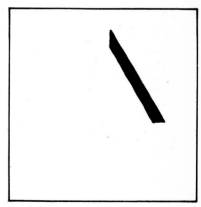

Rising diagonals (see page 246)

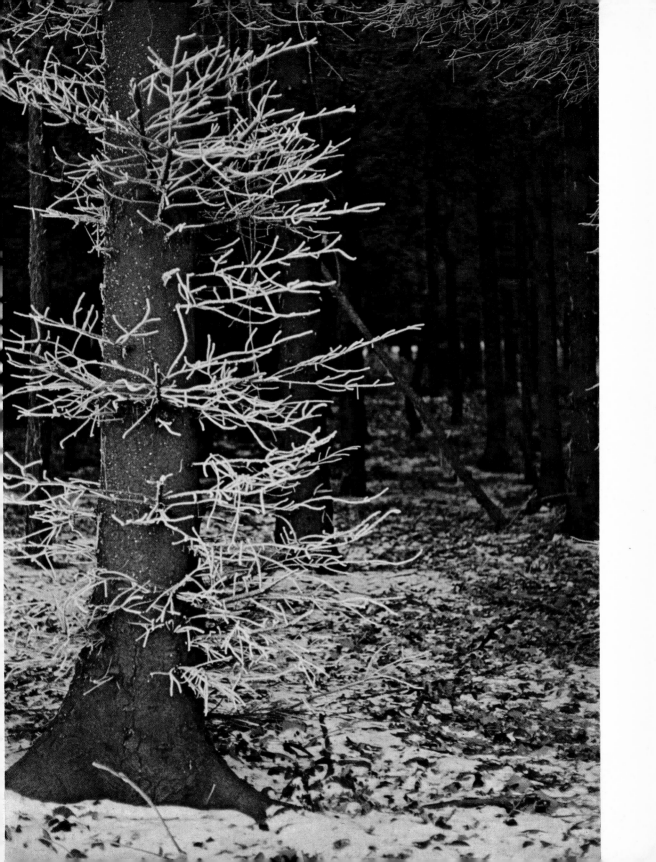

Snow and ice

Like frost, snow is still largely thought of as a monochrome subject. Snow is white and has black or grey shadows, so black and white film is the natural material on which to record it. So runs popular opinion. In fact, the shadows in snow very rarely are black or grey. They usually have a slight blue tinge to them and, when the sky is clear, they are very decidedly blue.

The great advantage of snow is that it covers things up. The ordinary landscape view is often cluttered with unwanted detail which spoils or even destroys the overall impression of a unified form and mass. Snow covers these details, smooths them out and imparts a more satisfying shape to the general scene.

Picture structure

By obscuring details, snow makes particular features such as streams, rivers, footsteps, walls, etc more prominent and form the structural base of the picture. The stream traversing the picture from foreground to background adds depth. Footprints in the snow can do the same and if the figure making the footprints is included he may be an effective focal point. Some shadow in the snow is essential to give it texture, otherwise it loses all life and looks like flour or dirty powder. So some sunshine, or at least a bright sky, is helpful. Where the sky is very blue, a UV or skylight filter can reduce the intensity of this colour in the snow shadows. Blue shadows are natural but few people recognize this as so and the photographer should bow to the popular conception. If the shadows are too blue, they look unnatural to most people.

Colour control

Snow pictures are undoubtedly improved by a blue sky. It emphasizes the brilliance of the snow and acts as a natural background of the right colour. Bright colours within the picture are acceptable, too, provided they do not look out of place. Brightly dressed people, for example, wearing anoraks, perhaps, in vivid colours would not look at all incongruous on a ski slope. Where the picture is essentially a landscape, however, bright colours, apart from the blue of the sky are rarely desirable or necessary.

There is colour enough in the natural features, as in the water, the stones and the snow reflections in the picture on the following left-hand page.

The other picture could easily have been a monochrome shot with a filter to darken the sky but how much more effective it is with that vivid blue backdrop. The icicles and the snow are far from white but they appear quite brilliant by contrast.

Warm yellow (see page 190)

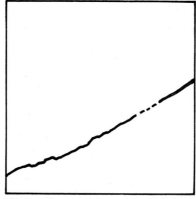
Rising diagonal (see page 246)

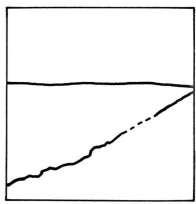
Triangle (see page 262)

The subject

There are countless opportunities for snow and ice photography. The following two pictures show only two aspects. Both pictures were taken on a bright day and show snow in its most pleasant form. But snow can be unpleasant too, as town slush or when falling from a bleak sky. There are then few bright colours and they are unnecessary to preserve the mood.

In the right-hand picture a bold foreground feature adds interest to an otherwise rather ordinary snowscape. Icicles seen in exaggerated perspective because of a wide angle lens and low viewpoint, lead the eye into the lower part of the picture and create a sensation of depth—the lower section, unusually, containing the distant subject matter.

Summary

Not all countries experience blue skies or brilliant sunshine when snow falls. Nor is the temperature always pleasant for outdoor photography. It is wise to venture out only if well prepared with warm clothing and, preferably, a camera that can be operated with gloved hands.

Shooting data

Left: Kodachrome II, 1/125 sec. *Tony Schneiders,* Kodak Archives.
Right: Hasselblad 38mm lens, Agfacolor CN17, 1/125 sec, *f*8. *Karl Mitvalter.*

Dominant blue (see page 222)— background colour (see page 190)

Triangle (see page 262)

Obliques (see page 242)

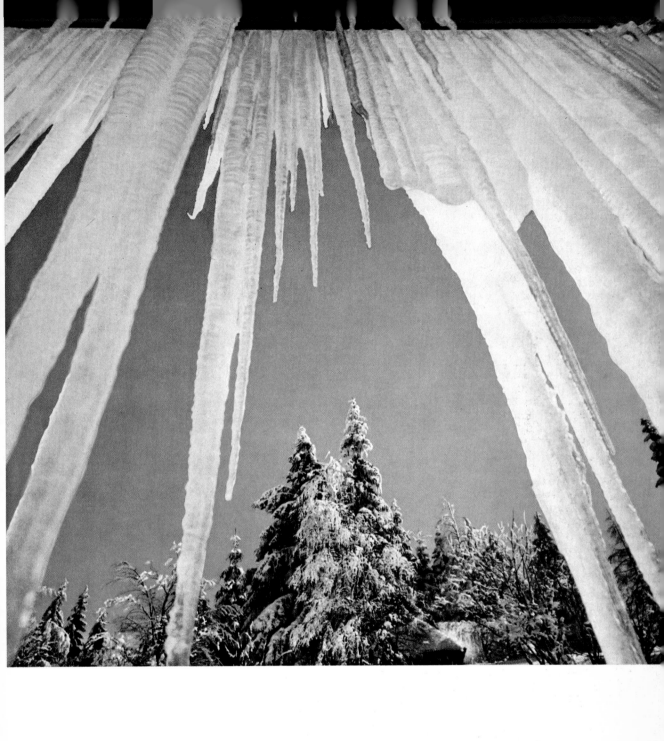

Sunrise and sunset

The photographer tends to pay more attention to sunset than to sunrise. Yet the sunrise can often have more "atmosphere", with early morning mist shrouding the countryside and fewer signs of human habitation.

At both times, sunlight, from a low position, has farther to travel through the earth's atmosphere. Consequently the shortwave rays are scattered and longwave rays (red and yellow) pre-dominate. Colour film is very sensitive to this change of character in the lighting and records it as a red/orange cast throughout the picture. Filters are available to counteract the effect when the photographer wishes to make the shot look as if it were taken in normal daylight.

The sun itself often looks startlingly red at sunrise and sunset, even to the eye, and with suitable clouds reflecting the reddish light, quite extraordinary colour pictures are possible.

Downward reflections on to water are also attractive and can lend foreground interest which echoes the effect. After sunset the red glow in the sky persists and can still be reflected in water.

Picture structure

Where the whole interest is the effect of sunrise or sunset, exposures should be kept quite short. This serves two purposes: it deepens the colour of the sun and sky and at the same time radically underexposes any figure, building, tree, etc in the scene. Such features are necessarily backlit and will appear in silhouette, which is normally best, because their only function is to provide balancing masses or shapes, not detail.

Colour control

Such lighting does not allow much control over colours in the picture. Cooler colours (blue, green, etc) cannot exist in strong reddish light conditions. They become considerably warmer or, by being underlit, disappear into darkness. This is as it should be because any cool colour would look totally out of place and destroy the effect required. It must be remembered particularly that the so-called "morning and evening" filters are not intended to make conditions look as they really are. These bluish filters counteract the tendency to red.

The subject

In the left-hand picture the sun is just about to set. It also demonstrates the value of a long-focus lens for such subjects. The sun looks impressive because it is seen through a 200mm lens. With the standard 50mm lens it would have occupied only one-sixteenth of the area it now does.

The other picture can be regarded as a sequel to the first. The sun has sunk below the

Dominant red (see page 222)—blue as mass (see page 198)

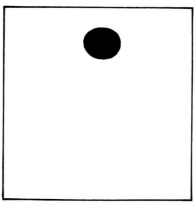

Accent (see page 234)—circle (see page 254)

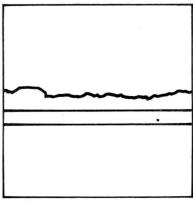

Horizontal (see page 242)

horizon but impressive colours and shapes still remain reflected in the clouds. These colours and shapes change rapidly and soon fade away altogether. Some judgment is needed to capture the right moment.

Summary

If the sun is to be included in the picture, a long-focus lens is almost essential. With a standard lens, the sun becomes unnaturally small. That may be acceptable if the reflections are really staggering but a larger image is generally preferable. Exposure has to be carefully handled. A direct meter reading will give an acceptable exposure but often, only half that exposure is necessary.

To be on the safe side, two or three shots should be made at different settings.

Shooting data

Left: Retina Reflex, 200mm lens, Kodachrome II, 1/60 sec, *f*8. *W. Köhler.*
Right: Agfacolor CT18, 1/30 sec, *f*4. *Dr Georg Wolff.*

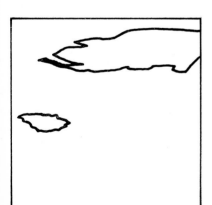

Dominant red (see page 222)

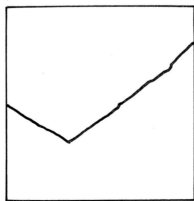

Rising and falling diagonals (see page 246)

Triangle (see page 262)

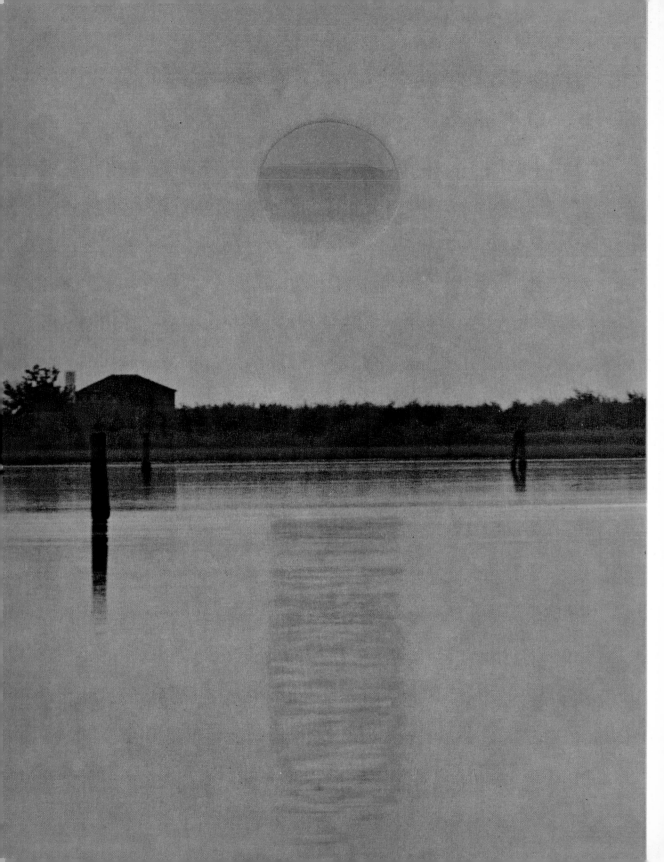

football, but there are innumerable subjects to which it can be applied. The subjects must suit the treatment, however. It would be difficult to justify a blurred landscape, statue or other static subject. Nor should every moving subject be blurred. The blur must have meaning.

Summary

When one of these pictures was sent to *Life* magazine, there was talk of a new epoch in photography. Blurred images became acceptable and, for a time, it seemed as if every photograph was being taken through bottle glass or with a sticking shutter. The phase soon passed and genuine uses of the technique became part of the photographer's stock in trade. Intentional blur, however induced, is now a common method of conveying various impressions but we must be on our guard against applying it meaninglessly.

Shooting data

Both pictures were taken by Ernst Haas with a Leica. No other details are available.

Dominant red (see page 222)

Cool colour blue (see page 190)

Verticals (see page 242)

Foreground blur

It is a general rule that the foreground of a picture must be sharp. All general rules have exceptions, however, and blur is sometimes deliberately introduced into the foreground to create a sensation of depth and to provide colour contrast.

This technique originated in fashion photography and has since infiltrated into many other fields. It is usually a matter of adding colour complementary to that of the main subject. The aim is to build up the colour in a logical way so that the added colour appears natural to the scene and does not look like a prop.

The method is simple. You cut the required shapes from coloured paper or transparent foil and position them in the picture field close to the camera—close enough to be out of focus to the extent required. A camera with a focusing screen is almost essential and a single-lens reflex is ideal.

Picture structure

The shapes of the foreground objects should complement those of the main subject. Frequently the coloured, blurred shapes look like repetitions of the objects in the picture. At other times they are deliberately made to introduce strong contrasts.

Some experiments are needed to ensure that the added shapes look right. A useful method is to make a frame into which a sheet of plate glass can be slipped to hold the coloured shapes and smears of petroleum jelly. The jelly is often placed around the edges of the picture area so that only the central parts of the subject are clearly seen.

Colour control

Both pictures overleaf have carefully arranged colours. In the right-hand picture for example, blue was chosen for the added colour because it was not present in the actual scene. It increases the intensity of the red to a marked degree. It also, of course, runs counter to the usual ideas of foreground and background colours, but here, because it is out of focus, and because it contrasts strongly with the red, it gives a marked impression of depth.

The subject

There is no restriction on the type of subject that can have a blurred foreground. As with all techniques that break established rules, however, it must be applied with reason and not just as a gimmick. The petroleum jelly method mentioned earlier is not always combined with added shapes. It is sometimes used alone simply to focus all attention on the centre part of the subject, often a figure or a face. The effect of the jelly is, of course, to diffuse the image and reduce contrast.

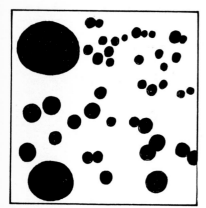
Dominant red (see page 222)

Circle (see page 254)

Verticals (see page 242)

Summary

The blurred foreground is a technique that has to be handled with care. It can easily be overdone and look utterly false. The aim is normally to create depth, add colour contrast, concentrate interest or perhaps even to cover up unsuitable foreground detail but it is up to the individual photographer to use his ingenuity to find suitable applications.

Shooting data

Left: 35mm SLR, 135mm lens, Agfacolor CN17, 1/200 sec, *f*4. *Horst Einfinger.*
Right: Leica, Hektor 135mm, Agfacolor CT18, 1/250 sec, *f*4.5. *Hans Windgassen.*

Dominant red (see page 222)

Colour as mass (see page 198)

Optical triangle (see page 238)

Reflections

Although they are often a nuisance, reflections can sometimes make interesting subjects in themselves or add interest to a subject that would otherwise be rather mundane. Reflections are, in fact, all around us—in mirrors, rivers, ponds, windows, polished surfaces, and so on. These surfaces need not even be flat. Pictures have been made of reflections in, for instance, the hubcaps of motor cars.

Now that the SLR is in such common use, focusing on reflections gives little trouble but when scale focusing is used, it must be remembered that the distance to be focused on is that from camera to reflecting surface plus reflecting surface to reflected object or scene. This sometimes gives depth of field problems as, for example, when both the reflector and the object seen in it must be rendered sharp.

Picture structure

Reflections can rarely form a completely satisfying picture in themselves, but there are innumerable occasions when they make very successful props. We have seen in previous examples how they can add foreground interest or improve a night scene. The reflected image in such cases is rarely a perfect mirror image, which tends to divide the interest and make a rather pointless picture. The reflection should preferably be in rippling water or some other irregular surface so that it is broken up into a barely recognizable colour composition occupying an area that would otherwise be empty and lacking in interest.

The mirror image is sometimes used to comical effect— reflections of real people mixed with the dummies in shop windows, for instance. The picture composed entirely from a reflection is often an abstract representation.

Colour control

The colours of a picture consisting entirely of a reflected image are controllable within very wide limits. If, for example, the result is an abstract composition, the colours need not be true.

The reflecting surface can be coloured; filters or the "wrong" type of film can be used.

Even when the reflected objects are recognizable, some manipulation of colour is often acceptable and in many cases is better to avoid a mirror image effect.

The colour content can also be controlled in the normal fashion, of course, by arrangement of the subject and/or camera viewpoint.

The subject

The left-hand picture is of a

Dominant red (see page 222)

Horizontals (see page 242)

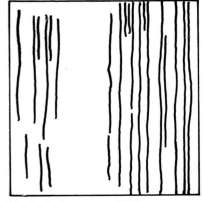
Verticals (see page 242)

company notice board in London
—apparently a very unexciting
subject. The photographer
noticed, however that it could be
made to reflect a part of the busy
London scene—a typical red bus
and other colours from the street.
The brass instruments in the other
picture were an obvious source of
reflections. Here, the
photographer sought to make the
most of his opportunity by
maximizing the reflections and
the colour contrast, while
retaining the atmosphere of the
brass band parade.

Summary

Reflections are almost literally
everywhere—in shop windows,
painted surfaces, polished tables,
chromium plate, puddles, wet
roads, spectacles and even in the
eyes. Not all of them make
worthwhile pictures but the
opportunities are there for those
who have sufficient vision to see
them.

Shooting data

Left: Leica, Telyt 200mm on
Visoflex, Agfacolor CN17, 1/50
sec, f5.6. *Erwin Fieger.*
Right: 35mm camera, 300mm
lens, Agfacolor CN17, 1/125 sec,
f8. *Hans-Helmut Freund.*

Abstract colour shape (see
page 210)

Complementary colours red and
green (see page 206)

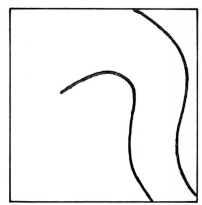

S-line (see page 250)

B & M GROUP

BELLISS & MORCOM LTD.
BIRMINGHAM

BRITISH ARC REGULATORS LTD.
AUTOMATIC REGULATORS GLOUCESTER

W. SISSON & COMPANY LTD.
ENGINEERS GLOUCESTER

FIFTH FLOOR

Interiors and stained glass windows

Photography inside buildings raises many problems of lighting, which is often uneven and composed of a mixture of daylight and artificial light. There may also be difficulties in choosing a viewpoint that does not involve tilting the camera and thus causing vertical lines in the picture to converge.

With the right equipment these difficulties can be overcome but for the average camera user they can be insuperable, in which case he has either to accept the distortions and imperfections, or decide to forgo the general view and concentrate on details.

Exposure for interior shots is often a matter of compromise. The light may be contrasty and shadow areas large and detailless. Often, too, the detail photographed may be inaccessible except to a spot or through the lens meter. A standard grey card is useful in these circumstances. The grey side reflects 18 per cent of the light falling on it and a direct reading from this at a range of about 15cm (or say 30 in) gives a good compromise exposure for colour film. If the light level is very low, the reading can be taken from the white side of the card and the exposure then indicated multiplied 4–5 times.

Picture structure

The examples overleaf show stained glass windows—a popular interior feature—and colour effects in various churches. Here, the grey card method of exposure assessment cannot be used because the photograph is taken by transmitted, not reflected light. The aim should be to approach the subject as closely as possible and take a direct reading.

Where the window is above eye height, a long-focus lens and a more distant viewpoint may help to minimize distortion of line. Generally, it is difficult, if not impossible to photograph interior features together with the stained glass window, except in silhouette or near-silhouette form. It can be done with ancillary lighting equipment or flash—perhaps sometimes merely with reflectors—but that is the field of the specialist.

Colour control

In this type of photography, colour control is largely exercised by the selection of the detail to be reproduced. The colours of stained glass windows are inevitably brighter and of different character from those of other interior details, such as sculpture, ornamental features, etc. There is usually no violent clash, however, because the original artists have designed the interior as a whole. Where later additions or, sometimes, commercial features such as bookstalls, notices, etc, seem

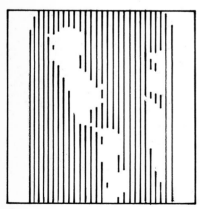

Dominant red-orange (see page 222)

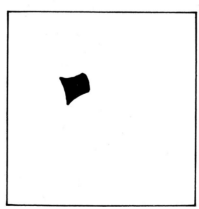

Blue accent (see page 198)

Verticals (see page 242)

incongruous, a viewpoint must be chosen to exclude them from the camera's view.

The subject

The following examples are from collections of such details made over a period of years. Most people have the opportunity of making such collections and, in time, they can become specialists in this type of work. Then, they can perhaps organize their trips to carry lighting equipment where required and even to reach normally inaccessible features. Special permission can often be obtained from church authorities to use equipment and to photograph features denied to the casual snapshooter.

Summary

Many people make a hobby of their interest in architecture and architectural features. Colour photography offers an opportunity to add a new dimension to the hobby. Visits to places of interest can be supplemented by a collection of photographs that serve both to give pleasure and to aid the memory.

Shooting data

Top, left to right: Retina, Kodachrome II, *A. Rudolph.* Retina, Kodachrome II, *H. Janicki.* Ektachrome-X, *H. Carlo.* Retina, Kodachrome II, *A. Rudolph.*
Bottom, left to right: Retina, Kodachrome II, *A. Rudolph.* Retina, Kodachrome II. *H. Janicki.* All pictures from Kodak Archives.

Lower picture: dominant red-orange (see page 222)

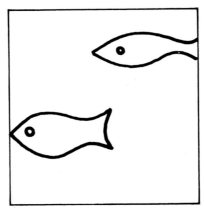

Contrasty colour shapes (see page 210)

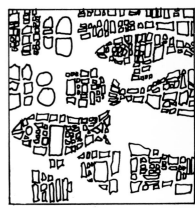

Square and rectangle (see page 258)

The best lighting for stained glass windows is diffuse sunlight or even dull overcast lighting. Direct sunlight streaming through the window has a bleaching effect on the colours and may also diffuse the outlines. If there is no opportunity to return when the lighting is more suitable, exposure should be kept as brief as possible to avoid these effects. Generally, exposures might be rather long and the camera should therefore be on a tripod. Even when hand-held exposures are possible it would be better to use a tripod to obtain the outline sharpness so important in this type of subject.

When you can approach a stained glass window closely, take two exposure meter readings, one from the brightest areas and one from the medium bright. Add the indicated figures together and then halve the sum (it is easier to work on aperture numbers). The correct exposure is then one half stop below the resulting figure. Example: f11 plus f5.6 divided by 2 = 8.3. The correct aperture is thus f6.3, between f5.6 and f8.

Architecture and statuary

Traditionally, architectural pictures should be distortion-free. Verticals should be vertical, horizontals parallel, arches faithfully arched and so on. For certain types of picture this is still necessary but, for the amateur at least, it does not have to be a rigid rule.

There are few buildings and fewer statues that were meant to stand in isolation. There is always something else in the vicinity—even if only a clump of trees. It is reasonable, when picturing the building or the statue to place it in its setting.

The reproduction may be true and faithful, or it may be impressionistic. There are plenty of photographic records of well-known structures. It is more interesting to try to produce an individual impression.

Picture structure

The camera viewpoint can be such that the building or statue is shown in isolation or with relatively neutral, non-obtrusive surroundings. This will probably give a faithful reproduction and a balanced composition—but a rather dull picture like a picture postcard. You should seek a camera position that gives a more imaginative view.

It is not easy to make artistically satisfying pictures of buildings. The surroundings—or the photographic possibilities inherent in the surroundings—have a great influence. The time of day, the seasons and the weather play their part, too, as the following two pictures show.

Here, we find pictures which use sharpness in a particular zone to concentrate interest, the one in the foreground, the other in the background.

Colour control

The statue in the left-hand picture is not in itself coloured. It carries just a hint of colour by reflection. The blurred leaves on the ground add warmth to what would otherwise be a composition of almost entirely cold tones. The warmth is echoed by the leaves carefully placed in the foreground. Together these tones push the statuary to the front of the picture and give it a three-dimensional effect.

The Eiffel Tower, taken shortly after sunset, stands against a neutral sky. The considerably blurred foliage in the foreground increases the impression of depth and fills the bald sky.

The subject

The left-hand picture is of a common enough subject in Paris and the right-hand one shows a world-famous structure. But each is individually presented. They are the views of a particular photographer, not just straightforward reproductions of well-known subjects. They

Warm colours (see page 190)—dominant colour (see page 222)

Triangle (see page 262)

Verticals (see page 242)

emphasize the importance of
personal impressions.

Summary

Buildings and statues are the
easiest of subjects to find but by
no means the easiest to
photograph. The straightforward
view intended to show the
design, shape and form of the
building itself demands
considerable skill and knowledge
and can often be obtained only
with specialized equipment. The
personal impression, which is a
more likely approach for the
average photographer, calls for
different qualities—vision and
imagination.

Shooting data

Left: 35mm wide-angle lens,
Agfacolor CN17, 1/60 sec, *f*4.
Fritz Frenzl.
Right: Leica, Hektor 135mm,
Agfacolor CN17, 1/10 sec, *f*5.6.
Fritz Frenzl.

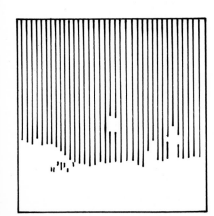

Warm colours (see page 190)—
dominant colour (see page 222)

Verticals (see page 242)

Low horizon (see page 286)

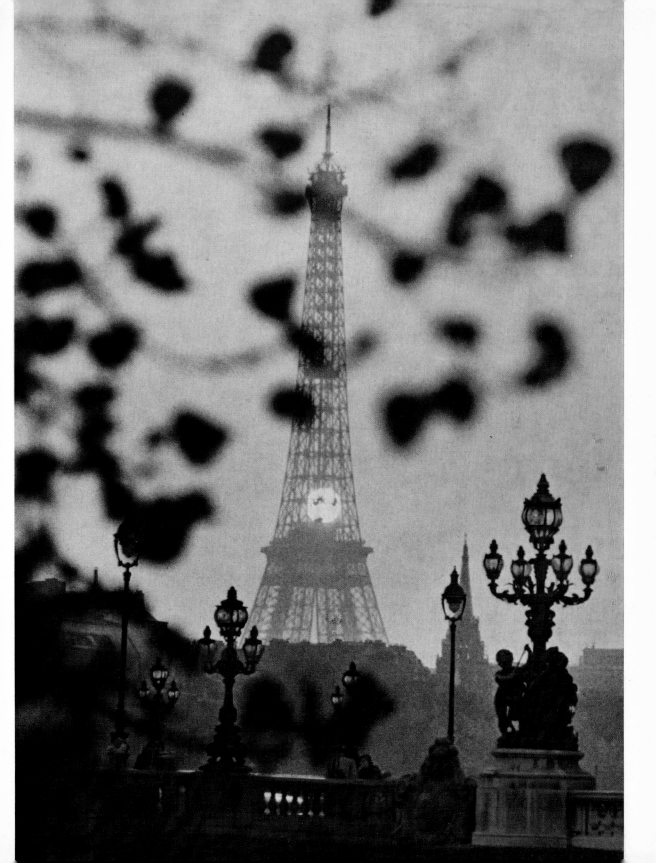

Stage pictures

The theatre lends itself to dramatic and colourful pictures. But in almost every case you must first obtain permission to take photographs. This you must do, because there are questions of copyright involved in the performance. Even if you are granted a permit you must still photograph inconspicuously and without marring the enjoyment of other members of the audience. If you are lucky enough to photograph a dress rehearsal, you can move much more freely and may even be allowed to use flash.

Generally, however, stage photography involves rather low light levels and fast film because a tripod cannot be used and relatively fast shutter speeds may be needed to cope with movement. Your films may even have to be force-processed to raise their effective speed still further but at the expense of quality.

You have to take risks with stage shots because your meter reading usually tells you that photography is impossible. In those circumstances you open up the lens as wide as practicable and use, perhaps, a shutter speed that risks some blur.

Picture structure

To get a clear view you have to be in the front row of the stalls—preferably right in the middle. Even then, you may need a long-focus lens so that you can concentrate on a particular piece of action. A box may also give a good view but is rarely satisfactory for picture composition and the subject may appear rather foreshortened.

The composition of the picture is largely dictated by the designer, choreographer, etc but you can exercise a reasonable amount of control by selection of details, using lenses of different focal lengths.

It helps if you take pictures only on a second visit, using the first to make notes on the performance and to choose the particular moments best suited to photography.

Colour control

The colours are provided by the stage designers and it would be unwise to try to exercise control over them other than by selecting a part of the scene rather than the whole. Your film will probably not record the colours with absolute fidelity because the stage lighting is unlikely to be the most suitable kind for your film. This is not usually important because the colours are often deliberately theatrical and inaccuracies are not easily detected. Colour print film has rather more tolerance of unsuitable lighting conditions and also provides more scope for later cropping to improve the composition.

Dominant red (see page 222)

Complementary colour green (see page 206)

Angle (see page 262)

The subject

The ballet scene on the left is an example of making a virtue out of a necessity. The relatively low light level made a slow shutter speed essential. The centre figure was carefully focused and, while she was stationary, the shutter was released to catch the other figures in motion.

The right hand picture demonstrates an entirely different treatment. It called for a smaller aperture to give all-over sharpness and therefore the photographer had to choose a moment when activity was at a minimum.

Summary

There are many small theatre groups who may readily give permission for photographs to be taken at their performances and who may even be amenable to photographers with a genuine interest in their activities attending a dress rehearsal. It is worth making the effort if you have such a group in your locality.

Shooting data

Left: Rolleiflex, Agfacolor CN17, 1/25 sec, *f4. Gertrude Zahour.*
Right: Contarex, Zeiss Ikon Archives.

Complementary colours red and green (see page 206)

Optical triangle (see page 238)

Circle (see page 254)

Photo safari

The extensive game reserves of the African continent are proving extremely popular with photographers. If you have the chance to go on a photo safari, be sure you have a long-focus lens and make the proper preparations to meet the special conditions.

High temperatures and humidity have their effect on colour film and suitable measures should be taken to lessen this influence. All unexposed film should be kept in airtight containers until just before they are loaded into the camera. Special tropical packings are available for some films.

After exposure the film must not be returned to an airtight container if the humidity is high. As soon as you open the container to put the film in, it will fill with humid air and, if the container is cooled at any time, the moist air will condense into water droplets.

If your stay is to be at all lengthy, exposed film should be dispatched to processors as soon as possible because in these conditions the latent image can be seriously affected.

The camera needs protection, too. In dusty areas it is best to keep a filter permanently over the lens—a UV for colour print film and a skylight filter for colour slide film. Keep the camera in a plastic bag or similar container when not in use, to preserve it from dust.

Picture structure

Animals often present themselves only momentarily, so shoot quickly and as soon as the opportunity arises, regardless of the finer points. Then, if the animal has not disappeared, look round for a better viewpoint, select a more suitable lens, add a filter if necessary and so on. Take several pictures while you can.

Lighting tends to be contrasty in tropical countries and shooting in direct sunshine should be avoided if possible. It will give either washed out lighter colours or almost colourless shadows. Colour film cannot cope simultaneously with both extremes. A lightly veiled sun gives the best type of lighting, keeping the shadows reasonably well illuminated and within the range of the colour film.

Colour control

There are few possibilities of controlling the colour content of the picture. You have to accept the animal in his surroundings, which are usually green or brown. If you can put a little warm colour in without it looking too incongruous it will probably liven up the picture. It is preferable, however, to make no such attempt if you are doubtful about the suitability of the added colour or object.

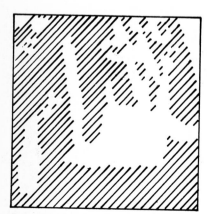
Dominant green (see page 222)

Diagonal (see page 246)

Horizontal (see page 242)

The subject

The short, hard shadows thrown by a high sun can ruin your photographs. Avoid the middle of the day and try to concentrate your photography into the 7–9 am and 4–6 pm periods. Remember that the animals are not the only worthwhile subject. The landscape, the safari transport, the natives and guides and even your colleagues can make interesting shots.

Summary

Before going on a photo safari, have your equipment checked and tropicalized if necessary. Give special thought to the type of picture you want and the accessories you need to take with you. Take plenty of film—more than you think you can possibly need—and, if you are staying long, make arrangements for it to be sent home for processing as soon as it has been exposed.

Shooting data

Left: Leica 280mm Telyt, 1/125 sec, *f*5.6. *J. Behnke.*
Right: Ektachrome-X, 1/60 sec, *f*4. *A. Stillmark,* Kodak Archives.

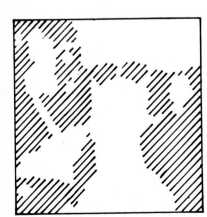
Dominant green (see page 222)

Warm colours (see page 190)

Golden section (see page 270)—asymmetry (see page 274)

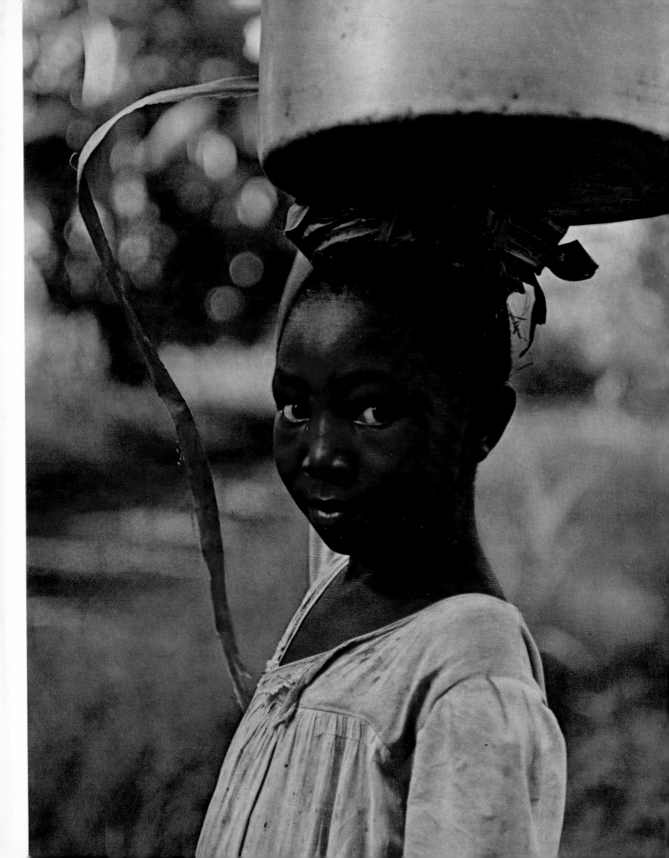

Travelling in distant countries

When you are in a foreign country, everything looks unusual and the photographic opportunities seem to be endless. It is difficult to sort the wheat from the chaff—to take worthwhile photographs rather than hosts of snapshots. You must not just become bemused by the strangeness of it all, but must try to record your impressions of the country through your pictures.

For different people this will take different forms. Whereas one person sees the character of a country in its buildings, another thinks its landscape more important. Yet another prefers to concentrate on the inhabitants.

Most people, however, will want to take a variety of photographs, with the idea, perhaps, that a suitable selection can make an interesting slide show. This certainly demands that the pictures be as original as possible. There are far too many collections of holiday slides being shown to rather bored audiences.

Picture structure

It is best, as in most photography, to let each picture deal with a single theme. Impressions cannot be put across by "busy" pictures so full of detail that nothing comes through at all. You cannot, for example, show the typical countryside, architecture and people all in the same shot. The pictures on the following pages emphasize this point. The monk on the left is shown in typical begging pose. He fills the frame, there being only a hint, in the vague background and the hovering pigeon, that he might be in a town. Similarly, the pagodas and other temple buildings opposite are allowed to dominate the picture; the monk is simply adding a splash of saturated colour to offset the mosaic effect. Here also is another example where reflections fill an otherwise rather empty foreground.

Colour control

Colours often look different in foreign countries. This is not normally because of any difference in the colours themselves but because of the way they are used. Shapes, too, especially in buildings, are frequently different. The aim should be to show these shapes and colours in the specially characteristic forms in which they are employed.

In tropical countries when the sky is clear, or in mountainous regions, a UV filter will counteract any excessive blue tone. With reversal film, a pinkish skylight filter is a good idea. Deciding when to resort to these filters is largely a matter of instinct and knowledge of the performance of your own equipment.

Dominant red and orange (see page 222)

Cool colour blue (see page 190)

Optical triangle (see page 238)

The subject

The type of picture you take in a foreign country depends mainly on your own interests but there should always be some attempt to emphasize particular features of the country. Yet the pictures must be your own, with as much thought put into them as time will allow. There is no point in duplicating the stereotyped views in picture postcards.

Summary

Carry plenty of film with you when you travel abroad, particularly when visiting the less-developed countries. You are sure to need rather more than usual and you may not be able to obtain fresh supplies of your favourite brand. It is unwise to settle for a film with which you are unfamiliar and particularly one for which there may be limited processing facilities.

Shooting data

Left: 35mm camera, 90mm lens, Agfacolor CT18, 1/125 sec, *f*4. *Dr Karl-Heinz Andres.* *Right:* Kodachrome II. Kodak Archives.

Warm colour red (see page 190)

Triangles (see page 262)

Vertical (see page 242)

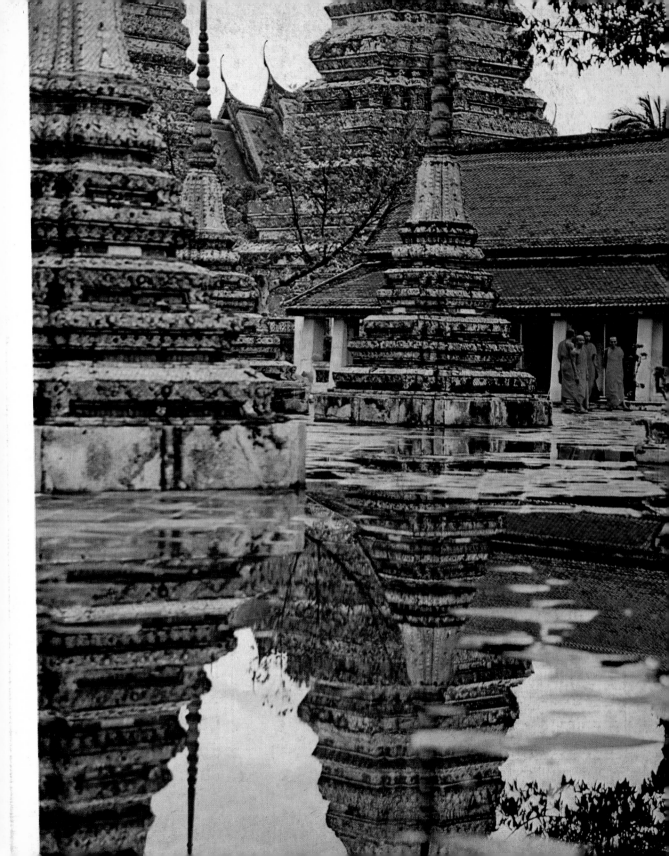

Holidays and the seaside

Everybody likes to look back on holidays and recall their experiences. Many of the shots we take on holiday are purely for our own enjoyment and it is right that these should be taken. There is no point in trying too hard to make every holiday shot a masterpiece. Nevertheless, the serious camera user must not lower his standards altogether. He must try to take some pictures of wider interest.

By the sea, the camera needs protection from salt water and sand. It is sensible to keep it in a plastic bag when not in use because sand can penetrate any ever-ready case with ease and, although your camera may be light-tight, it is certainly not sand-tight and sand in any moving part can induce wear very quickly. A UV filter permanently in place over the lens protects it from spray when you shoot near the water and is a lot easier to clean and cheaper to replace than the camera lens if it does suffer damage.

Picture structure

Generally, holiday shots should be lively, particularly those at the seaside. Those that show movement have most appeal. Follow the basic rules for placing of the main figure leaving more space in the direction in which the figure is moving.

"Bathing beauty" pictures have universal appeal and they are not difficult to find. They need careful arrangement and the elimination of distracting detail to be completely successful. The background can be formed, according to viewpoint, by sea, sky or sand. If the crowded beach has to be the background, the shot can rarely be satisfactory because it is difficult to use a large enough aperture to throw the background sufficiently far out of focus.

Naturally, there can be gloomy holiday pictures, too. The sun does not always shine and a windswept empty beach can make a picture; so can would-be holidaymakers sheltering from the rain or a detail, perhaps, of rain beating down on hastily abandoned deckchairs.

Colour control

On fine days, the water and the sky are blue. But blue is a cold colour and the holiday scene needs plenty of bright, warm colour to combat this effect. If you often use your own family as models, persuade them to wear red, orange or yellow. Blue, green, brown, etc will not help your photography very much.

Props such as beach balls, airbeds, buckets and spades, are handy. But you must be careful not to overdo them. With so much colour available, it is only too easy to lose the point of the picture by over-emphasis.

Warm colour red, cool colour blue (see page 190)

Abstract colour shapes (see page 210)

Optical right angle (see page 238)

The subject

The picture on the left-hand page is a perfect example of how to simplify such a scene. It has three elements only—the girl, the water and the ball. It may even have been oversimplified, in fact, because the location looks more like a swimming pool than the seaside, but the colours have been well handled. The girl's costume is not particularly vivid and is overlaid by the reflected blue in the water. Red and orange adds the brighter touch that induces a gayer atmosphere.

The right-hand picture looks far more spontaneous and is an example of how to dominate the blue and green of sea and sky by a large splash of warmer colour.

Summary

Snapshots belong to holidays because there is so much personal enjoyment that is worth recording. Nevertheless, the opportunities for more serious photography should not be overlooked. The sea and sky, in particular, offer such perfect backdrops for simply conceived pictures that it is terribly wasteful not to use them.

Shooting data

Left: Retina Reflex, Kodachrome II, 1/125 sec, *f*11. *G. Binanzer,* Kodak Archives.
Right: 200mm lens, Agfacolor CN17, 1/250 sec, *f*8. *Horst H. Baumann.*

Dominant yellow (see page 222)—foreground colour (see page 190)

Cool colour blue—background colour (see page 190)

Horizontal (see page 242)—low horizon (see page 250)

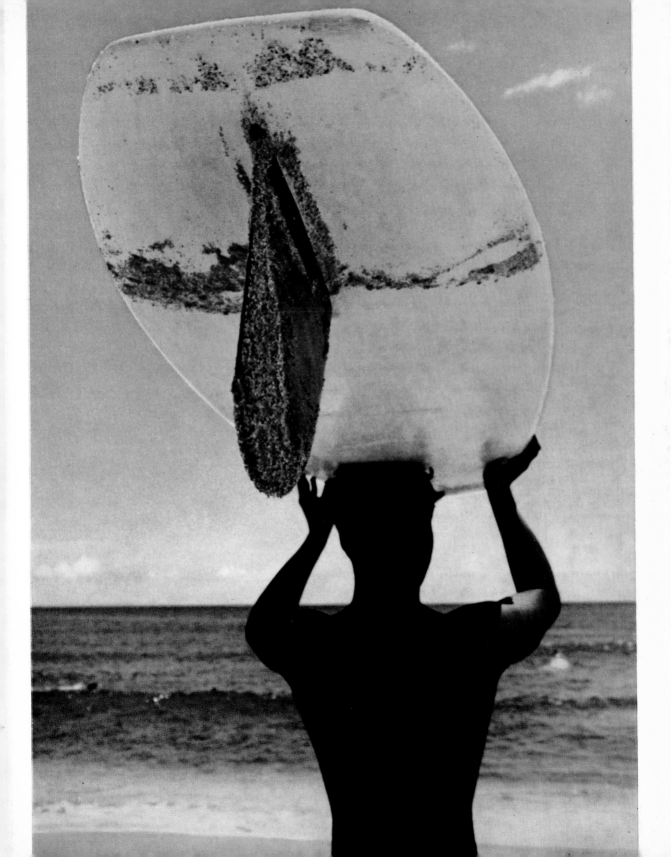

Underwater photography

Photography underwater is not such a difficult or expensive hobby as is commonly believed. Face mask, flippers and snorkel are all the diving equipment needed and a simple housing for the camera is not difficult to construct.

Naturally, you cannot go very deep with such equipment and it may, indeed, become expensive if you want to go really deep and use flash equipment. The water pressure builds up the deeper you go and your equipment has to be able to stand up to that pressure.

Still water is required for the best pictures because it is difficult to hold the camera steady in moving water and turbulence can also stir up any impurities present and scatter the light. The sun should be high so that its rays penetrate deeply before losing too much strength.

Once under the surface, you must move quickly. You can move forward easily by leg action alone if you wear flippers, leaving both hands free to operate the camera.

Picture structure

It is best to approach fish from the side, although good pictures can also be obtained from the front. Shooting from behind rarely gives satisfactory results and, in any case, fish should not be disturbed by chasing them. Unless elaborate equipment is available, scale focusing is used and it is often advisable to set the focus first and then approach the subject until it is at the required distance. Relatively short focus lenses are a help because they give greater depth of field and because long-range photography is not really feasible even in very clear water. Water has a magnifying effect, however, and the subject usually looks about one-third larger and therefore nearer than it would look in air. You have to learn to allow for this in focusing. When rangefinders or focusing screens can be used, this problem no longer arises.

Colour control

In deep water, there is virtually no colour and divers have to take their own lights down with them if they want to photograph in colour. Nearer the surface, however, some colour remains. Red and yellow begin to disappear at about 10 ft. At first you will be happy enough to get *any* picture, without worrying too much about organizing the colour but as you become more experienced, you can try to place your subject against rock formations, other divers, etc, if they need a darker background. The angle of the shot can also control the colour to some extent in that nearly all the light comes from the top when you are near the surface.

Left top: Dominant colour blue (see page 222)

Warm colour yellow (see page 190)—colour accent (see page 198)

Rightangle (see page 268)—triangle (see page 262)

If you can use flash, clear glass flashbulbs can be used with daylight film to compensate for the lack of warm tones.

The subject

Your subject underwater will be almost anything you find, whether fish, plant, rock or shipwreck. Your companions can also make interesting pictures, particularly if they can be shown close to fish or other underwater life. Even upward shots of any boat from which you may be operating or of other divers entering the water can be tried if the underwater life seems to be unwilling to pose.

Summary

You can start underwater photography with quite simple equipment. In fact, you can even use a glass-sided box from above the surface, holding it underwater at arm's length. For more ambitious work you need more sophisticated equipment and some training in its use. Moreover, when diving to greater depths with your own air supply you should never go alone.

Shooting data

Top Left: Kodachrome-X. *W. Kreig.*
Middle left: Kodachrome II, *J. A. Piechatzek.*
Bottom left: Ektachrome-X.
Right: Ektachrome HS. Peter H. Krause. All pictures from Kodak Archives.

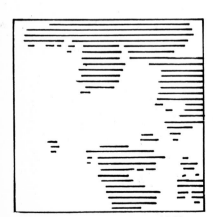

Colour as mass (see page 198)— background colour (see page 190)

Warm colours red and yellow (see page 190)

Horizontals (see page 242)

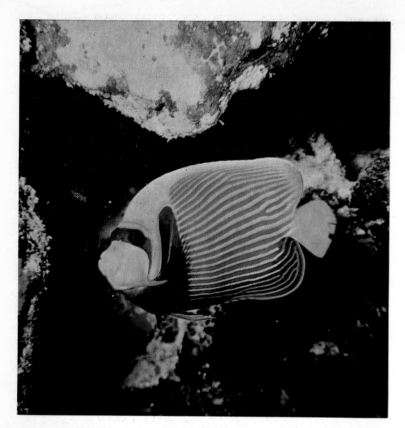

Diving has no dangers if you are careful and act sensibly. You will normally run into danger only because your equipment is unsuitable, your training inadequate or you are just plain foolhardy. Always be sure that you know exactly what you are doing.

It is important to know how to handle underwater equipment. The camera housing in particular must be handled with care. When first brought out of the water (and before opening it) it must be washed thoroughly in fresh water and dried. Before it is put away all metal parts should be coated with petroleum jelly and rubber parts with glycerine.

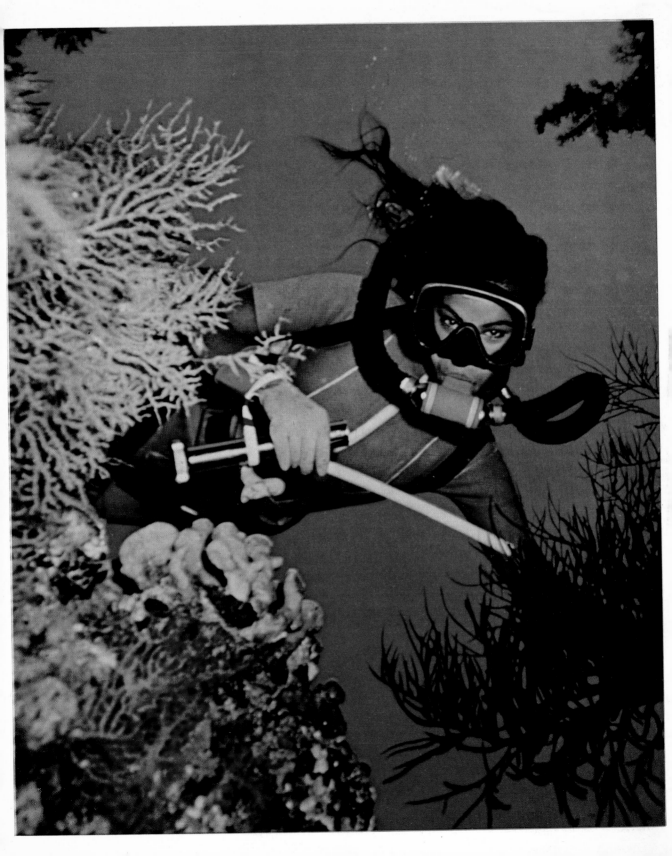

Instant colour pictures

The normal colour picture takes time to produce. The chemistry is complicated and the film has to go through several different solutions before the full colour image appears. Polacolor film, however, produces a full-colour print in about 60 seconds from the time the shutter release is pressed. The film can be used in special Polaroid-Land cameras or in Polaroid backs designed to fit other cameras.

Basically, only this back part of the camera is significantly different from any other camera. It is loaded with special packs of positive and negative material arranged in such a way that they can be drawn through the camera by pulling a series of protruding tabs. The negative material is first exposed in the conventional way. When one of the tabs is pulled, the negative passes round behind the pressure plate and is brought into contact with the positive material which carries pods of jellified processing chemicals. Steel rollers crush these pods and distribute the chemicals evenly. The negative image is then transferred in positive form to the positive material by a diffusion-transfer process.

Colour quality depends on time and temperature. The normal 60 seconds processing time gives correct colour rendering. Longer or shorter times give cooler or warmer renderings.

Picture structure

Naturally, the normal picture-making rules apply as much to Polacolor as to any other colour material, but it is even more essential to fill the frame with the subject. Various ancillary services *are* available to provide duplicate or enlarged prints but that rather defeats the object of the exercise, which is to produce finished colour prints barely one minute after shooting.

Colour control

Again, the normal rules apply. There is no basic difference in picture-taking technique between the Polaroid process and any other. There is, however, an additional facility in the Polacolor process of making the colour rendering warmer by shortening the processing time or cooler by lengthening it. This can be done instantaneously, so that experimental pictures can be taken *and judged* in rapid succession.

The subject

All the normal subjects are available to Polacolor with the addition of many special uses. Polaroid cameras are frequently used as a check on lighting balance, for example, before the actual shot is made on more conventional material. They are used by hairdressers so that they can show their clients a range of

Warm colours (see page 190)

Optical triangles (see page 238)

Rising diagonals (see page 246)

styles from a collection built up with the minimum of trouble. Storekeepers use them for stock control purposes and there are innumerable other specialized applications.

There are various models of camera, some of them automatic and giving exposures ranging from 1/1000 sec to several seconds. Flash can be used and there are many specialized attachments.

Summary

There is no limit to the versatility of the instant-picture camera. It can be adopted for all normal colour photography and its specialized applications are limited only by the ingenuity of the user. There is even a close-up model which takes pictures from one quarter to three times life size.

Shooting data

Both pictures are Polacolor prints. No details of camera or exposure are available.

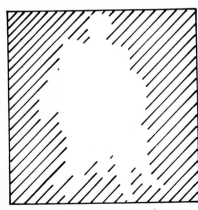

Colour as mass (see page 198)

Optical triangles (see page 238)

Rising diagonals (see page 246)

Sport

Innumerable opportunities exist for photography in the enormous variety of sports that are now practised in many countries. It is usually best, however, to avoid the top-class professional arena because very often you cannot approach the action closely enough, and also because there may be restrictions on photography.

Sometimes, as with cricket, you have to use a long-focus lens, but try to stick to the standard lens as much as possible. It is difficult to get real dynamism and impact into a picture with a long-focus lens. In athletics, for example, you cannot show the high-jump effectively from a distant viewpoint. A melee in the football goalmouth looks much more impressive when shot from close-range.

Picture structure

For pictures that tell the story you need to know something of the sport or game you are shooting. Then you can anticipate the action and be ready to shoot at the right moment. But there are plenty of other pictures at sporting events. The picture overleaf, for example, does not tell you much about motor racing. It uses the elements of a meeting to create an interesting colour composition. Similar themes could be found at most sporting events.

Speed of movement is a feature in many sports and, as colour film is not very fast, you need to know how to handle a moving subject without necessarily having to use the fastest shutter speed. One method is to pan the camera, i.e. to sight the subject in the viewfinder and to keep it in the same position while swinging the body round from the hips so as to follow the movement. The subject can then appear quite sharp at relatively slow shutter speeds. Stationary parts of the scene are blurred and increase the impression of movement. Another method is to wait for the "dead point". A ball thrown into the air, for example, attains a certain height and then momentarily stops before descending. The same applies to high jumpers, show jumping horses, a golfer's swing, a tennis player's service and so on. It is at this dead point that you can catch the action without using a fast shutter speed.

Colour control

Some sports are colourful, some are not. Generally you have to make what you can of the circumstances. If you intend to do most of your shooting at a particular event from a fixed viewpoint, it is as well to take a good look at the background first to ensure that you will not include patches of bright colour

Warm colour red—foreground colour (see page 190)

Cool colour blue (see page 190)

Abstract colour shape (see page 210)

that might attract the eye away from the subject.

The picture overleaf shows a particularly careful use of colour. The shot has been taken across the bonnet of a stationary red car contrasting strongly with the blue car in the background and effectively drawing it forward. The foreground car has been thrown so far out of focus that it is barely recognizable and our interest is centred on the sharp image of the car aimed straight at the viewer.

The subject

Local sports clubs and athletic meetings, games in public parks, regattas on the river, horse and motor racing tracks, and so on, offer all the opportunities you could wish for in sports photography. Approach the subject closely whenever you can. The long shot gives unnatural perspective that can sometimes be used to advantage but more often than not it makes the action seem remote and lacking in force.

Summary

If you intend to take photographs at big professional events, make sure first that photography is allowed. There are places where the conditions under which you buy your ticket deny you the right even to take a camera into the ground and, moreover, provide that it can be confiscated if you ignore the regulations. Even where photography is allowed, be careful not to interfere with the enjoyment of other spectators or to impede the competitors.

Shooting data

Leica, 400mm Telyt, Agfacolor CN17, 1/125 sec, f8. *Horst H. Baumann.*

S-line (see page 250)

Verticals (see page 242)

Circles (see page 254)